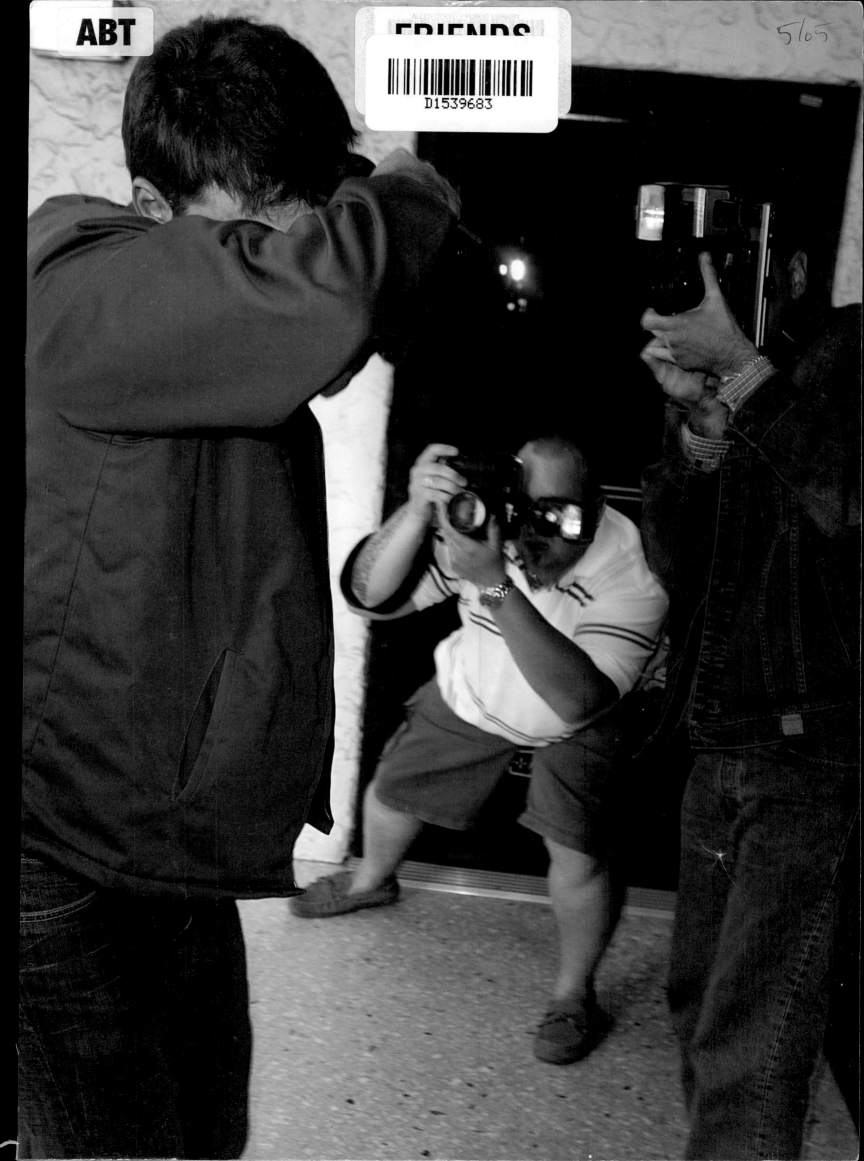

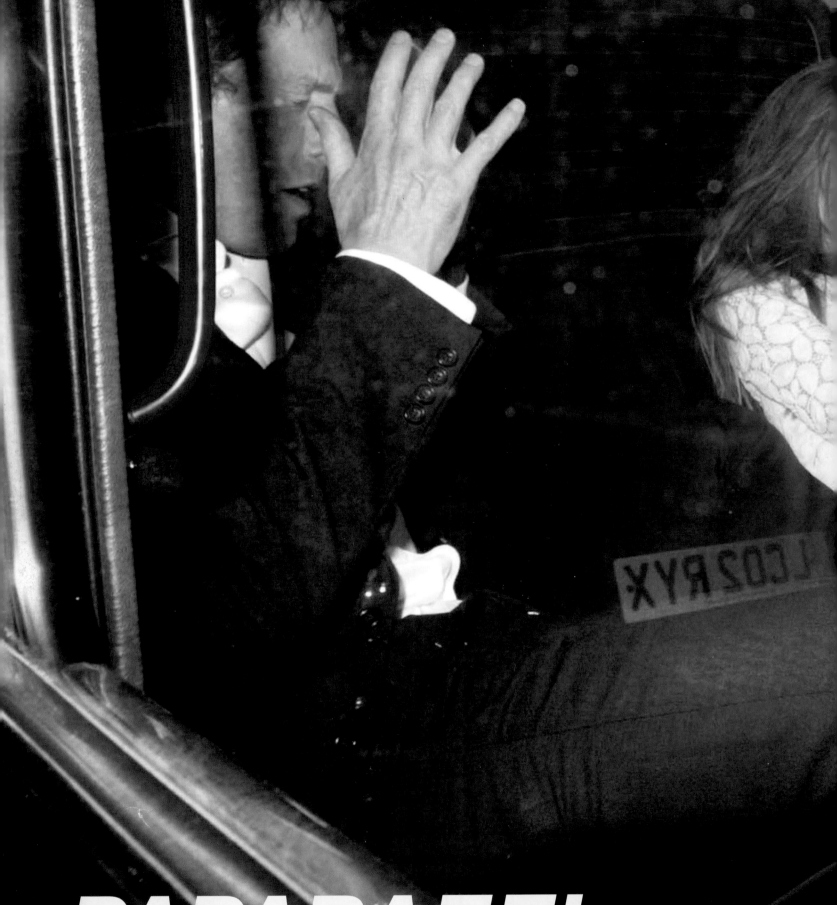

PAPARAZZI PETER HOWE

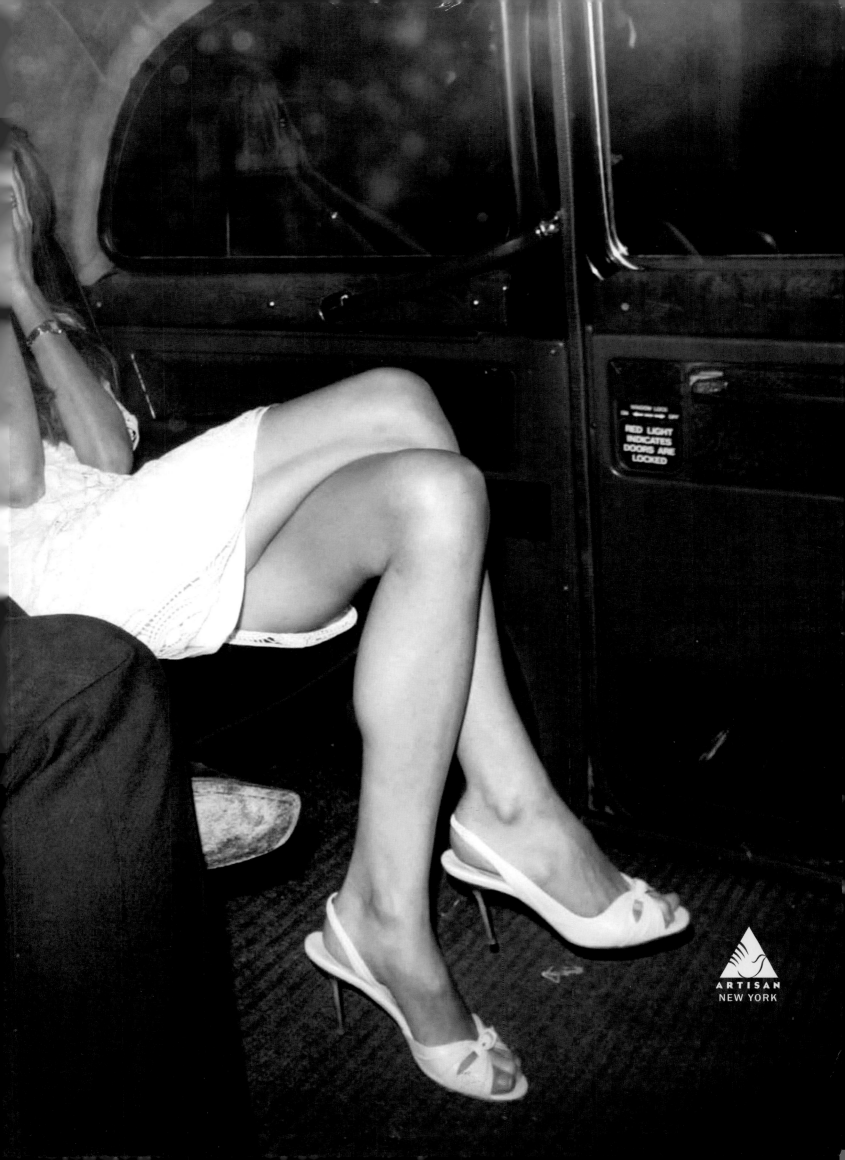

RED LIGHT
INDICATES
DOORS ARE
LOCKED

ARTISAN
NEW YORK

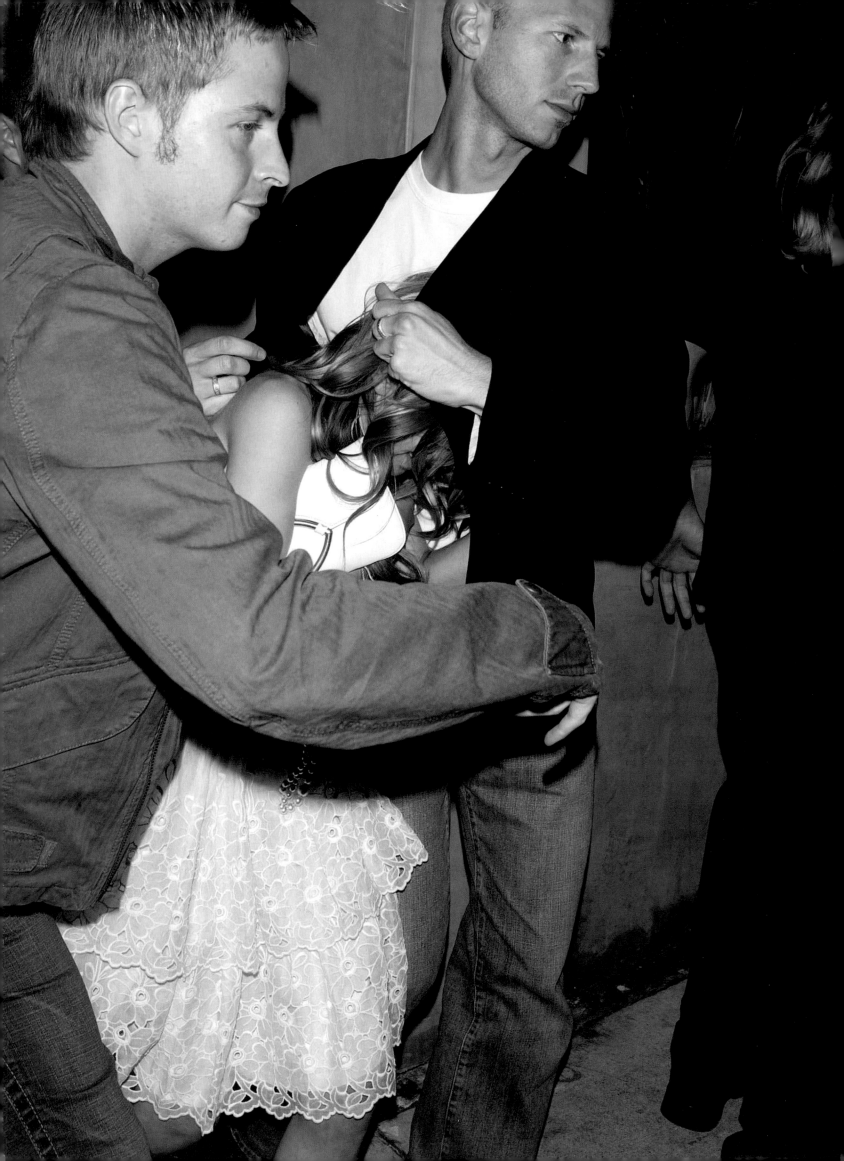

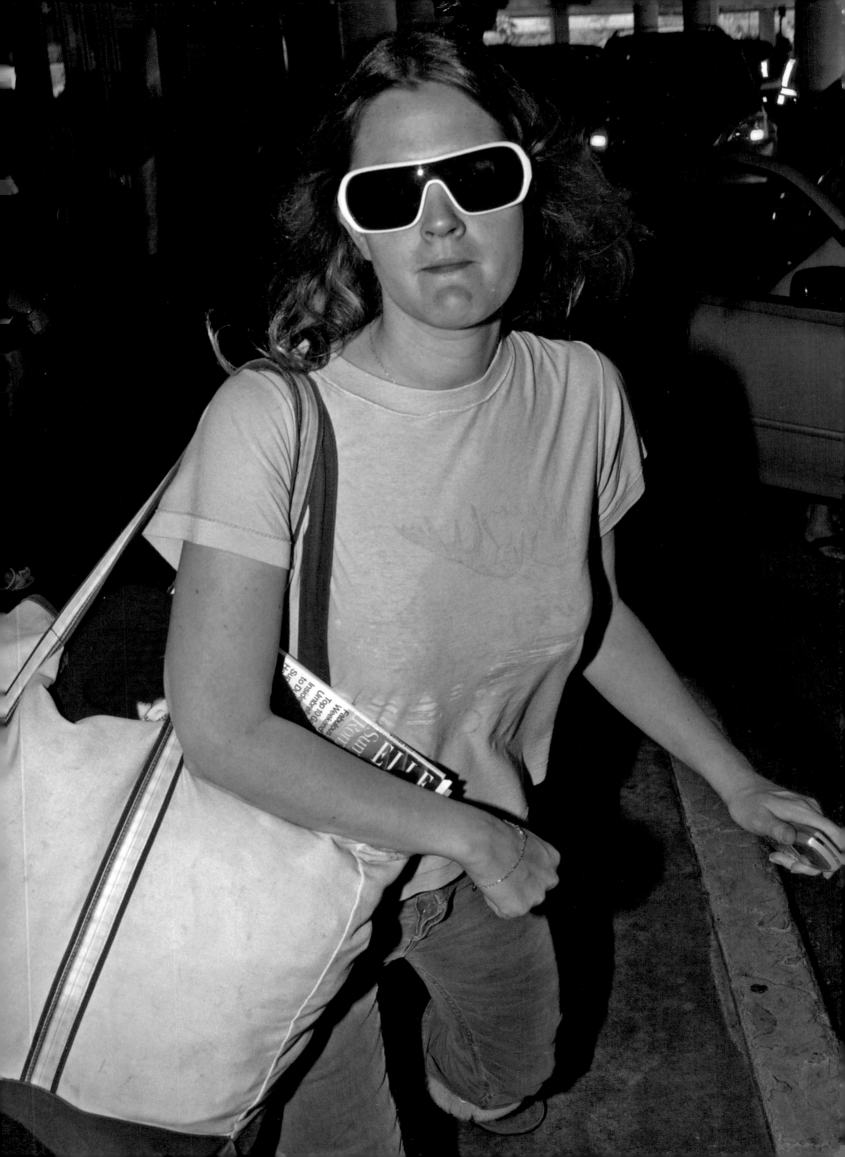

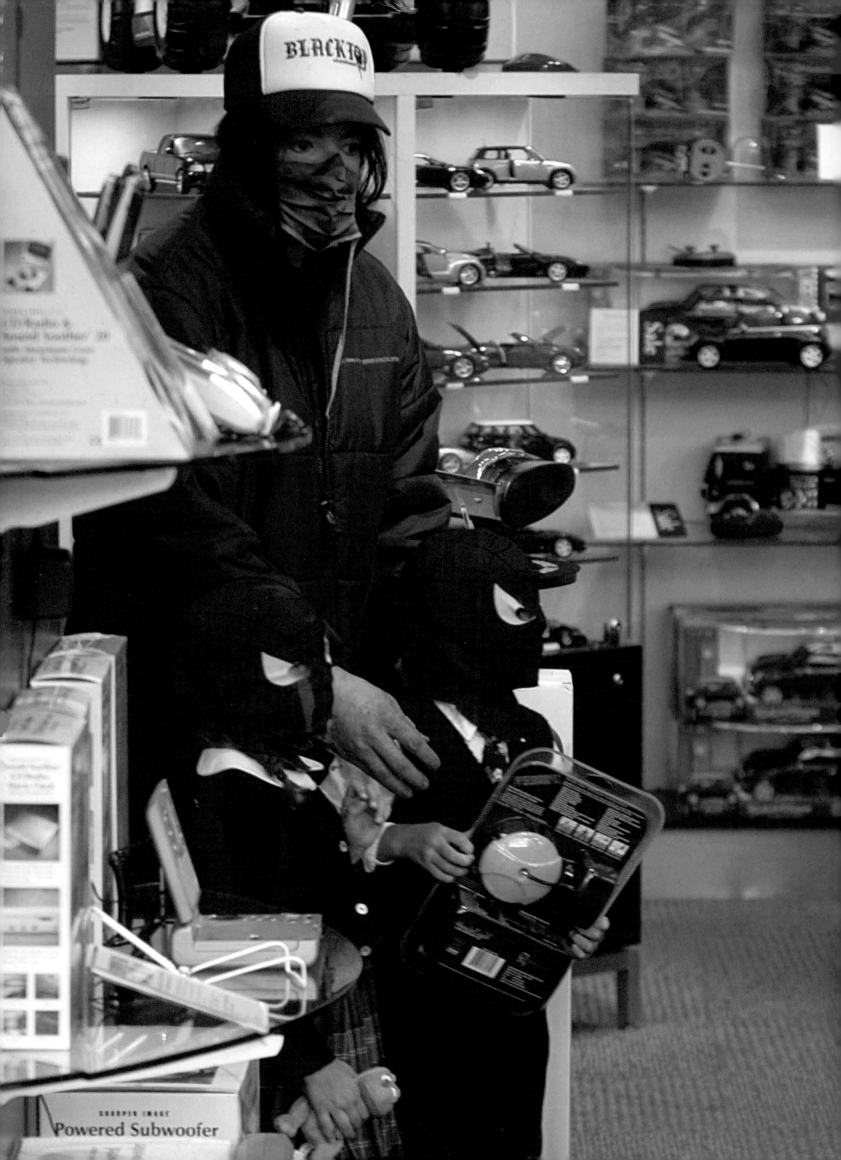

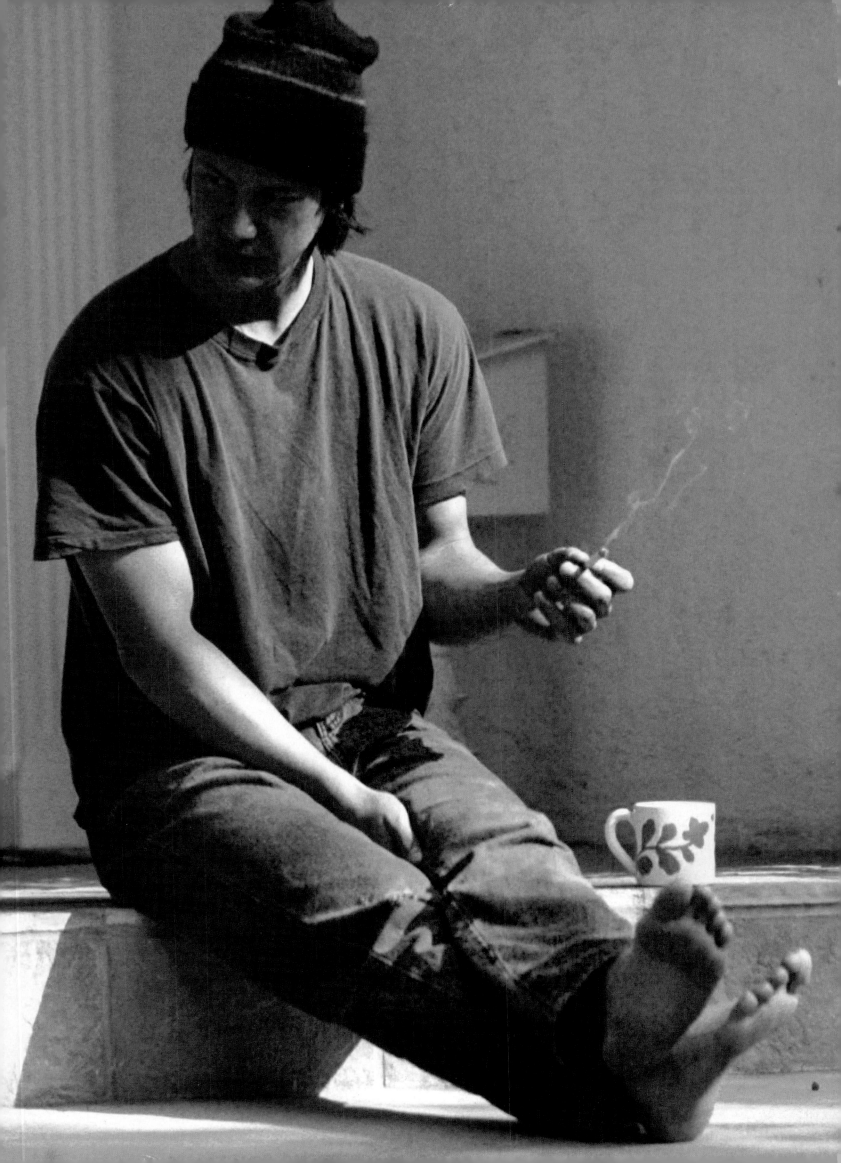

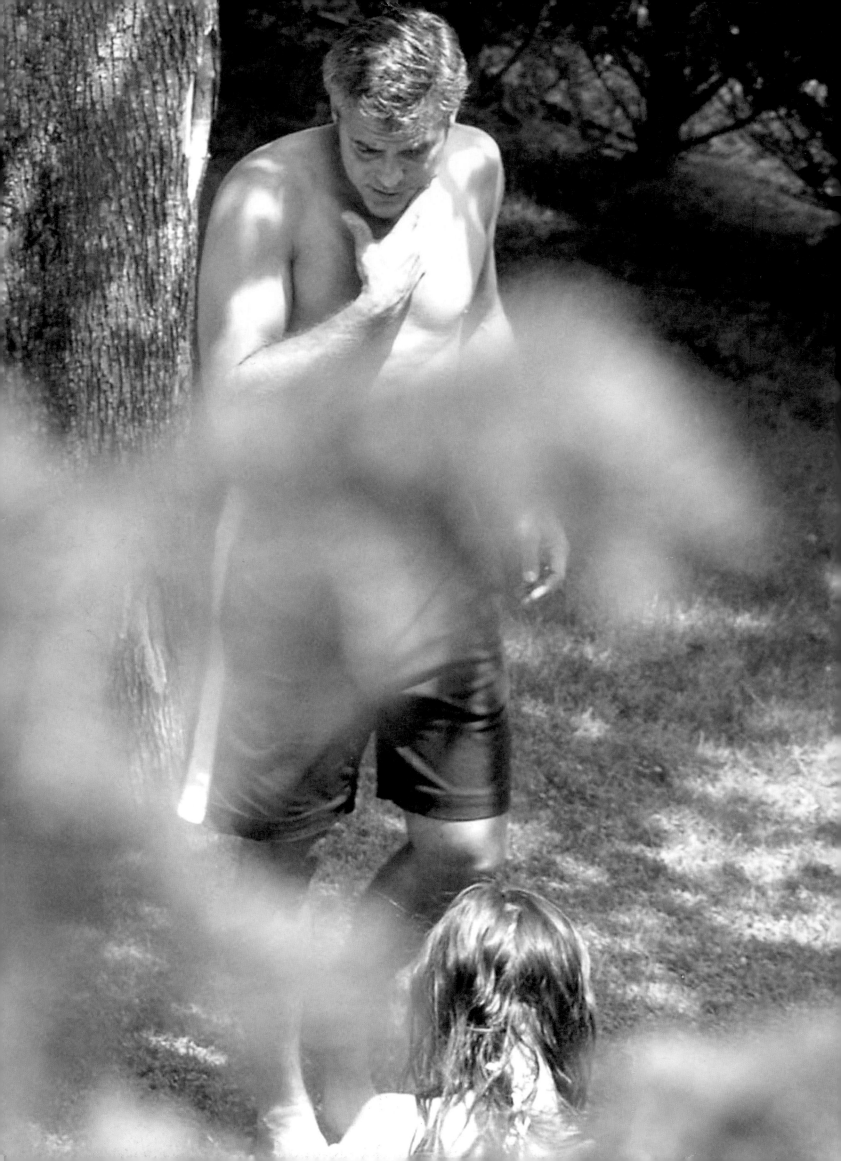

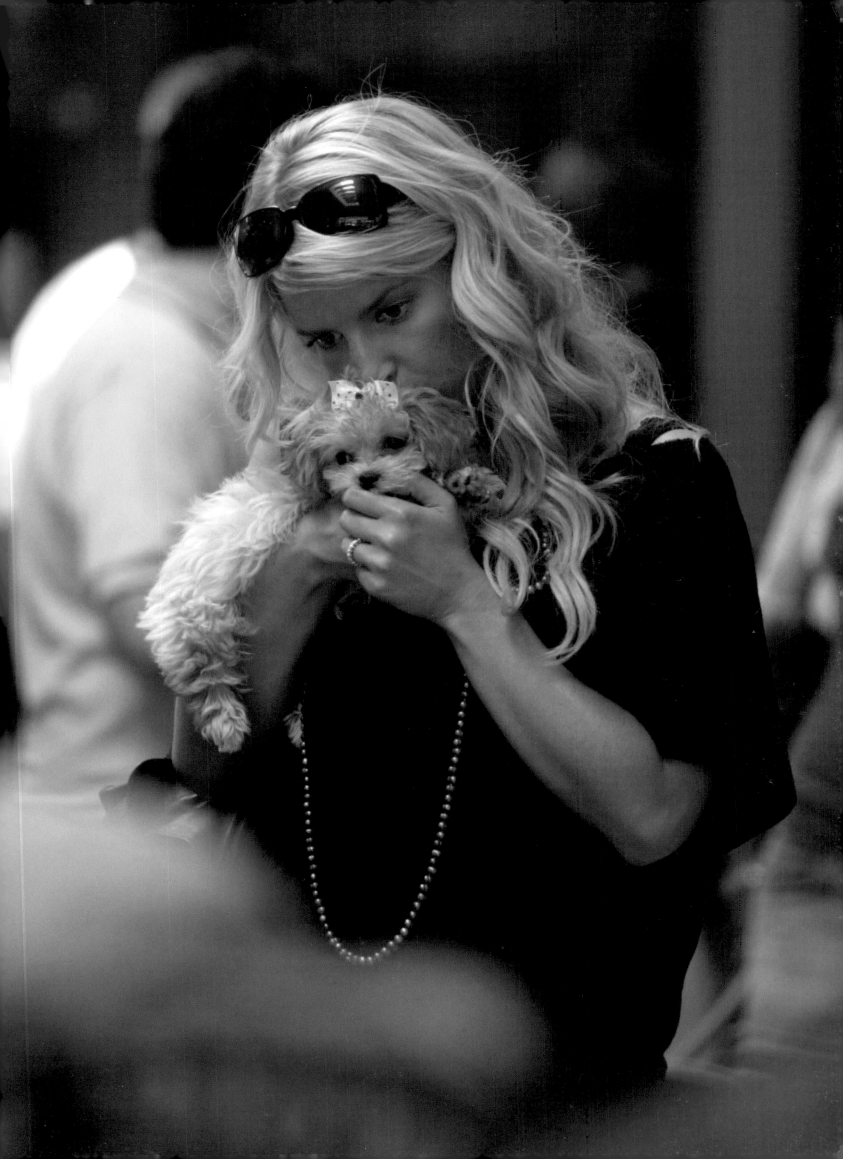

PAGE 1: Ben Affleck hides his face from photographers as he enters the CNN building in Los Angeles for an appearance on *Larry King Live.*

PAGES 2-3: Hugh Grant and socialite Jemima Kahn leave supermodel Elle Macpherson's house in London, confirming rumors of their relationship.

PAGE 4: Mary-Kate Olsen after the post-premiere party she and her twin sister, Ashley, held in Ashton Kutcher's fashionable restaurant, Dolce, in West Hollywood, May 2004.

PAGE 5: Drew Barrymore, arriving at Los Angeles International Airport after a flight from New York, isn't pleased to see the waiting photographers.

PAGE 6: Michael Jackson's idea of shopping incognito is to wear a close relative to the surgical mask; his children, Paris and Prince, both wore full Spiderman masks. The Sharper Image in Beverly Hills shut down for two hours while he was there.

PAGE 7: Spotting celebrities in their downtime is a skill in itself. This homeless person is actually Keanu Reeves in "shabby chic" mode.

PAGE 8: An intimate, and not-so-private, moment between George Clooney and Lisa Snowdon, July 2004. Clooney's vocal stand against the paparazzi caused an "industrial action" by them, during which they refused to photograph him at premieres and other events.

PAGE 9: Jessica Simpson window-shopping on Robertson Boulevard in Beverly Hills in the company of her puppy.

PAGE 11: The utilitarian power of fashion comes to the aid of Gwyneth Paltrow as she returns from marketing in London. Designer features that help confound the waiting paparazzi are clearly a factor in her selection of clothes.

PAGE 14: Tara Reid leaves Hollywood's trendy Concorde Club after a night of partying, June 2004. She is best known for her work in the movie *American Pie,* in which she played a virgin named Vicki.

PAGE 176: Princess Diana angrily reacts to photographers pursuing her in the street in London.

Published by Artisan
A Division of Workman Publishing, Inc.
708 Broadway
New York, New York 10003-9555
www.artisanbooks.com

Library of Congress Cataloging-in-Publication Data is on file

Printed in China

10 9 8 7 6 5 4 3 2 1

Book design by Vivian Ghazarian

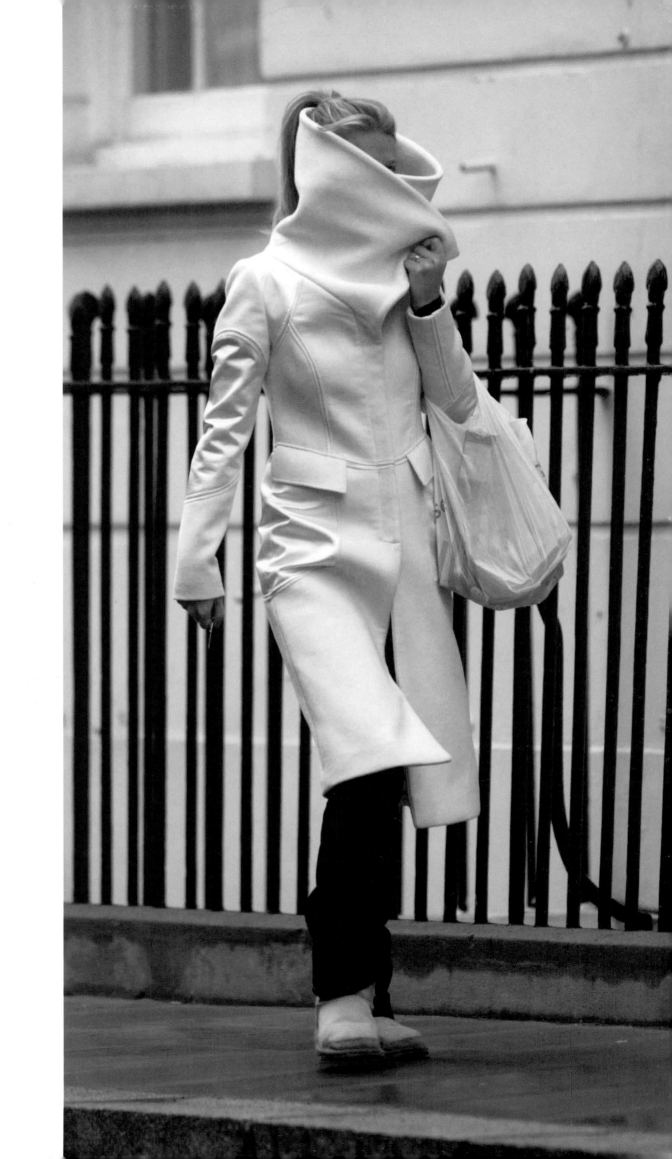

CAST

Rino Barillari — Self-proclaimed Caesar of the Via Veneto. One of the original paparazzi of Rome's street of sin and longtime staff photographer for the Roman newspaper *Il Messaggero*. Claims to have been beaten, stabbed, and shot at during his forty-plus-year career.

Adriano Bartoloni — The Pope's paparazzo. Rome-based photographer who has pursued the pontiff from the swimming pool of his private villa to the bed of his private hospital room.

Randy Bauer — Frank Griffin's partner—business only—in one of the most successful paparazzi agencies in the United States, Bauer-Griffin.

Jean-Paul Dousset — The scourge of Saint-Tropez. French photographers Dousset and his former partner, Daniel Angeli, became best known for their infamous toe-sucking pictures of Fergie, the Duchess of York.

Ron Galella — The Dean. The photographer who defines the term *paparazzo* in many Americans' minds. Most famous for his pictures of Jacqueline Kennedy Onassis and the court orders imposed on him to stay away from her.

Steven Ginsburg — Plays prince to Phil Ramey's king. Young, ambitious former Santa Monica bartender who, until four years ago, had never picked up a camera and is now in the process of forming his own agency.

Frank Griffin — Photo agent who's seen it all and sold most of it. Expatriate Brit and former paparazzo.

Mustafa Khalili — Present-day paparazzo and war photographer wanna-be. Born in London of Palestinian parents, he cut his professional teeth on the English celebrity scene.

Barry Levine — Mr. Tabloid. Assistant executive editor of *The National Enquirer* and its New York bureau chief. Also served in various roles at the *Star, A Current Affair, Extra!,* and *American Journal.*

Duncan Raban — The Cockney Gate-crasher. London-based photographer. Don't send him an invitation to your event—he won't need one. For the past twenty years he has turned up at celebrity gatherings whether he was invited or not.

Phil Ramey — Master paparazzo and the terror of Hollywood. Los Angeles–based photographer since the late 1970s and one of the most successful paparazzi of all time.

Susan Sarandon If you don't know who she is, you're reading the wrong book.

Massimo Sestini Still a paparazzo even though he doesn't have to be; keeps his hand in through the occasional stakeout. Now one of Italy's most successful editorial and advertising photographers.

Brittain Stone *Us Weekly* magazine's photo maestro. Lead editor at the publication, responsible for deciding which photographs will run and how much they are worth.

CREW
NOT NECESSARILY IN ORDER OF IMPORTANCE

PRODUCER	**Laurie Orseck**
LINE PRODUCER	**Pamela Cannon**
ART DIRECTOR	**Vivian Ghazarian**
DIRECTOR OF PHOTOGRAPHY	**Meg Handler**
DIRECTOR OF PRODUCTION	**Nancy Murray**
PUBLICITY	**Amy Corley**
L.A. PRODUCTION COORDINATORS	**Jim Roehrig** **Fredda Weiss**
ROME PRODUCTION COORDINATORS	**Grazia Neri** **Gaia Tripoli**
TRANSLATORS	**Geoff Sansbury** **Ricardo Ripanti**
ASSISTANT TO MR. HOWE	**Bobby Blue**
TRANSPORTATION	**M.T.A. #6 line** **N.Y.C. Taxi & Limousine Commission** **JetBlue Airways**
CATERING	**Starbucks**

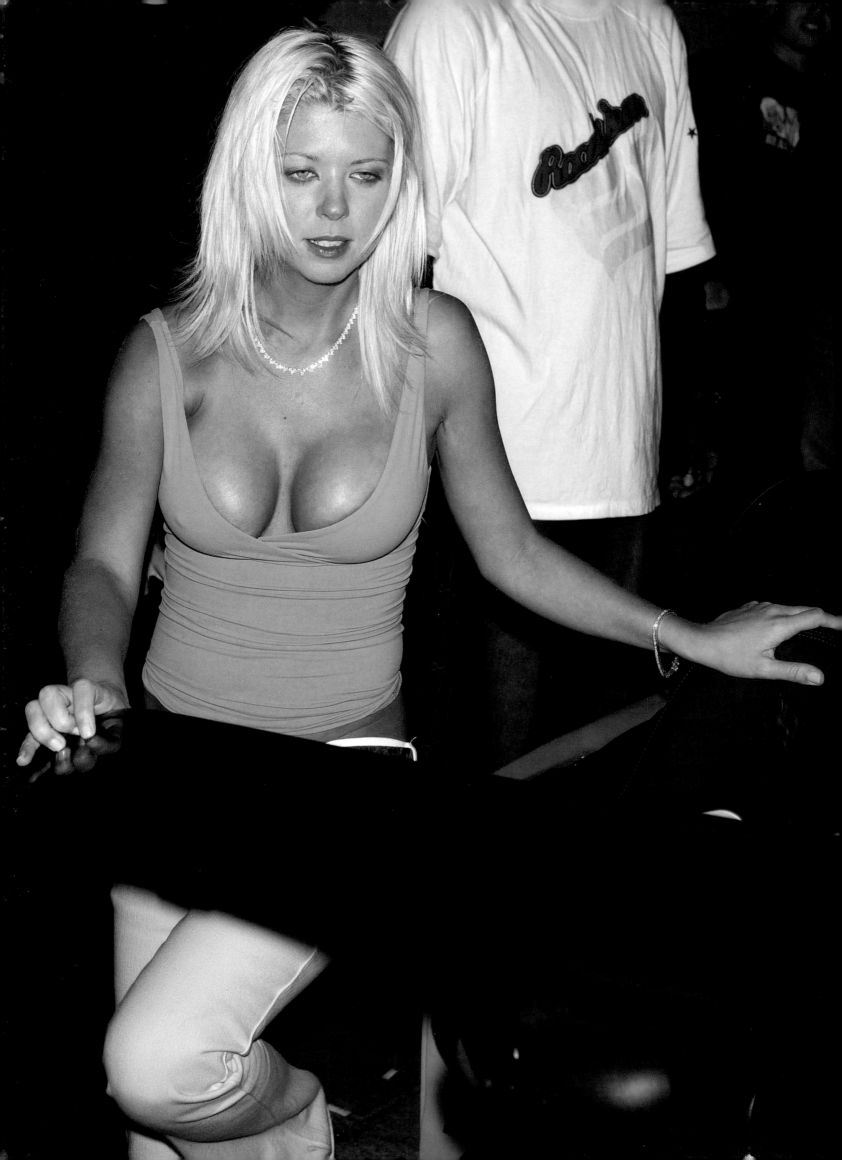

CONTENTS

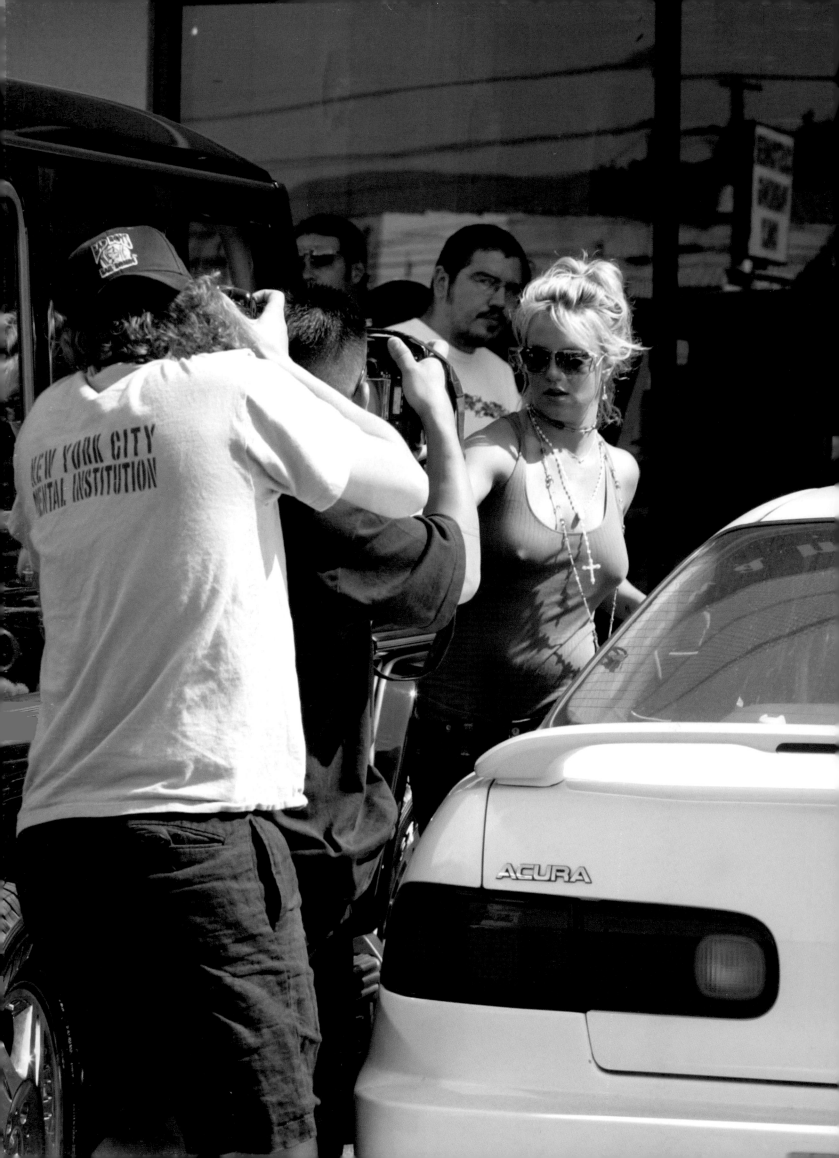

HYPE AND HYPOCRISY: THE PAPARAZZI AND US

I've long been fascinated by the phenomenon of the paparazzi, and I confess that this is partly due to the realization that I could never do their job. I don't think I have an especially strong fear of rejection, but it's certainly below the threshold that would enable me to go out on a daily basis and stick my nose, or at least my lens, where it's neither allowed nor wanted; to take abuse from my subjects, both verbal and sometimes physical; and to do without respect or admiration from my peers or even the people who buy my work in the magazines they read. But the paparazzi are hardly the Rodney Dangerfields of photography. Although neither gets respect, Mr. Dangerfield complained about it, whereas for the most part the paparazzi apparently don't care one way or the other. I have yet to meet another group that seems so blissfully unconcerned about the opinions of others. Occasionally you'll hit a nerve—use an unacceptable word or description—and the hackles go up. For the most part, though, these men and women are perfectly at ease with the way they earn their often considerable living and feel no need to justify their existence; that there are no yearly awards for the best paparazzi photographs is an indication of their collective self-confidence. This sometimes worked against me during this project, because whether or not they appear in a book on the subject is of little interest to them.

One of the more surprising aspects of writing this book wasn't the people who agreed to be interviewed for it, but the ones who didn't. Those included some of the biggest celebrities and their publicists, as well as Time Inc., which refused to let me talk to the picture editor of *People* magazine, for whatever reason we can only guess. Of the celebrities I approached, only actress Susan Sarandon agreed to talk on the record. An experienced film producer who was helping me set up interviews with the people at the sharp end of the paparazzi's lenses was advised by one Hollywood insider that no one would discuss this subject. Indeed, one young Academy Award–winning actor told me through an intermediary that he wouldn't be interviewed because he was planning to live with these people for a long time and he didn't want to antagonize them. His attitude embraces a common misconception among those who are pursued by the paparazzi: that their unwanted attention is in some way personal. It isn't; who gets photographed and who doesn't is entirely market-driven. There may be times when a paparazzo relishes the opportunity to extact revenge on a certain celebrity for a perceived slight, but not at the expense of being able to sell a picture. The paparazzi care about sales above and beyond all other considerations.

Now is probably the time to define exactly what the word *paparazzi* means in this book. It refers to those photographers who seek out and follow celebrities, or crash events to which they weren't invited, in order to photograph them in their most unguarded moments. In short, it's taking photographs you shouldn't take in places you shouldn't be. It doesn't refer to the photographers massed on either side of the red carpet

MADNESS ON MELROSE: Britney Spears and her fiancé at the time, Kevin Federline, are surrounded by photographers in West Hollywood, July 2004. One of them is wearing a T-shirt appropriate to the situation.

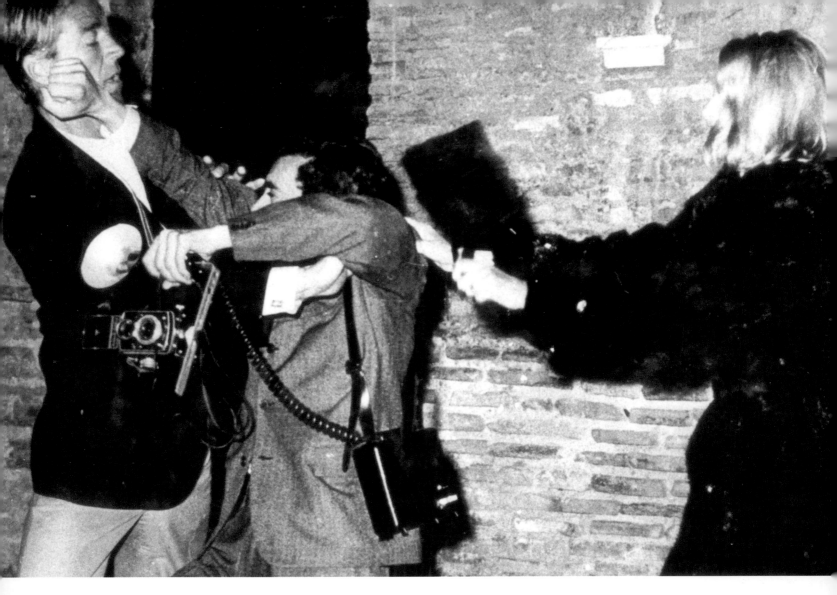

CURSE OF THE PURSE:
Rino Barillari, self-proclaimed "King of the Paparazzi," center, scuffles with Mickey Hargitay, Jayne Mansfield's husband, while model Watussa Vitta hits him with her handbag after he had taken photos of them on the Via Veneto, 1962.

at the Academy Awards or similar events where publicists herd an agitated flock of camera operators who then desperately scream at the incoming celebrities in the hope that they will turn their way. That is called event photography, and although the real paparazzi may do it from time to time, their true calling requires more cunning, resourcefulness, creativity, and sheer nerve than a red carpet ever demanded.

While the paparazzi are relentless in the pursuit of their subjects, they will drop them without even a second's consideration if the pictures no longer sell. This is one reason the term *stalker*, which is so often applied to them—especially in the form of *stalkerazzi*—doesn't totally fit. A classic stalker is obsessed with one person, whom he pursues endlessly; a paparazzo pursues many celebrities, but only as long as dollar signs are emblazoned on their backs. This may be small consolation to those whose lives are made hell by the photographers, but at least the attention probably means their careers are on track—unless, of course, they recently murdered someone or were arrested for drunk driving. Even in one of the rare instances of a paparazzo becoming entranced with one subject—Ron Galella with Jacqueline Kennedy Onassis—the relationship began with a solid commercial basis from the photographer's point of view. It also ended when the court actions Mrs. Onassis took against his omnipresence became more trouble to him than her image was worth.

The other aspect of the paparazzi that fascinates me is the hypocrisy with which their activities are viewed—that moral shroud under which we try to hide our guilty pleasures. Society's attitude toward them and their work is a bit like Yogi Berra's famous aphorism about a certain restaurant that nobody goes to anymore because it's too crowded. If everyone hates their work, why are they the best-paid and busiest

photojournalists in the world? This was particularly apparent after the tragedy of Princess Diana's death in 1997, when some of their most vociferous critics were the very people who had made a fortune publishing their pictures of the princess. The angriest mourners among the general public, those who most blamed the photographers for her death, were the same people who had purchased the magazines and newspapers that published paparazzi photos of her while she was alive—and it was the intimate glimpses of her life that these pictures gave to readers that made their grief so strong when she died.

This book is neither a defense nor a condemnation of the paparazzi. What it does attempt to do is connect the dots between their profession and our obsession, both of which are centered on a relatively small group of people called celebrities. The Roman historian Tacitus wrote, "The desire for fame is the last infirmity cast off even by the wise." If that was true in the first century A.D., it is much more so now, and it is certainly not confined to the wise. The need for fame, and the adulation that the superfamous are accorded in our society, is evident in the number and prosperity of celebrity magazines, the popularity of television programs about Hollywood personalities, and, of course, the rash of reality TV shows that feature "normal" people in abnormal circumstances (although how normal you have to be to want to appear on *Survivor* or *The Fear Factor* is debatable). Equally debatable is whether the desire for fame is an infirmity. What is certain is that those who pursue it in any field will be the objects of intense scrutiny. If you're an actor, a professional athlete, or a television personality, the price you pay for success is to almost entirely give up your privacy and to spend your public life in the company of (mostly) young (mostly) men with long lenses.

That the paparazzi make the lives of celebrities difficult is obvious, but the relationship between the two groups is much more complex than that. An interdependency develops between them, and performers' need for publicity on the way up is replaced by disdain for it when fame is achieved—only to be courted again by the desperate on the way down, much to the contempt of the photographers. Once the genie of fame is out of the bottle of obscurity, you're a public figure forever, and only failure can return you to your former state.

Whatever the public's opinion of the paparazzi—and for most people it's probably pretty negative—it's undeniable that the life isn't easy. You have to be thick-skinned; you are despised by your subjects, your peers, and the public, who are the ultimate consumers of your work; you will run afoul of security guards and public relations people, lawyers, and the police; you will be punched, spat upon, and have any number of objects thrown at you. The only people you will come across whose respect you can earn are the editors who appreciate the value of your work and are likely to reward you handsomely for your efforts. The bottom line is that if you have enough nerve, determination, and inventiveness, you will earn a lot of money and you will rarely be bored. But if you're at a cocktail party and a fellow guest asks you what you do, it's probably best to say you're a photographer and leave it at that. A glass of red wine in the face can leave nasty stains on a freshly laundered shirt.

PETER HOWE

FROM ANDREW JACKSON TO MICHAEL JACKSON

A SHORT HISTORY OF A LONG OBSESSION

OLD HICKORY: Andrew Jackson (1767–1845), the seventh president of the United States, in a portrait dated around 1825. The men he commanded during the War of 1812 nicknamed him Old Hickory because he was deemed to be as tough as that tree. He would have endeared himself to the paparazzi of his day, had there been any, when he fought a duel and killed a man who cast a slur on the character of his wife, Rachel.

On a sunny day in Malibu, a young woman, her child on her lap, is having lunch at a sidewalk café. She's a movie actress, with several starring roles to her credit, and has achieved that status so prized by our society—she's a celebrity. As she pushes an arugula salad around with her fork, a late-model Mercedes pulls up at the curb. A man steps out; he's dressed in that L.A. style that is almost a uniform for men of his background— chinos, sockless loafers, and a polo shirt. Nobody pays him the slightest attention. He has a worried look as he appears to write something in the Palm Pilot he's holding. He stops in front of the actress without looking up, then snaps the device shut, returns to his car, and drives off. Although the actress doesn't know it yet, she has just been photographed by a paparazzo using the latest in electronic gadgetry.

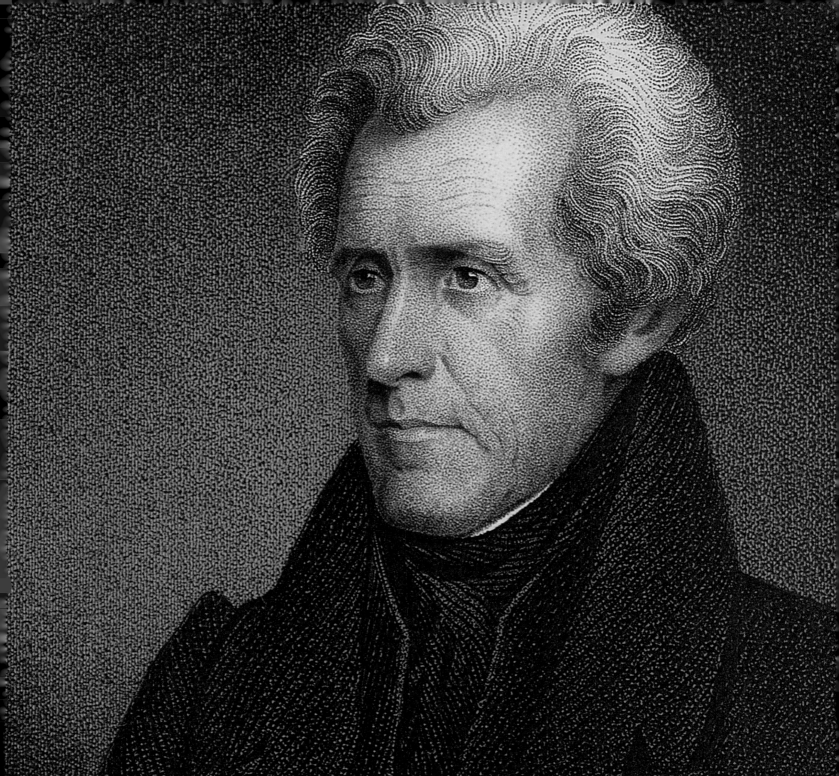

To some people the work of the paparazzi is as important as their own family photos, so the paparazzi do play a huge role in the lives of Americans today. BARRY LEVINE

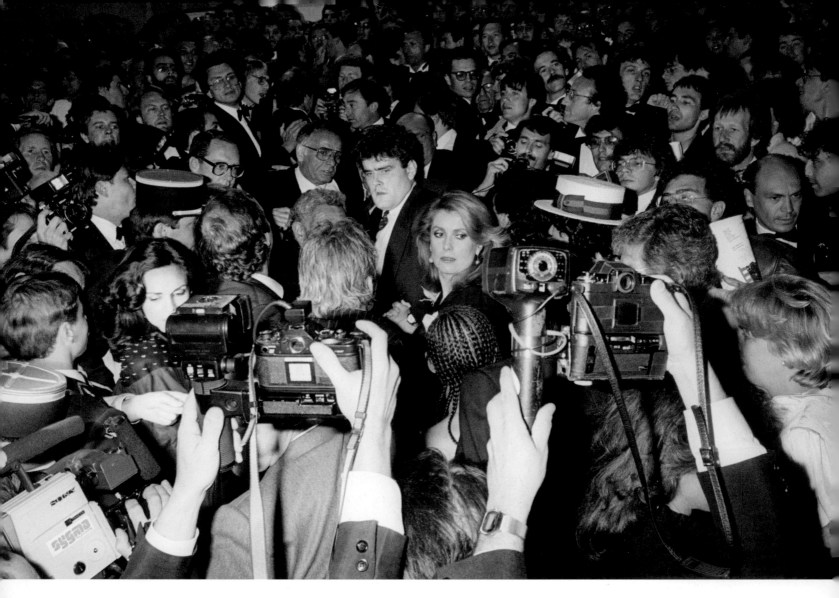

HAIL CATHERINE: A crowd of reporters surrounds French actress Catherine Deneuve, who can be seen in the center of the picture as she arrives in Cannes in 1983. The photographers in the foreground of the photograph are doing what is known in the trade as a "Hail Mary"—holding their cameras above their heads to get the shot. A hit-and-miss tactic of the desperate, it does sometimes hit, but more often misses.

Technology has changed the working habits of the paparazzi in much the same way that it has transformed the rest of photography. Long gone are the days when poor young Italian men pushed Rolleiflex cameras into the faces of stars relaxing on Rome's Via Veneto after a hard day's work filming at Cinecittà, Italy's low-rent alternative to the expensive studios in Hollywood. Today's lightweight long lenses and digital cameras capable of working in low light levels mean that, like the young woman at the sidewalk café, the victims often don't even know their pictures have been taken until they see them in the next edition of *Us Weekly*, *People*, or *Hello!* magazine.

Some things, however, haven't changed—our fascination with the lives of the recognizably famous, for one. If anything, we're more obsessed with the minutiae of their daily existence than ever before. The market for photographic glimpses of them has increased exponentially in the last fifty years, and the prices that publications are willing to pay for the right shot taken at the right moment have reached levels the early paparazzi would never have dreamed of asking. But though contemporary paparazzi are more handsomely rewarded for their efforts than the pioneers were, they still operate as much like espionage agents as photographers, relying not only on James Bond gadgets but also on an extensive network of contacts that includes even some of the lower-paid employees of the celebrity's own public relations firm. Part spy, part detective, part hunter, as their stories in this book will reveal, they have a tenacity that often propels them to go to astonishing lengths to get their photographs.

HOW WE SEE THEM

The Italian filmmaker Federico Fellini first used the term *paparazzo* for one of the characters in his 1960 masterpiece, *La Dolce Vita*. It was the name he gave to a fictional photographer who makes his living by photographing the excesses of the post–World War II life of wealthy Romans. In the movie, Paparazzo and his peers bribe their way into exclusive nightclubs and chase their targets down the Via Veneto on the backs of motor scooters or in open cars. During the making of the film, Fellini was reading *By the Ionian Sea*, a book about a visit to southern Italy by the nineteenth-century British novelist George Gissing. The author describes a hotel keeper called Coriolano Paparazzo; Fellini loved the buzzing sound the name evoked and thought it would be perfect for his frenetic celluloid photographer.

> ## Celebrities are people well known for their well knownness. DANIEL BOORSTIN

If the name came from the nineteenth century, the character was strictly contemporary, based on Tazio Secchiaroli, one of the original and most successful of the burgeoning group of early paparazzi. After spending many years recording the decadence of Roman nightlife, Secchiaroli eventually became Sophia Loren's personal photographer—presumably on her theory that if you can't beat them, employ them. But the paparazzi didn't just spring up overnight like a poisonous Italian mushroom, nor were their activities confined to the Eternal City. In order to understand how celebrity snooping developed into a multimillion-dollar business, it's necessary to understand how and why our popular culture became so obsessed with the lives of celebrities in the first place.

Talk to most people about the activities of the paparazzi, and the first thing that comes to mind is the death of Princess Diana and Dodi al-Fayed in Paris in 1997. When the Mercedes carrying them crashed in a tunnel and killed three of its four occupants, it was being chased by a pack of photographers on motorcycles. Initially, the authorities and the public blamed the photographers for the accident, to the extent that seven of them were arrested. It wasn't until the autopsies were completed that it was discovered that the driver's blood alcohol level was three times the French legal limit and that he had ingested the antidepressant Prozac as well as Tiapride, a drug used to combat alcoholism. The authorities concluded that he probably lost control of the car because of his intoxication.

Even though the photographers were cleared of direct culpability, most people still felt that they were somehow complicit and that the driver wouldn't have attempted to travel at such an excessive speed had they not been in pursuit. The princess's brother, Charles Spencer, in an angry outburst immediately after the news of her death, pointed the finger of responsibility at the press:

"I always believed the press would kill her in the end, but not even I could imagine they'd take such a direct hand in her death, as seems to be the case. It would appear that every proprietor and editor of every publication that has paid for intrusive and exploitative photographs of her, encouraging greedy and ruthless individuals to risk everything in pursuit of Diana's image, has blood on his hands today."

Anyone with even a passing knowledge of the publishing world knows that editors and publishers don't part with vast sums of money for photographs unless the investment will be returned in the form

of increased circulation. (An acquaintance who was then the editor of a national women's magazine said that she got down on her knees every day and thanked God for Diana. If she was the people's princess, she was the publishers' princess as well.) So through an extension of Spencer's logic, the readers of the publications are as guilty as the photographers who were supplying the fuel for their collective obsession.

Indeed, *obsession* is not too strong a word for our society's fascination with celebrities. Andy Warhol's assertion that in the future everyone would be famous for fifteen minutes has transcended its original status as a smart phrase to become a profound prophecy. To be celebrated is the apogee of success in our society, whether it's as a princess, a supermodel, an actor, a musician, a politician, a professional athlete, or a mob boss. What you did to become a celebrity isn't as important as having become one.

HOLLYWOOD RULES

The popular culture of the United States is the dominant cultural force in most of the developed world today. This isn't to say that the royal soap operas of Great Britain and Monaco haven't supplied copious material for the lenses of the paparazzi, but these really have been side shows to the main event: Hollywood and the American film industry. The term *celebrity* was first used in its present context by nineteenth-century American author and journalist Nathaniel Parker Willis. His biographer, Thomas Baker, claims that Willis "was instrumental in creating the celebrity market—and the idea that to really know someone, we must know their private life." Until that time, people who attracted public attention were described as "famous" or "renowned," and for the most part it was their public life that was discussed.

The kind of people we choose to celebrate has also changed over the years. Around the time of the Revolutionary War, society's heroes were statesmen, generals, and religious leaders; as the West was opened up, explorers and pioneers were added to their number, and with the development of America's economic might, industrialists and financiers joined their ranks. But the key event that helped shape the nature of celebrity as it came to be known in the twentieth century was the massive influx of immigrants from Europe in the latter half of the nineteenth. This flood of people changed the character of America in many ways; from the point of view of celebrity, it did two things: It weakened the hitherto predominantly Anglo-Saxon influence on popular culture, and it provided a mass market for outlets of entertainment.

By the turn of the twentieth century, the ruling principle was that entertainment was more interesting, and therefore more salable, than news. As journalism developed to cater to a burgeoning mass audience, the most successful publishers, such as William Randolph Hearst and Joseph Pulitzer, delivered to their readers reports that were selected more for their gossip value than for the useful information that they contained. Arthur McEwen, the first editor of the *San Francisco Examiner,* was quoted as saying that "news is anything that makes a reader say, 'Gee whiz!'" Neal Gabler, in his book *Life the Movie: How Entertainment Conquered Reality,* describes the progression from information to entertainment: "Where American newspaper publisher James Gordon Bennett was constrained by the written word and Pulitzer by actual events, Hearst treated the news the way an artist might treat a model, as raw material for his imagination. The news that actually happened was too dull for him, and besides it was available to other papers."

STYLE SUPREME:
British-born actor Cary Grant, photographed during the 1940s. Grant was one of the major stars whose success depended upon a screen persona that he carried from film to film. Although he was married five times, he was linked with several men during his life, the most notable being actor Randolph Scott. This was during the period when the all-powerful studios insisted that their leading men be married, even if they were known to be gay. It led to what were known as "lavender marriages," which were undertaken for the sake of appearances.

IMAGE IS EVERYTHING

During the nineteenth century, the other essential ingredient for successful mass journalism, the reproduction of photography, was developed. The first photograph was printed in a newspaper in London in 1842, but it wasn't until the availability of high-speed rotary presses and half-tone engravings toward the end of the century that the medium was exploited to its fullest. The publishers of popular newspapers at the time instantly realized the value of imagery on two levels. First, to write about a murder is interesting; to actually see the body lying in a pool of its own blood is compelling. Second, unless the victim is an assassinated world leader or someone of equal importance, the news value of such a photograph is limited—but its entertainment value

Everyone wants to be Cary Grant. Even I want to be Cary Grant. CARY GRANT

is enormous. Further proof that images have more popular appeal than words was forcefully provided with the rise of the American film industry. In the early days of what was to become the biggest influence on popular culture, even silent films were powerful enough to give rise to the fascination that moviegoers have had with those ethereal figures—the stars. (That leading film actors should be called "stars" is in itself interesting. After all, stars can only be seen in darkness, they are luminescent, they can be viewed long after they have died, and, most important from the point of view of this analogy, they are unreachable and therefore unknowable.)

If the early movie producers, such as the Edison and Biograph companies, had had their way, there would have been no stars at all. Initially, the actors' identities were withheld from the public, because the executives feared—quite correctly, as it turned out—that to divulge such information would give the performers too much leverage to command more money. By the 1920s, popular demand had forced the production companies to reverse this seemingly wise business decision. Audiences wanted to know not only who these godlike beings were but how they lived, who they loved, and how they fell from grace if that day came. It didn't take the producers long to

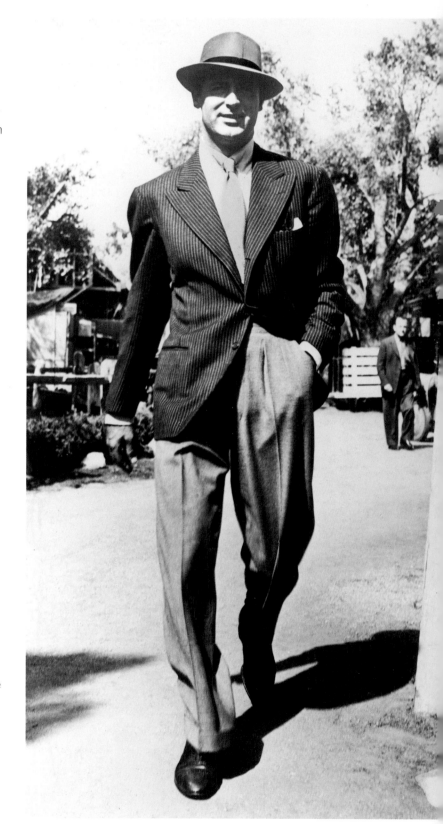

realize that if controlled properly, this fascination could be turned into a marketing windfall. Thus was born the modern mythology that actors are gods and goddesses who share many traits with their Greek counterparts, except, of course, that they're real people.

The word of the day was control. Movie moguls kept their players under tight reins, deciding not only which roles they would play in which films, but where they would live, how they would dress, what cars they would drive, and even in some instances whom they would marry. So powerful was the studio system during its heyday that few were prepared to take it on. Fan magazines were at the height of their popularity, but in terms of content they were little more than extensions of the studio publicity machines, which supplied most of their material. They would never have considered showing a screen idol in a compromising situation, knowing that if they did, future access to the star, or indeed to any of the other leading actors of that star's studio, would be curtailed or even severed.

The cracks in studio control began to appear as early as the late 1930s, just when their power appeared to be at its zenith. Two actresses, Bette Davis and Olivia de Havilland, led the way in the fight over the dictatorial business methods of the entertainment cartel. Davis, tired of the roles that Warner Brothers forced her to play, sued against the company's injunction that prevented her from working for other studios. Although she lost the case, her act of rebellion empowered others to challenge the status quo. De Havilland, following her success in *Gone With the Wind* in 1939, sued Warner Brothers to be released from her seven-year contract. Her victory in court—the landmark "De Havilland decision"—ended the long-term contract system. After the 1948 Supreme Court decision in the Paramount antitrust case that effectively broke the studios' monopoly, the remaining vestiges of the old power were finally stripped away. Jimmy Stewart became the first artist to demand and get a percentage of the gross receipts as a condition for his participation in a movie. By the early 1950s, the key word for both producers and stars had become *independence*.

THE DOMESTICATION OF THE SILVER SCREEN

Along with the decline of the studio star system, television, by changing the way we related to the stars, became one of the most significant events that helped create a market for the paparazzi. Up to this time the stars were astral bodies distant from our daily lives; our main point of contact was when we made a conscious decision to go to the movies. We would pay our money and settle into a seat in a movie house, a building that was often designed to resemble a temple or palace; our entry into the world of fantasy had begun as soon as we walked through its doors. The projected images of men and women who soared above us on the screen were literally larger than life, superhuman ideals rather than realities.

What television did was to cut the stars down to size; they lost their former luster and became mere celebrities. Now they were smaller than life; they were in our homes, and our relationship with them was much more casual. We didn't have to give them our full attention; if we didn't like their efforts to entertain us, we simply changed channels. Not only did television produce a considerable power shift in the relationship between the entertainer and the entertained, it also created a sense of false intimacy with them that was unlikely to occur within a movie theater. We were in their house then; now they were in ours. The rules of the game had changed.

SCREEN GODDESS, SCREEN ACTIVIST: Bette Davis, around 1930. Davis was one of the first movie stars to take action against the restrictive practices of the major film companies. Although she lost in the courts, she took a stand that contributed to the eventual breakup of the studio system.

People started to exchange the protection of the studios for a more hands-on life and more autonomy.

SUSAN SARANDON

Despite this evolution, the movie star remained the royalty of celebrity's realm. Even the most successful and loved television stars didn't achieve the grandeur of Katharine Hepburn or Humphrey Bogart. Many of television's greatest entertainers, such as Lucille Ball and Jackie Gleason, were successful precisely because they weren't larger than life, they were just like us only more so. Even the outrageous "glamour" of Liberace had a populist quality to it; Audrey Hepburn he wasn't.

Over time and through a process of cross-pollination between the two media, the lines have become blurred. There were early defections from film to television, such as Bob Hope and Groucho Marx; today we see traffic in the other direction—Tim Allen, Bill Murray, Eddie Murphy, and Jennifer Aniston are all examples.

In recent years, television has also extended the definition of people we consider celebrities. Now news readers and forecasters of weather, doctors and diet gurus, chefs and home decorators, sports commentators and even marketers of chickens have become television "personalities." With the advent of the genre of reality television, everyone is potentially a celebrity, just as Andy Warhol predicted. And the closer each of us comes to being a celebrity, the more rights we feel we have to the lives of those who already are. It's a bit like Lotto: Not many of us win it, but we can all be in it. My wife and I attended a charity dinner at Tavern on the Green in Manhattan where celebrities were to be honored, including several prominent television actors. The organizers of the event had placed all of them at one table, and during the evening I noticed a crowd gathered around it, gazing at and talking about the stars as if they were still on television and not there in the flesh. To be a celebrity now is truly to be public property.

We're always looking for perfection, and somehow we think the stars have it. RON GALELLA

The paparazzi also feed our common fantasy that our idols are just like us only luckier. Madonna may be a superstar, but she falls off her bike—just like us. Cameron Diaz may be one of the highest-paid actresses in Hollywood, but she plays air guitar—just like us. Part of the success of the reality shows is that they produce celebrities who really are just like us, because they *are* us. When we buy *Us Weekly* and see photographs of our favorite stars doing silly everyday things, it fosters the illusion that we could be them one day, even though the logical part of our brain knows that we are worlds apart. The notion that we knock our heroes and heroines off their pedestals simply to denigrate them is flawed; we also knock them down so that we can identify with them more strongly. If we can't enter their world of private jets and oceanfront estates, we get them to enter ours by seeing them perform the mundane tasks of life. And their frequent tumbles from their pedestals help us manage our envy of the adoration and power we accord them. In a consumer society, in which those of us who can't buy anything we want are confronted with those who can, it's always comforting to have examples of money not buying happiness.

STREET PHOTOGRAPHERS ON A MISSION

Enter the paparazzi, the result of a collision between a culture obsessed with celebrity and an established tradition of street photography. When I interviewed the most famous of the older generation of American paparazzi, Ron Galella, he told me that his photographic heroes were Brassaï and Henri Cartier-Bresson,

neither of whom would immediately be thought of as paparazzi but both of whom had distinguished careers photographing people in the street without asking their permission. The people pictured in some of the classic works of these photographers, or others such as Robert Frank, the chronicler of mid-twentieth-century America, didn't sign model releases after the photographs were taken, and they're often shown in an unflattering light. I'm not suggesting that these photographers were protopaparazzi; as far as I know, Frank never rammed the car of someone he wanted to photograph in order to get the person out of the vehicle, nor did Cartier-Bresson ever hide in a Dumpster for three days waiting for his subject to appear. Street photographers do what the paparazzi do, but they don't take it to such extremes. From the day that equipment light enough and small enough became available to them, photographers have used hidden cameras, worked in concealed locations, and gone to considerable lengths to get photographs that, because the subject was unaware of their presence, seem to be truer. In respectable photographic circles, it's called being a fly on the wall. In the case of the paparazzi, it's more like a hornet.

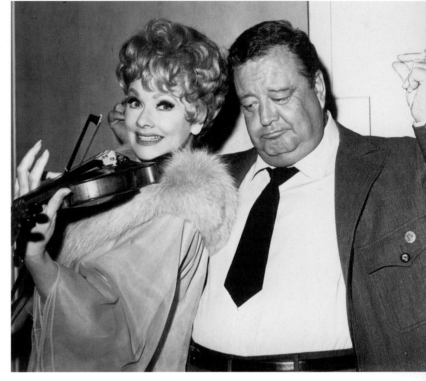

BIG STARS, SMALL SCREEN: An undated photograph of Jackie Gleason grooving to the violin of Lucille Ball in a scene from her fourth television series, *Here's Lucy.* Although she had appeared in more than sixty films by the late 1940s, Ball never became a major film star. Her first series, *I Love Lucy*, premiered in October 1951 and ran for six years; during the first four it was number one in the Nielsen ratings, and it never went below number three. Jackie Gleason is best known for his role as the Brooklyn bus driver Ralph Kramden in *The Honeymooners,* a spinoff from sketches that originated in his variety series *Cavalcade of Stars* in 1951. He produced only thirty-nine episodes of the situation comedy during the 1955–1956 season for CBS. Although it was not a success when first broadcast, it became one of the most popular shows ever in syndication.

If you're looking for a prototype for the American paparazzo, the obvious candidate is Arthur Fellig, better known as Weegee. This Austrian immigrant who spent his time photographing on the streets of New York, mostly during the 1930s and 1940s, was described by *The New York Times* as "the world's most notorious news photographer." Although most of his work dealt with crime and disasters ("my two bestsellers, my bread and butter"), his technique is as intrusive as the most aggressive paparazzo's. His series of photographs of lovers on a Coney Island beach at night would be exactly the work of a paparazzo had one of the anonymous couples been Jennifer Aniston and Brad Pitt (or better yet, someone who wasn't Brad Pitt). In one of his most famous pictures, now known as "The Critic," two society women in ball gowns and diamonds are shown on their way to the opera; to the right of the frame a decidedly nonsociety woman scowls at them in a thoroughly disapproving manner. It is her presence and demeanor that makes a dull picture an amusing social commentary. Weegee understood this—he planted the "critic" (a regular in a Bowery bar that he used to frequent) in the frame. Like all paparazzi, he not only knew what would appeal to the public, but he was also prepared to go to any length to get it.

SHOOTOUT ON THE VIA VENETO

The early paparazzi on the Via Veneto were no strangers to this kind of manipulation. It didn't take them long to understand that the best and most salable photographs have to have an element of confrontation. The most dramatic of these manufactured events was between Tazio Secchiaroli and the actor Walter Chiari in 1958. Chiari and Ava Gardner had just come to the end of an evening of nightclubbing. Four Via Veneto photographers who had been following them all night had taken some standard, and fairly worthless,

FAKE IT TO MAKE IT: The woman at the right in this 1943 photograph didn't appear there by chance. Weegee paid for her participation and had an assistant push her into the right place at the right moment so she seems to be passing judgment on two well-turned-out society woman. This manipulation transforms a mundane picture into a social commmentary.

pictures. As Chiari was parking his car at an apartment building, Secchiaroli, after making sure that his collaborators were well positioned, went up to Gardner and exploded his flash right in her face. She screamed, which of course infuriated Chiari, who immediately went for Secchiaroli—only to be photographed in the act by one of the waiting photographers. The pictures were widely published, and the paparazzi learned a valuable lesson. "In situations like this one, we discovered that by creating little incidents we could produce great features that earned us a lot of money," Secchiaroli said. "That way we could break the humiliating barrier of only earning the three thousand lire from the newspapers for a photograph, and instead earn as much as two hundred thousand." It didn't take long for the celebrities themselves to realize that such incidents, or *paparazzate* as they became known, were more likely to be published and therefore to increase their own fame. Thus developed the symbiosis between the celebrity and the paparazzo: The celebrities started giving out the evening's likely itinerary to the photographers so that they would be in the right place at the right time.

Of course, one of the reasons that these photographers had to be literally "in your face" was that most of them were using Rolleiflexes, for which there were no long-focus lenses and which required the photographer to come in close and use a flash for a picture of any quality. But as the sixties progressed, and longer, lighter, faster lenses attached to single-lens reflex cameras became available, the element of stealth came into the picture. Now many of the images were stolen moments when, like our actress in the Malibu café at the beginning of this chapter, the subject wasn't even aware of the presence of the photographer.

During this period, the paparazzi also developed a roster of international celebrities whose images they knew would always find a market: Elizabeth Taylor and Richard Burton; almost any member of the royal families of Britain (including the Duke and Duchess of Windsor) and the principality of Monaco; Jacqueline Kennedy Onassis; Brigitte Bardot; Sophia Loren; Marlon Brando. Add to their number the disgraced politician or corrupt business executive of the day, and you have the target list for most paparazzi at that time. The mixture of celebrity and scandal always provided the most prized and most published images.

YOU THINK IT'S BAD HERE? TRY EUROPE

This was also the period when the schism between the European and American paparazzi first developed. The French, British, and Italian photographers have always been known for a much more aggressive approach to their work, with a "shoot first and damn the rights to privacy" attitude that includes deception, bribery, trespass, and any other violations necessary to get the picture. Even today, many of the most successful photographers in Los Angeles are of French or British nationality. (By comparison, American

photographers were, and to some extent still are, a much better-behaved bunch, despite what many celebrities think.) Instead of provoking confrontation, European photographers now positioned themselves and their long lenses in any spot that gave them a view of their prey in private moments. Whether it was Settimio Garritano pretending to be a newly hired gardener on the island of Skorpios in order to shoot sunbathing pictures of a nude Jackie O, or Jacques Lange bursting into a schoolroom with a Minox hidden in a pack of cigarettes to shoot a single frame of Princess Caroline of Monaco taking her exams, the European paparazzi showed the lengths to which they would go in order to guarantee payday. And what a payday it often was. The money that regularly changed hands for exclusive pictures of grade-A celebrities made these photographers the highest-paid photojournalists in the world. Tens of thousands of dollars for a single shot was common, and hundreds of thousands was by no means infrequent.

The 1980s and early 1990s was a great period for the paparazzi. In Europe, three princesses—Diana of Wales and Stephanie and Caroline of Monaco—as well as one duchess (of York, Sarah Ferguson, aka Fergie) provided a constant source of material. In the United States a whole new batch of celebrities was embracing the camera, including Madonna and the increasingly strange Michael Jackson. Studio 54 was the shrine in the religion of fame where some worshipped several times a week. The trend of glorifying photographic models that had begun in the sixties reached its peak with the advent of supermodels, among them Claudia Schiffer and Cindy Crawford; and there was no lack of good scandals: the trial and imprisonment of Ivan Boesky, the romance between Woody Allen and his lover's adopted daughter. And there was always Elizabeth Taylor, overweight or thin, hospitalized or healthy.

It was also during the 1980s that the demand for paparazzi photography was fueled by an unlikely source: the publicist. In Los Angeles, a new breed developed whose sole function was to tightly control access to the stars and the distribution of their images. What had formerly been a press agent now became an antipress agent, and what had been an amicable relationship during the acquiescent days of the fan magazines became warfare in which the publicist usually won the battles. The combat went this way: A magazine decided to do a story on a celebrity; it contacted the celebrity's publicist, who determined whether or not to cooperate. If the decision was made to go ahead, the publicist chose who would photograph the celebrity, even though the magazine was paying the bill; demanded, and received, photo approval and cover placement; demanded, and received, an embargo of a certain period after the magazine's publication before which date the photograph could not be licensed to any other publication. (Any further use would have to be approved by the publicist, who could withhold permission without explanation or even logical reason.)

Needless to say, this didn't sit too well with magazine editors. It was demeaning to be treated like some form of household pest, and it also forced the less wealthy and prestigious publications to use the visual droppings of their better-off competitors, who had already jumped through expensive hoops to get the pictures in the first place. Furthermore, the process was time consuming; requests for use were often ignored for weeks, then denied without a reason. The result was that the paparazzi became an appealing source to a wider range of publications: Not only did their photographs require no sign-off from a publicist, they also returned control to the editors. There was a bonus as well: Readers loved these photographs, the very antithesis of the tightly controlled, homogenized portraits that publicists preferred.

WE DEMAND, THEY SUPPLY

The general public has—and maybe always has had—an ambivalent attitude toward celebrities. The need for both the glossy studio portrait and the unglamorous, sometimes seamy, paparazzi representation of them is a product of this ambivalence. If you exclude for the moment the phenomenon of the "reality" celebrities, our idols appeal to us on one level as superbeings, deities who inhabit a world that we can imagine but will never experience. The job of the highly paid portrait photographer, and his or her accompanying army of stylists, hairdressers, and makeup artists, is to transform the stars into icons for the temples of our imagination. The paparazzo, on the other hand, fulfills another fantasy—namely, that these revered beings are just like us underneath their fabulous surface. By showing them shopping, arguing, getting drunk, playing with or even slapping their kids, we're allowed the illusion that not only are they people just like us, but that with better luck, or a different turn of events, we could be just like them. This fantasy makes the celebrities more appealing to us, and it helps us deal with our envy of their elevated lifestyles when we compare them to our more humdrum daily lives. They may be rich, powerful, and adored, but they also look fat, plain, angry, stupid, or whatever unflattering image of them that is captured by the paparazzo's lens. Only if you're a celebrity is there a demand for bad pictures of you; the ones that you and I would throw away end up as photo spreads in magazines.

The market for the work of the paparazzi is at a peak as I write this book. The money that their photographs fetch is often staggering, reflecting our culture's obsession with celebrity in two ways. First, the readers of magazines and newspapers seem to have an unquenchable thirst for an intimate look into the private lives of their heroes. Second, publishers, having realized this, are either publishing more new celebrity-based magazines or are converting existing vehicles into them. Although it is not yet an outlet for the work of the paparazzi, even *Vogue* nearly always opts to show a film or television star rather than a model on its cover. What was once almost exclusively the bailiwick of the tabloids is now increasingly becoming mainstream. In a seller's market, the price tag on an exclusive shot of an A-list personality seems almost without limit. One of the leading celebrity magazines paid $120,000 for photographs of Britney Spears's quickie Las Vegas wedding, and they weren't even exclusive. *People* reportedly spent close to $700,000 for two sets of pictures for a single issue of the magazine: $50,000 for photographs of Gwyneth Paltrow and Chris Martin as they left her doctor's office, having just discovered that she was pregnant, and $600,000 for exclusive shots of the wedding of Trista Rehn and Ryan Sutter, "stars" of ABC's reality show *The Bachelorette*.

EVEN POP PRINCESSES FALL: Madonna tumbles off her bike en route from Pilates to Kaballah, May 2003. Trying to juggle both coffee and water contributed to her tumble at the fashionable intersection of Little Santa Monica Boulevard and Rodeo Drive in Los Angeles.

ROUT OF THE GIRLIE MAN: Arnold Schwarzenegger, when he was still a humble film star, at the Los Angeles Inner City Games in October 2002. He was elected governor of California in 2003. Says actress Susan Sarandon: "You know that the line between the people you play and the person you are has become smudged when somebody gets elected to an office based on his film persona."

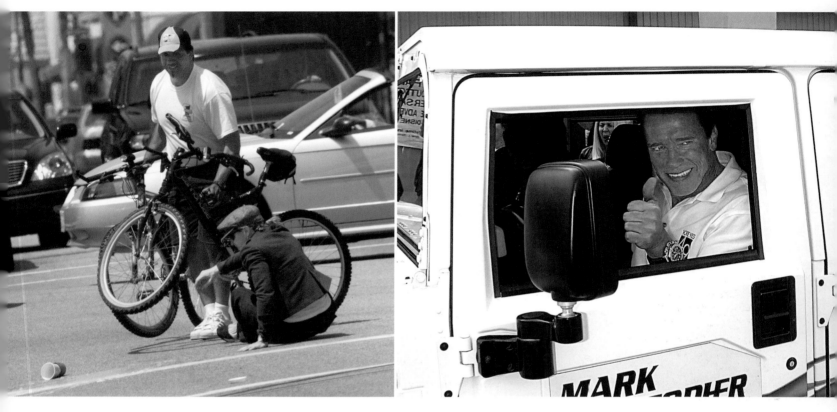

LOOK GOOD VS. BE GOOD

In the end, does any of this matter? If we get pleasure from watching the antics of the famous through the lenses of the paparazzi, what's wrong with that? As with most other human activities, nothing is wrong with that—unless it's taken to some of the extremes that we're witnessing now. Psychotherapists and psychiatrists are justifiably concerned when patients spend their sessions discussing television characters as if they were real people; when the boundary between reality and fantasy becomes foggy and confused.

The lengths to which these photographers will go to get the pictures that sell also causes us to consider the issue of privacy in our modern information-based society with its closed-circuit TV cameras and computer cookies. The traditional definitions of privacy may not apply when long lenses can "trespass," even though the photographer using them doesn't. But in many ways, the most disturbing effect that the cult of celebrity can have on a democratic society is in the realm of politics. How many times have we heard of a well-qualified, experienced professional politician either leaving public life or declining candidacy for higher office because of the media scrutiny that accompanies such occupations? And when the people of California elected an Austrian-born bodybuilder-turned-actor to be their governor, were they choosing Arnold Schwarzenegger, a political neophyte with no office-holding or administrative experience, or the Terminator? This may have been a case where the boundary line between fantasy and reality became blurred. As the cult of celebrity invades more of our society's institutions and influences more of its decisions, the daily stream of visual gossip supplied by the paparazzi gains significance out of proportion to its actual worth. If it becomes more important to look like a president than to act like one, their constant scrutiny could have global consequences.

SO YOU WANT TO BE A PAPARAZZO

ONLY THE DEVIOUS AND DETERMINED NEED APPLY

TERMINAL EXPOSURE:
Actress Kate Jackson fends off a photographer at Los Angeles International Airport, July 1999. The airport is still a hive of paparazzi activity despite tougher security measures.

Twice a month, a group of about twenty friends from different backgrounds gathers in a private dining room in the Four Seasons Hotel in Los Angeles. The hotel's executive chef prepares a special meal for them, but their real interest is the wines that accompany it. They are all wine enthusiasts and bring two or three bottles apiece from a variety of vineyards. The diners pour a small amount into each glass; they savor the bouquet and pronounce it to have "vanilla overtones" or "a hint of butter." Some they deem to be too young, but with the possibility of improvement over time; others are so perfect that the aficionados voice much regret at not having bought more when it was affordable. The passion of the devotees assembled around the table is palpable.

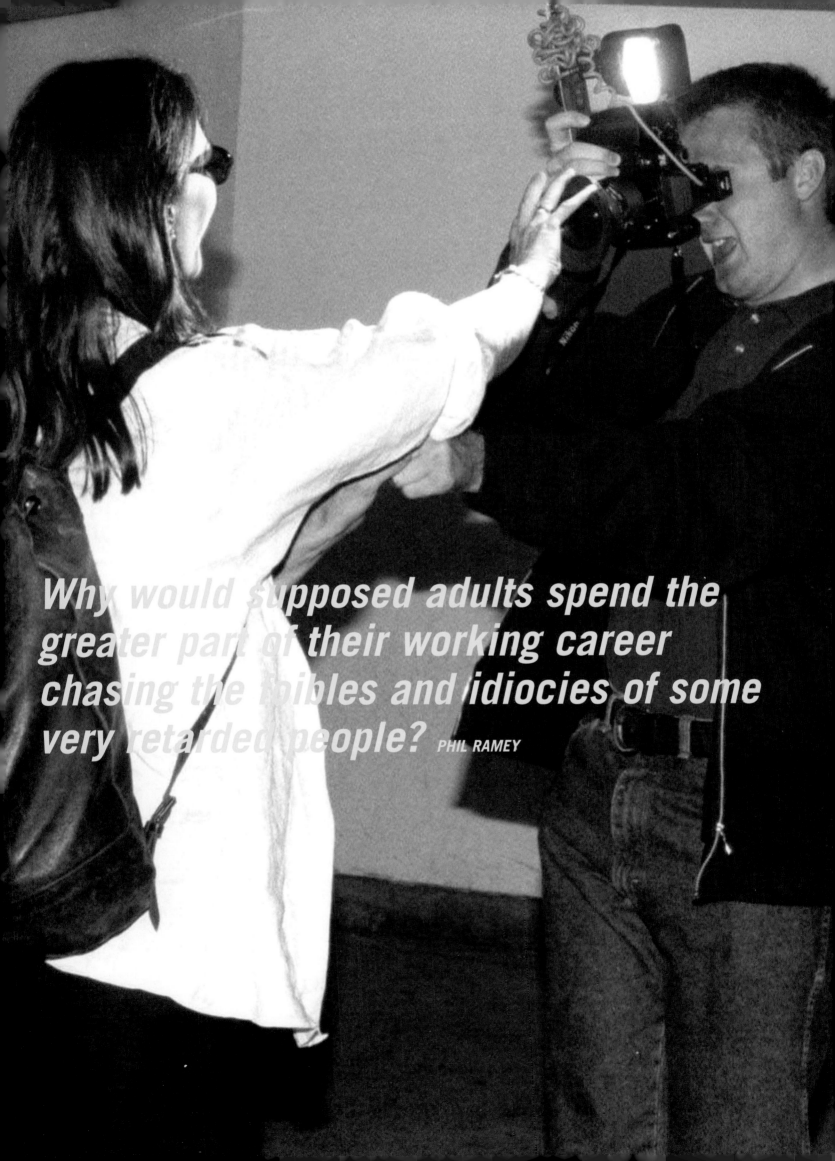

Why would supposed adults spend the greater part of their working career chasing the foibles and idiocies of some very retarded people? PHIL RAMEY

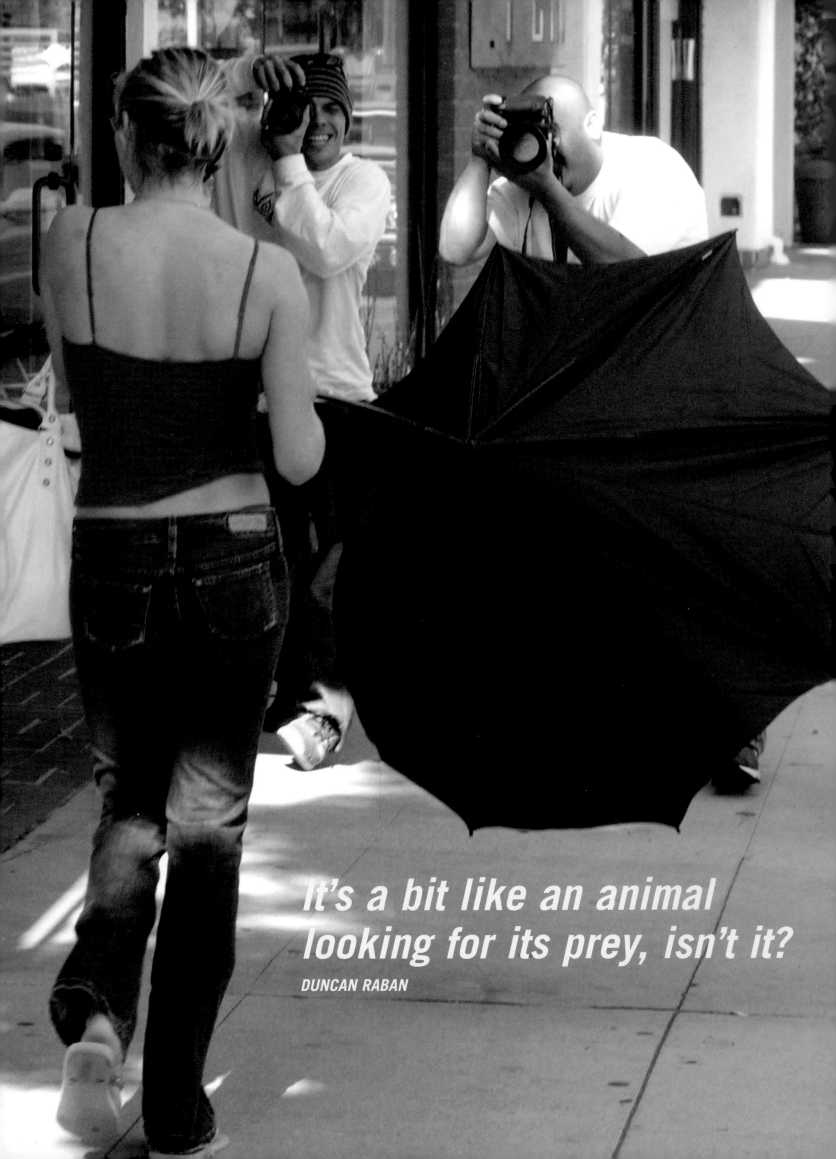

It's a bit like an animal
looking for its prey, isn't it?

DUNCAN RABAN

One of the oenophiles is Phil Ramey, a man in his mid-fifties and probably the best-known paparazzo working in Los Angeles today. His mere presence can induce fear in the famous even if he has no camera dangling from his neck—once, when he was waiting to get into a fashionable Malibu eatery, the woman around whom he was wrapped told him that as Jack Nicholson left the restaurant, he saw the photographer and ran down the street.

The celebrities who are terrified of Ramey's proximity would probably be surprised to know of his refined hobby, for he almost certainly knows more about good wine than most of them. As I got to know more of the paparazzi, one of the things I came to expect was the unexpected. The paparazzi are not a one-size-fits-all group—having a nose for fine wine isn't a requirement for the job—but a broad profile of the breed does emerge. Photo agency owner Frank Griffin has a nose for the kind of photographer he prefers to work with:

"We look for those who are a bit obsessive, have an ability to treat the equipment like it's an extension of the human body, as well as general good skills at photojournalism, and are not ashamed of the genre. You can't be worried that some actress is going to turn around and say, 'Fuck off, get a life.' You can't let that bother you; you have to be able to not say anything, which is probably best, or pretend to like them. You need to be able to use technology, to not be afraid of going up in a helicopter, to be able to stay up all night, to not have a weak bladder. You have to be able to work on a boat with a long lens and not get seasick; you have to able to say at midnight, 'Sorry, darling, I've got to go and work' because it's a good story, and then work though the night."

The ranks possess a number of specific skill sets. Some photographers specialize in stakeouts; others prefer to get up close and confrontational with the celebrities on the street; and a third group are masters of the long lens. If *The National Enquirer* is working on a story about royalty in Monaco, they'll employ a photographer who can look comfortable in this kind of exclusive resort and can dress the part, as opposed to "other photographers who are best suited to hanging from trees," as the *Enquirer*'s executive editor Barry Levine so delicately puts it.

HUNTER/DETECTIVE/SPY

The paparazzi often sound more like spies or undercover cops than photographers, and sometimes the actual taking of the photograph is the least difficult part of their job. Tracking down the hot celebrities takes more time and effort than photographing them. It requires good eyes, a good memory, and immense amounts of patience and concentration. A good paparazzo has to observe with an intensity that few of us will ever master. "Whether you go to Burger King at midnight or you're driving around L.A. at two in the afternoon," says Steven Ginsburg, "you have to be constantly looking—at that car license, into the windshields, the stores, people walking on the side of the road."

If you work as a paparazzo in Los Angeles, your car becomes a central part of your life. It's your studio, office, communications center, and coffee shop, as well as, of course, your means of transportation. In some ways the car is for the paparazzi what it is for cops on patrol. Police spend much more time cruising the streets at thirty miles an hour than in high-speed car chases, and the same is true of the paparazzi. The police list license plates they're on the lookout for, and so do the paparazzi. The police do stakeouts from

COME RAIN OR COME SHINE: A well-placed umbrella can ruin a photographer's day. Cameron Diaz, on her way to get her nails done in Beverly Hills, effectively uses hers to protect herself from uninvited paparazzi lenses. Although this technique is only partially successful, it has the psychological value of giving celebrities the feeling of fighting back.

their car, and so do the paparazzi. Both professions intersperse endless hours of tedium with moments of adrenaline-fueled intensity. The ability to stay focused during one in order to be effective during the other is a skill vital to both professions. "Keeping mental focus for hours on end takes training, like anything else," says Phil Ramey. "There's really no big secret. If you want to make the money, if you want to make the picture, you have to do what you have to do. It's that simple. If you're there trying to pass the time of day and read the paper, well, you might as well just go home and read the paper, because you ain't going to make any money here. When I see competition on the job doing that, I know I've got no problems. That's when I know I have no competition."

L.A. paparazzo Mustafa Khalili's attitude about the long hours of inactivity is one Ramey wouldn't approve of. He uses the downtime to catch up on his reading on subjects such as psychology and current affairs. Magazines, newspapers, and the Internet offset the boredom of being parked outside a celebrity's house, or doorstepping as it's known in the trade. "If you're a panicky type of character, a little shaky, you're not going to last long in this business," he says.

Both Ramey and Griffin bemoan the fact that in this age of automated photography, when a camera can think for you, many of the younger people entering the business don't spend enough time honing their photographic skills. "They don't know an f-stop from a shutter speed," says Griffin. "It's just beyond them; they just don't understand why light comes in one end and a picture comes out the other. The ones who are going to be really good at the job and want a career out of it are going to need to know this. You can hire loads of kids and say, 'This is a camera. Put it on the little-running-man setting and go out and take pictures,' and sixty or seventy percent will come back with a picture. But when you need to compose a picture that will make you say, 'Wow, that's really well done,' that's when you need to be a photographer."

> *You'd think this business was totally freewheeling, but there are a lot of rules.* PHIL RAMEY

Even so, not every good photographer makes a good paparazzo. Ramey tried to train an accomplished sports photographer to do this kind of work and failed; even when he was placed in the right position, he couldn't get the picture—the reflexes that enabled him to stop a baseball in flight didn't translate into being able to capture the moment when a *celebrity* is in the right position. "It takes a certain precognitive sixth sense," Ramey observes, "to anticipate all the elements that are opening in front of you to be able to get the picture—what they're going to do, how they're going to do it, how they're going to come out, what moves they might make. It's all got to run through your brain, and you play it over and over, so if the scenario changes, you're ready to go."

THE MORE YOU KNOW, THE MORE YOU SEE

Like an espionage agent, the successful paparazzo depends upon a well-established and well-oiled network of informants. These can be anyone who comes into even minimal contact with celebrities, and the list of likely candidates includes drivers, maître d's, personal trainers, valet parkers, sometimes even the lower-paid employees of the celebrity's agent or publicist. Frank Griffin claims to be able to tell where any celebrity

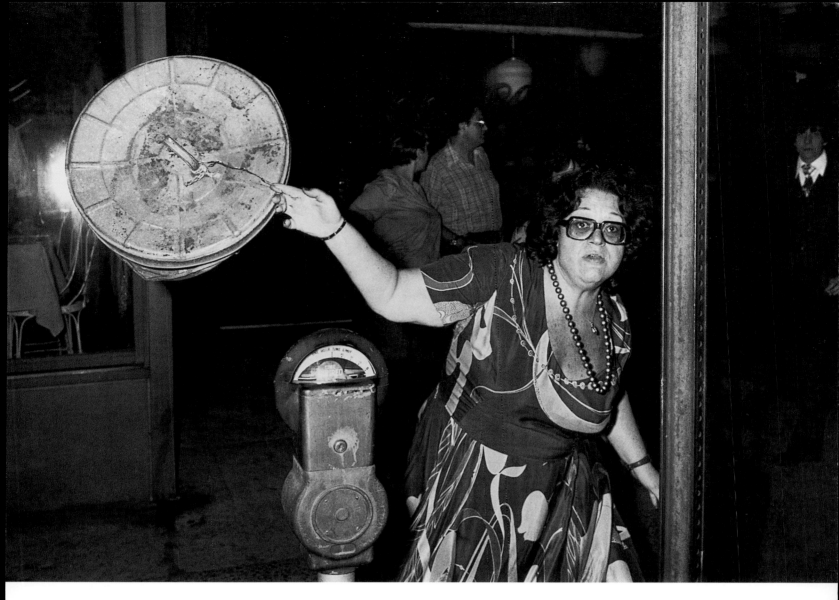

is anywhere in the world within an hour. His agency pays people in the airline industry to supply them with daily passenger manifests. Because most celebrities usually book under a pseudonym when they fly on commercial carriers, the agency has become expert at decoding such attempts at deception. It also checks the lists for the names of celebrities' personal assistants, who are normally booked under their own names. Still, the most valuable information comes from those who are closest to the celebrities. "Jealousies play a part," says Griffin. "One celebrity had a brother who loved to smoke pot, and he'd give you anything for enough money to buy an ounce. And once, years ago, unknown to Cameron Diaz, her fiancé at the time called to tell us where they were going furniture shopping so that he could get some publicity with her. We have the license plates, pseudonyms, and aka's of every major celebrity. Some guys have three hundred license plates memorized."

Steven Ginsburg takes it one step further: He and his partner photograph celebrity license plates, then use Photoshop to assemble them onto one page to give them an instant visual reference. And superpaparazzo Phil Ramey, whose office overlooks the runways at Santa Monica Airport, knows by heart many of the tail plane identifications of the private aircraft used by the leading stars.

Ron Galella doesn't believe in the need for an elaborate (and expensive), intelligence network. He finds that his own intelligence is quite adequate for the job, and takes the simpler, more direct approach of waiting outside restaurants and asking departing diners if they've seen any celebrities inside. That this works very well for him is probably because his stomping ground is the relatively compact island of Manhattan. But it does have the downside of sometimes antagonizing the owner of the establishment where he camps out.

GETTING TRASHED IN NEW YORK: Foreign objects hurtling through the air are a common occurrence in the lives of paparazzi. The doughty Elaine Kaufman, owner of the eponymous Manhattan restaurant and celebrity hangout, Elaine's, had requested Ron Galella's absence from the sidewalk in front of her establishment. When he failed to comply, she tossed a garbage can at him; it missed its target but hit a waiting limousine.

 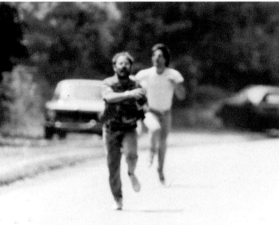 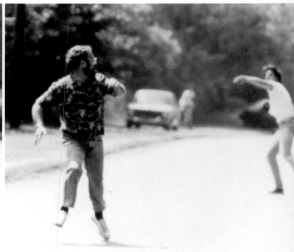

BAGEL BOY GETS STEAMED:
In the 1980s, Cher had a three-year relationship with Rob Camilletti, dubbed Bagel Boy by the media because he was a baker when she met him. One day, Phil Ramey was driving down the hill to her house when he came across this scene: Camilletti had sideswiped a photographer's car with his Ferrari, grabbed the photographer's cameras, and chased him up the hill. Ramey shot the whole sequence leaning out the window and driving toward them at forty miles per hour: "If I wasn't locked, loaded, and ready, babe, I would've had nothing."

If you've gotten this far into the book and you still find the idea of being a celebrity appealing, Barry Levine has some valuable advice—pay off the family: "You'd be surprised that with all the millions some celebrities have, they may take care of immediate family members, but cousins they could care less about. Sometimes these people have information about them—when the celebrity's wife walks out on them or something like that—and we're the first publication they call."

LIKE THE BOY SCOUTS, BE PREPARED

Paparazzi may look like easy-come-easy-go kind of guys, but the most successful among them are highly organized and disciplined operators. Phil Ramey bases his considerable success on attention to detail and a high degree of motivation. He lives by certain professional rules that he has established for himself as the result of mistakes made in the past. He is a man who has learned from experience: "Don't show up unless you're ready. Don't look down, because you've just missed the picture. Don't ever look down; it's like you blink, you look up, and it's gone. Never roll up to a house unless you have your camera in your lap, prefocused—right focal length, right exposure, right shutter speed—and all ready to go, because as soon as you don't do it that way, you'll screw up. You pull up and say, 'Oh, I've got time to get my camera out of the trunk'—and you just missed a shot, idiot. 'Oh, I'll try and reach in the backseat for my camera, which is set up'—and you just missed the picture. I've proved it a thousand times."

Being prepared also means knowing who you're shooting, which often isn't as easy as it sounds. You and I might pass a major celebrity on the street and not realize that we were in his celestial presence; not so the paparazzi. Part of the job is knowing when the shlubby guy in shorts, sneakers, and a baseball cap in your viewfinder really is Russell Crowe looking like the master and commander of nothing much. It's knowledge that you get from experience, from watching all the entertainment programs such as *Extra,* *Entertainment Tonight,* and *Access Hollywood,* and from reading every celebrity magazine and tabloid.

The experienced paparazzo can also anticipate certain actions that will produce a good picture: "If somebody comes out of a swimming pool and puts on a robe, what do they usually do?" says French

UNIVERSAL LANGUAGE, DIFFERENT ACCENTS

THE ITALIANS: "The Italian paparazzi are completely different from the paparazzi of any other part of the world. There is a Mediterranean character that makes them do things which are absolutely unthinkable; they act first and think later. They will make the most incredible efforts to take a picture, and they don't care if it's dangerous or what they have to put up with or if they are going to be arrested." MASSIMO SESTINI

THE FRENCH: "I don't think there's any difference between a paparazzo and another press photographer, although I would say that the paparazzi must be sharper. There's a French word that explains what I mean—*débrouiller,* which translates as "to be able to arrange things." I'll give you an example: One day we were doing a funeral; the graveyard was hidden behind a high wall, and we didn't have any ladders, but there was a utility pole. So I took some Scotch tape and made two big loops around the pole and used them to help me climb up. Lots of French photographers have that knack— much more, in my generation, than American photographers. The Americans are intellectual and talk about obscure photographic techniques like solarization; the French photographer is more down to earth—he's got the picture or not, that's it. The English are pretty basic on everything. The Italians have much more panache: They will completely forget to put film in the camera, or start talking to the actor, who then just jumps in his car, and they wind up not getting the picture." JEAN-PAUL DOUSSET

THE AMERICANS (as seen by an Italian): "The American paparazzo doesn't need so much imagination to solve a situation, to take a picture. He has so much money behind him, with people financing the cost of a helicopter or whatever else he needs, that life is easier for him. He knows before he takes a picture that he has a contract with somebody who will provide all the money he needs, so he doesn't have to think too much about the difficulties." MASSIMO SESTINI

If paparazzing were an Olympic event (and after beach volleyball almost anything could be), who would get the gold? It would probably be a European, but the contest would take place in Los Angeles. Here's how the teams would stack up.

THE AMERICANS (through a Brit's eyes): "An interesting question is: Why aren't there more American paparazzi in Los Angeles? What I don't understand is why they're all French, British, and German. Most of the photographers out there are European, not from the United States. Our agency's got Salvadoran, Filipino, French, Palestinian; there's only one American." FRANK GRIFFIN

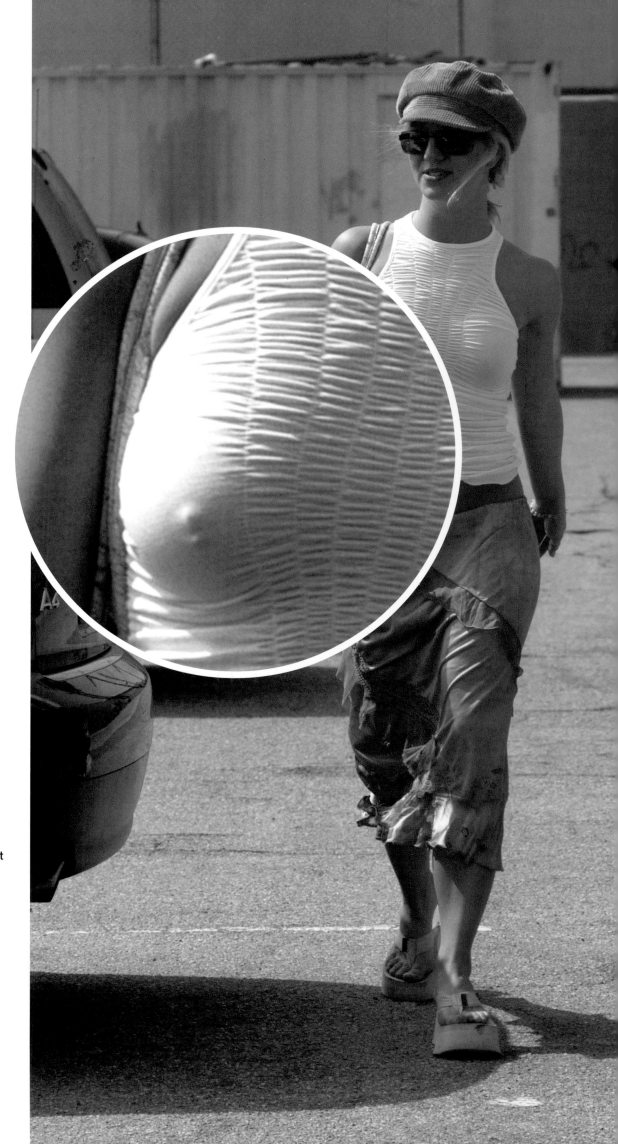

ON THE LOOKOUT FOR THE CLOSE-UP: Steven Ginsburg was reviewing a not particularly outstanding take of Britney Spears going to the studio with her bodyguard when his girlfriend took a long second look. "It looks like she has a nipple ring," she said. On close—very close—inspection, there was indeed a foreign object beneath the singer's form-fitting white top. It was just visible enough to transform a mundane picture into a high money earner for the photographer.

photographer Jean-Paul Dousset. "They open it up before closing it, so it's then that you take the picture. Or when a film star arrives at a ski resort or hotel—the first thing that they do is look at the view, so when they go inside, you check out the hotel to see which balcony they're going to come out of. These are just stupid basic things. If a couple has only known each other for the past week, they'll kiss more than if they have twenty years of marriage behind them; if an actress gives her three-year-old kid an ice cream, there's a huge chance that the ice cream will spill. They're just basics."

WHERE ARE THE WOMEN?

Photography is a profession in which women have traditionally been successful, but very few paparazzi are women. There's only one female photographer working with the Bauer-Griffin agency, Axelle Woussen; although she primarily does red-carpet work, she's also a hard-core paparazza. Frank Griffin thinks the profession sees itself as macho and resents the presence of women. He appreciates how tough it is for Woussen ("Belgian, a gorgeous blonde who speaks four languages and went to photography college") to work in this testosterone-driven environment. Even when she was an event photographer her first year in Los Angeles, she was subjected to verbal harassment from her peers, who accused her of participating in any number of unnatural sexual practices in order to get the job.

WHERE TO WORK, HOW TO WORK

The way individual paparazzi work is influenced by where they're working as much as by their national characteristics. London-born Palestinian photographer Mustafa Khalili, who's with Bauer-Griffin in Los Angeles, is familiar with conditions in both cities. Staff positions are a rarity in London, where competing freelancers operate in a much more ruthless and self-centered way. In L.A., Khalili teams up with other photographers from the same agency. He finds this a better organized, more efficient, and more discreet system, as a result of which celebrities are often unaware of the presence of photographers.

Los Angeles has a better class of celebrity, according to Khalili. In London he worked on a smaller group of lesser celebrities, mostly TV actors from the British soaps, who not only bored him but were much less lucrative subjects: "Instead of photographing [British singer] Martine McCutcheon on a daily basis, here I'm photographing Britney Spears on a daily basis—B-list to A-list as it were. Here it's an everyday thing—everyone from Jennifer Aniston and Brad Pitt to Charlize Theron."

We eat crap and we read crap and there's too much information. I think everything's just gone mad. DUNCAN RABAN

Khalili's average working day begins at around eight in the morning, an hour that he feels is unreasonably early. Unless he's already been contacted, his first task is to call in to either Frank Griffin or Randy Bauer for a list of stories to be covered that day. The agency then divides its photographers into teams of two or three, who position themselves outside the celebrities' houses and wait. The day we spoke to him, one group was at the Peninsula Hotel covering Beyoncé, another was working on Kate

Hudson, and a third was on Calista Flockhart. The teams are in constant contact; like the police, they can help one another should assistance be required. What happens when the targeted celebrity appears is completely unpredictable, and this day the team covering Beyoncé ended up in a car chase with her from the hotel to Studio City.

Conversations with paparazzi always come back to money; it's the unifying and motivating element in Milan, Paris, London, or Los Angeles. The best and most successful among them are good businessmen who spend time on researching and understanding their markets, and they can be very tough in negotiations. For Ron Galella, the disparity between the paycheck that he got for celebrity work and all other kinds was too great to ignore. As a student at the Los Angeles Arts Center, he did a self-assigned photo-essay that he called "The First Day of Nursery School." It took him three days to complete—one to find the nursery school, another to shoot it, and a third in the darkroom. His instructor was so impressed with the results that he encouraged Galella to try to sell the story. Several publications turned it down, but finally the Loeb Picture Agency in New York sold it on his behalf to the *Daily News,* for $160. Galella got half, so for three days' work he earned only $80; with Jackie Onassis he was regularly paid $1,000 a take. It's not hard to understand why he stuck with celebrities.

But it's too simplistic to assume that the only motivation for enduring a life of abuse, disrespect, and sometimes physical aggression is financial. Some, like Galella, are fascinated by and in love with the craft of photography; for him the approach of the paparazzo has stylistic merits. His best pictures are the ones

One thing I want to stress is that I never really did it for the money. RON GALELLA

that got him into the most trouble—Jackie looking lively, flirtatious, angry, aggressive, always vibrant; compared to the more formal portraits of the Camelot years, they give a much fuller and more accurate view of a complex woman. Galella is convinced that this is because they were taken with the paparazzi techniques, which allow—in fact, demand—that the subject behave more naturally.

For younger photographers, there's excitement and glamour in a job that allows them a high degree of independence and moves them beyond the constraints of a nine-to-five job. For Steven Ginsburg it was the much preferred alternative to the bartending that was his occupation prior to coming into the business:

"When I first heard about this job, it sounded exciting. There I was sitting behind the bar working really, really hard with lousy hours and getting paid next to nothing. Now I'm doing a job where there's no age thing; nobody says, 'Ah, he's twenty, put him behind the bar and pay him eight dollars an hour plus tips.' If you shoot the right picture, you're the man of the month and the paycheck's coming to you. You get to the point when you shoot a picture that you can almost see it in the magazine as you shoot it. Every day it's different, and you find yourself laughing and saying, 'God, did that really just happen?'"

Although he's proud of the work he's done so far, Khalili resents the paparazzi being used as convenient scapegoats, and admits that his mother still hates his occupation. His long-term ambition is to become a full-time combat photographer, building on the experience he already has from shooting in the Middle East. It's an area where his background as a paparazzo is both a help and a hindrance. With a portfolio almost entirely composed of celebrity photography, he finds it impossible to get picture editors to take him seriously. Ironically, he might make a better combat photographer because of his paparazzo training and

experience. The demands of war photography are that you be the ultimate fly on the wall, finding places from which to shoot where you won't be spotted. "A lot of my Middle East pictures stand out because I shot like a pap would," he says. "I was away from the pack and the other press, did my own thing, my own angles. I got into so much trouble, but I got my pictures. I definitely learned a lot of things from this work, a lot of skills that people undervalue."

The paparazzi have always been interested in one thing, and that's making money. BARRY LEVINE

Many of the more successful paparazzi move on to other, more stable areas of the profession. For some, however, the allure remains irresistible. Massimo Sestini is now one of Italy's most successful editorial and corporate photographers, yet he continues to do an occasional paparazzo assignment. "I still consider myself a paparazzo, because when it comes down to it, that's what I really love to do," he explains. "I still love the idea of 'stealing the picture.' For me being a paparazzo is like the excitement of hunting, or maybe a better analogy is when you meet a woman and you have no problem whatsoever to convince her to sleep with you. That's not very exciting. But if you have a hard time convincing her—that's exciting."

HOW GOOD IS GOOD?

A good paparazzi photograph may be a bad photograph in conventional terms because in this work content really is king. It doesn't have to be completely in focus or exactly exposed as long as the people in it are recognizable. If it's an important enough story—on the level that a reunion between Tom Cruise and Nicole Kidman would be—"then it doesn't matter if it's a shadow," according to Steven Ginsburg. Unlike most photojournalists, who hate having their work cropped, the circumstances under which the paparazzi take photographs often makes this necessary. If you're staking out a celebrity with a long lens, you're seldom in a position to frame exactly the way you'd like to. When Phil Ramey was trying to get photographs of Farrah Fawcett with her new baby, he hid in thick bushes, using a long lens pointed through a hole: "I shot everything. I didn't want to leave the position, but I knew I had to move the pictures, so I sent the film to the best lab in Los Angeles. I called them about two hours later and got the manager on the phone. I said, 'You've got to help me. I can't leave my spot. Look at the material and tell me how good the stuff is.' She left the phone to look, and when she came back she said, 'I don't see Farrah Fawcett in any of the pictures. It's mostly trees and bushes.'

"I knew I hadn't missed the picture. I got so pissed that I left the stakeout went down to the lab, and sure enough I had Farrah Fawcett swinging the kid. The manager wasn't trained to look at the pictures, so she couldn't see it, but it was tack sharp, although it was only about twenty percent of the frame and required enormous blowups and a custom print job. In those days we used to routinely pushed film two, three, and four stops and did things you wouldn't think could ever turn into a picture, so the quality is never an issue if the content is there."

One of the problems Ramey sees with modern cameras is that they won't fire until they've acquired a certain amount of information about the level of focus—by which time the moment may have passed. "I've made a lot of money on pictures that were hardly in focus at all by any criteria," he says.

STARTING OUT:
FIRST STEPS ON THE ROAD TO INFAMY

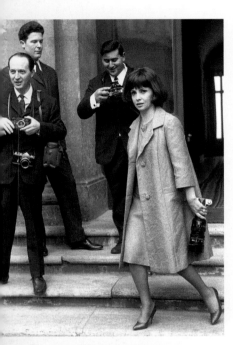

THE ORIGINAL: Tazio Secchiaroli, partially seen at far left, upon whom Fellini based the character named Paparazzo in *La Dolce Vita,* at work in 1964. The camera-carrying woman on the right is Italian actress Gina Lollobrigida.

RON GALELLA: When the Korean War broke out in 1950, I enlisted in the air force to avoid being drafted into the army. Photography was the closest I could get in the air force to my first love, art. After spending four years as an aerial photographer, I was discharged in 1955 and attended the Art Center College in Los Angeles on the GI bill. I graduated with a degree in photojournalism in 1958, came back to New York, and started freelancing, but it was very difficult because of a recession at the time. So I took odd jobs, working part-time as a photographers' assistant. I also worked in the Time-Life lab for a year. I became a very good printer, developing an expertise in black-and-white—which I love, by the way; to me it's the best.

I was always interested in celebrities. Even while I was a student, I was crashing premieres in Hollywood. It was easy to do in those days— all you did was throw the cameras on, dress right, and walk right in. Those were the golden days, with no security.

JEAN-PAUL DOUSSET: It was the period of the film *Blowup,* and photography had a special attraction—fashion photography because there was glamour and nice girls, and newspaper photography because of travel, meeting people, and interesting situations. In 1968 I was twenty-something years old; I had just come out of the army when the May 1968 student revolution happened in France, and that was where I first met a couple of photographers. Because I spoke

English, I started working as an office clerk for an American insurance company. Of course, it wasn't very thrilling and I really wanted to do photography. When I was a teenager, my father gave me a Voigtlander camera. I could only take black-and-white with it, and processing the pictures was very expensive, so I couldn't do it very often. I was living cheaply in a small room, and I started putting money aside so that I could buy myself a Nikon. At the office I started doing some pictures for the other employees; eventually they asked me to do weddings, and within about four to five months I more than tripled my salary. About a couple of months afterwards, I became the photographer for the insurance company's magazine.

During this period there were a couple of cinemas on the Champs-Elysées where film premieres took place. These would sometimes occur two or three times a week, and the actors in the films would often attend. One day I was standing outside one of these movie houses with my black Nikon, quite shy, not being intrusive, when a guy came out and said, "You, press, get in." So I just went in; nobody asked me anything. I was in the dark at the back of the theater, and I watched the film. I said to myself, This is fantastic because I can see the film for free. From then on I went to lots of premieres, and as a result I met people and got together with other, older photographers. One day a photographer from *France Soir* didn't show up, and I replaced him. That's how I started in the job.

STEVEN GINSBURG: My girlfriend and I needed a place to live out here in Los Angeles. I saw an ad for a room to rent, I met the guy who owned it, a French guy, and we moved into his place. I was working in Santa Monica as a bartender at a restaurant, and I knew he was a photographer. He would come home with these massive paychecks—ten, fourteen thousand dollars. Eventually I asked him what kind of photography he did, although by that time I'd been in his room, had seen a stack of tabloids there, and put two and two together. He was illegal at the time so he didn't have a driver's license, and he needed somebody to drive him around. He offered me the job, and I said sure, and straightaway I started spotting celebrities. After about two months, he asked me if I wanted to work for him as a photographer. I said sure. It's lot of fun, especially when you're young. And the money's better than bartending.

I'd never taken photographs before, and although I didn't like school, I always excel in the subjects that interest me. I liked photography right away. I've always been a movie guy, a celebrity person—not star-struck, but I know who they are. So it came relatively easy to me, and I saw how much fun this French guy had. You'd hear the shutter go off and then you'd see his smile and his laugh as if he knew it was "click, money in the bank," so it really was attractive to me. I got into it, the boss really liked me, and I felt like I was good. He kept telling me, "Man, you're going to be better than me."

MUSTAFA KHALILI: I was born in London of Palestinian parents, and a friend there brought me into the business. He was working as a pap, doing a lot of Diana stuff. I always wanted to take pictures, so he went with me to buy my first camera, then just left me alone for a year and a half to let me learn how to use it. When he came back, we started working together. While I was studying broadcasting and journalism at the University of London, I was also working for a couple of Arabic networks, including Al Jazeera, and I did some freelance work for Sky, editing news stories and promos, but I got soured by television. As an editor, especially a news editor, the amount of footage that I saw every day, compared to what was compiled as the final news story, was very disappointing a lot of the time, and lacked so much. Plus as an editor you start thinking to yourself, Why didn't the cameraman shoot it from this side? Why didn't he shoot it from here? All of these things combined to make me want to break away from video. I see what I want, I know what I'm looking for, and I can shoot it myself.

I want to be a combat photographer; I know I can do it. I spent eight months in Palestine from the summer of 2002 until February 2003 photographing the current intifada. It took me a while to adjust to the surroundings and to hearing gunshots and tanks, but after I got past that initial phase, that was it, I knew that this is what I want to do. I came back to doing the paparazzi thing for a while to make some money and then hopefully go out again.

DUNCAN RABAN: In 1976 I worked at an old Fleet Street agency called Fox Photos, one of four trainee photographers' assistants. I spent most of my time making the tea and helping out wherever I could. In 1977, on the Queen's Silver Jubilee, I snuck out and did some pictures of the celebrations and put my prints in with the agency prints that were sent round to the newspapers. One of mine ended up on the front page of the *Daily Telegraph,* and they sacked me for that—I was a cheeky little bastard, I suppose.

The first time I did celebrities was in 1984 or 1985. I was in New York shooting an American football game. I was staying in the Hilton in New York, and there was a big event at Radio City Music Hall, "The Night of a Hundred Stars." I thought I wanted to have a go at that. I found out in the hotel where they were giving out credentials and where all the passes were; I hung around trying to get one, but I couldn't. So I rented a dinner suit and just turned up at Radio City Music Hall. I just winged it, got in, went into the auditorium, and sat down. A couple of people came up to check up on me; I said I was working for the BBC, doing stills for the *Radio Times*—I used to do a lot of work for the *Radio Times,* football features and things. I shot the whole show on a long lens. Towards the end I just went backstage and got upstairs to the green room where all the cast of *Dallas* was eating pasta and sitting around talking. I told them I was with the *Radio Times,* and they were as pleased as punch. It's like being an assassin because I wasn't meant to be there—I had no passes, I had no nothing—but I've done that all my life. I came back to London and sold the pictures to *Woman's Own* for 1,200 pounds, and I thought, This is all right. So I just started doing more celebrities.

I'm very nonconformist anyway. Everything's a gamble with me, and I think I've always been a bit of a show-off. You've got to have tons of front to do this job and this is what a lot of these top paps have got. It's like a drive.

MASSIMO SESTINI: When I was in high school, I used to go to rock concerts, and I started to take photographs of the musicians as a hobby. When I enrolled in the university in Florence to study law, I took a job at the local newspaper, *La Nazione,* to make some money. After six months I realized that what I wanted to do in life was be a photographer, so I quit university without even taking any exams. My mother wasn't at all happy; she wanted a lawyer as a son, but the opportunity was too good to miss. *La Nazione* covers all of Tuscany, providing the local news from about thirty-two different towns. Every night they get the day's shoot from the different photographers, and my initial job was to develop the film, all black-and-white. The newspaper didn't employ photographers directly; they used an agency contracted to them, and eventually I started working for this agency, although it was like being on staff at the newspaper because they were the only people I shot for. When I started out I'd shoot minor stories like strikes or students demonstrations, things like that.

My first *paparazzate* didn't involve a celebrity at all. In 1984 or maybe 1985, somebody, probably the Mafia, put a bomb in a train, and the train exploded while it was going through a tunnel near Florence, killing some sixty people. This tunnel is one of the longest in Italy, about thirty-five kilometers long. All the photographers rushed to the site, while I

had to stay put at the agency, but when I finished my job I asked permission to leave and immediately went to the tunnel. The police wouldn't allow anyone access to the disaster, and on top of this it was also inaccessible because of the terrain as well as snow and inclement weather. But there was a service train with the lights on, so I hopped on it, hiding my camera bag under the seat. At that point some magistrates got on board with a photographer from the police scientific department in Bologna. When they asked me who I was, I said I was from the police scientific department in Florence. They never asked for any identification, and I managed to take pictures of the disaster; they were published all over Europe.

PHIL RAMEY: I started in this business around 1979. I really didn't have any attraction to, or particular interest in, celebrities, and I had no formal training in photography. A long train of serendipitous madness brought me to California: I broke up with an actress I was living with in New York; she wound up with a stunt man who was a close friend of Steve McQueen's. I met McQueen when he came out to the East Coast to look at some antique motorcycles the stunt man friend had me round up for him. McQueen bought them all and paid me to make sure they all got to the West Coast without being damaged, which I did. He sort of befriended me after that and helped me out, even offered me one of his places to live for a while. That's how I physically ended up out here.

I was living in Malibu with no money, if you can believe that. One day I saw Loni Anderson going into a beach house in Malibu I knew was owned or inhabited by Burt Reynolds. So I found the number for the *Enquirer,* because everybody said the *Enquirer* likes these things, and I called in the information on a cold call. Somebody got back to me; I later found out it was a guy based in Los Angeles by the name of Don Monte. He was called the Godfather of Gossip, like in the Mafia—a big, heavy Italian guy, lived with his parents on the top of Mount Olympus, drove a Rolls-Royce with a license plate that said GOSSIP. He had the whole gossip of L.A. wired; that's all he did twenty-four hours a day, and every major restaurant, every maître d', was on the take from him. He'd go out every night of the week, pick ten to fifteen of the top bars and restaurants, schmooze people, and leave them money. Everybody called him; he carried a bag of money, and he paid them all in cash. Anyway, he called me and interviewed me. I gave him more particulars—again, it was just a sighting; he kind of doctored the item up for his column, which was called "In His Own Particular Way." I later found out that nobody was hotter for them at that time than Burt Reynolds. He told me that if I could get a picture, it would be worth money, so I parked myself across the street from Reynolds's house. I saw somebody else in the vicinity who I thought was attempting to do the same thing; I later found out he was a photographer with a big reputation, called Russell Turiak. He was from New York, but he used to winter out here, and the *Enquirer* had given him the assignment to try to get Burt and Lonnie on the beach. I hooked up with this guy; I was smart enough to know that while they weren't going to hire me, they weren't going to lose me, either, even if I wasn't smart enough to get the picture.

DADDY DEAREST

Ryan O'Neal and Farrah Fawcett were the hot item in the early eighties. You could make money shooting them no matter what they did. Ryan's daughter, Tatum, also made news and made money. Word came to me one Thanksgiving that Tatum was seeing John McEnroe. I started staking out her house at the beach, hoping he'd come by. He didn't, but one day I saw Tatum come out on the rooftop terrace, wrapped in a towel and hair dripping wet, as if she'd just stepped out of the shower, looking out furiously for somebody or something. Five minutes later I saw her brother, Griffin, come running out of the house, frantically trying to thumb a ride on the Pacific Coast Highway. I threw the big lens in the back of the car, covered it up, then flipped a U-turn and picked the kid up.

He was completely wired up and agitated; he kept playing with the heater controls and the radio. I said, "Where do you want to go?" and he said, "I've gotta go to my girlfriend's in Westwood. My father had me under house arrest, wouldn't let me out of the house." I said, "Okay, I'll take you there." He said, "You wouldn't believe what happened," and he grabs his jaw back. "Look, my father knocked my teeth out." I was ready to take my little point-and-shoot from under the seat of the car and snap him, even if I had to hammer him against the window to get a picture, but I schmoozed him instead. I talked about his father, and he told me his plans to be an actor.

When we got to his girlfriend's house, I said, "You've got to pose for me— nobody's going to believe this." He didn't know I was a photographer, so he gave me an enormous smile, with his teeth punched out, and I made pictures that were portrait quality from four feet away. Then as he was walking away, I screamed his name out. He turned over his shoulder and smiled, and I had him on a second take.

They were enormous pictures because unbeknownst to me the *Enquirer* had been working the story. I made a huge amount of money from them for the pictures; it was also my first major sale to *People*.

This job is all about being in the right place, at the right time, with the right attitude. It's luck, too, but luck is being in the right place at the right time with your brain in gear or else the luck will go right by you. If I'd been sitting there like a lump reading the goddamn paper, I would never have seen Griffin come out. ✳ PHIL RAMEY

ENTER STAGE RIGHT ON A STRETCHER

Liz Taylor was at St. John's Hospital in Santa Monica in 1990 affected with some rare respiratory disease, and people believed, accurately I think, that she was near death. I staked out the hospital around the clock for close to two weeks with a whole crew, and we got nothing. The *Enquirer* paid off a hospital security person, who tipped them off that they were going to move her at a certain time to do an MRI in a different building. The *Enquirer* gave me the information, but there was no way you could shoot from the sidewalk overlooking the courtyard where they would move her without being spotted, so I had to position myself across a wide, four-lane street in another courtyard, where I'd have a point of view.

All of a sudden, another photographer shows up and spots me, and I'm sunk. He knows I'm waiting for something, because I always have good information—and lo and behold, Liz comes out. Some guys in white push her up the walkway and bring her to the MRI, where I get a great shot of her with an exit sign. I shoot a roll, and the other guy shoots, and I know I'm screwed because it's not exclusive.

I think the hospital found out we were there, because after a period of time, when they brought her back out, they pushed her very rapidly. I shot out another roll because I was shooting as fast as the motor would go, so I picked up the backup camera, which had a 500-millimeter lens. It was with this camera that I made the famous picture of her from the waist up, looking like she was in a casket, surrounded by bushes. The 500 wasn't a long enough lens; it was somewhat loose, so it required an enormous blowup to get to the picture. I remember thinking as I looked at the negatives that I didn't know if it was going to hold up, but it did. It made covers all over the world. I think it's one of the best pictures I've ever shot. It ran as a double-page spread all over the world and made lots and lots of money. The photographer who was shooting beside me didn't make one frame; all his film was unusable. But it's a very sad picture, I mean compared to the vitality of what I shot of her in 1984. Very, very sad. ✳ PHIL RAMEY

LA DOLCE VITA AIN'T WHAT IT USED TO BE

THE EARLY YEARS

MOVING PICTURES: The first paparazzo, Tazio Secchiaroli, drives while fellow photographer Luciano Mellace shoots from the back of a Lambretta, Rome, 1952. It was a common practice for photographers to work in teams on the Via Veneto.

The lives of the paparazzi have never been easy. Among other things, they can have no fear of rejection, must be comfortable with being ostracized and be prepared for physical confrontation, and often risk arrest and criminal prosecution. It's not a profession for the timid or faint of heart. Still, those who have been associated with the activity for a long time look back on the early days with wistful nostalgia. If it was tough then, they claim, it's even tougher now. Given that the older practitioners of any job always think that the glory days are past, there is nevertheless some justification for the claim by the original paparazzi that it was easier when they started. We've all become used to the increased security precautions that permeate almost every aspect of our lives today, and if you think it tedious to get through the lines at the airport, try gate-crashing a post-Oscar party. Not only has the technology

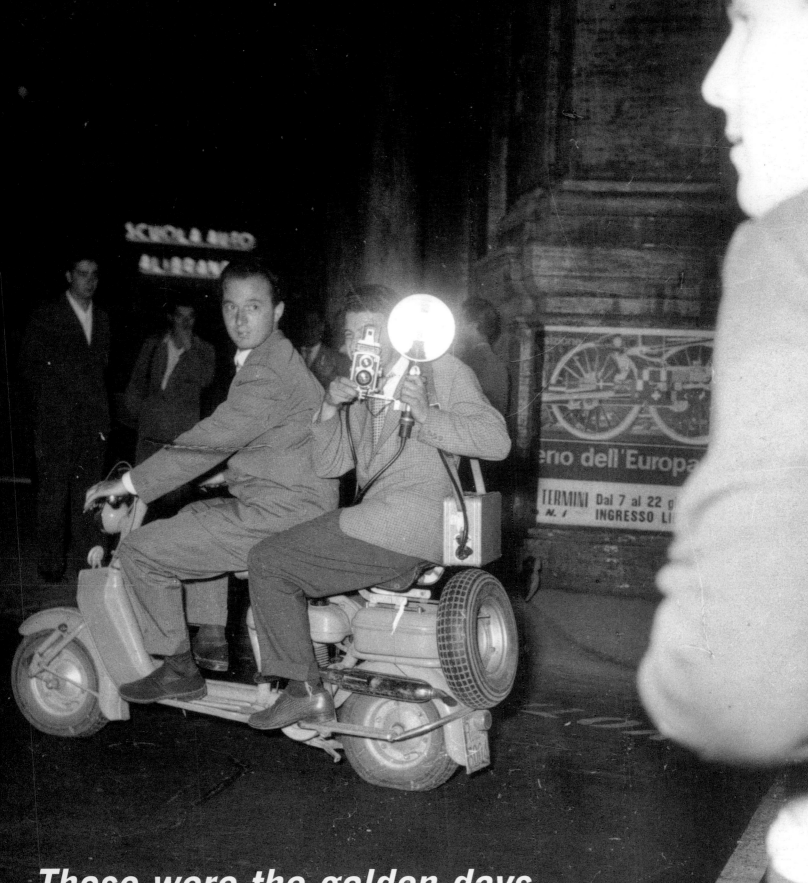

Those were the golden days. RON GALELLA

of security become much more sophisticated, but the presence and power of the public relations personnel employed by celebrities have also increased to levels that were unimaginable in the 1950s and 1960s. The principal role of these superpublicists, some of whom have become celebrities in their own right, is to strictly control the amount and quality of coverage their clients receive. Of course, the work of the paparazzi goes against everything they aim for; it's uncontrollable, and more often than not it shows the celebrity in an unflattering light.

THE WAY TO THE VIA VENETO

The earliest Italian paparazzi of the 1950s were poor young men trying to survive the rigors of postwar Italy. Rino Barillari, whose business card proudly proclaims him "King of the Paparazzi," came from a small village in Calabria where his uncle owned the local cinema. It was while assisting him in the projection room that he was first exposed to, and began to recognize, American movie stars. His first job in photography also involved Americans, but they were tourists, not actors. During the fifties the combination of postwar prosperity in the United States and easier travel produced an influx of American visitors to European cities such as Rome. As a result, a modest living could be made photographing them in front of the Trevi Fountain, a location with the added advantage that at night you could fish out the coins the tourists had tossed in during the day. Barillari's introduction to the world of professional photography was to move nontourists out of the way so the photographers could get clean pictures of the paying customers in front of the fountain. Because he was only fifteen, Barillari had to keep a constant lookout for the police. His biggest fear was that they would catch him and return him to the countryside; he had neither legitimate employment nor residence. He also spoke no English, a state that he maintains to this day. On one occasion, when one of the photographers was foolish enough to leave his camera with Barillari for safekeeping, the teenager took over his turf.

In the days when Barillari was working the fountain, another poor fifteen-year-old was beginning a career in photography from an equally lowly position. Tazio Secchiaroli, from a tiny village less than ten kilometers from Rome, had intended to continue his education beyond his second year in high school, but his mother, thinking that it was time for him to earn his keep, sent him out to get a job. He found employment as an X-ray technician, and while his day job was photographing broken tibias, in his spare time he was taking pictures of tourists, mostly off-duty GIs in front of the Colosseum.

Meanwhile, across the pond, a third teenager, Ron Galella, enlisted in the U.S. Air Force to avoid being drafted into the army during the Korean War. He was trained as an aerial photographer, which in some ways is the military equivalent of being an X-ray technician. Being one of five kids in a poor Italian family from the Bronx, he couldn't have realized his dream of going to art college on his own; but with his air force training, in 1955 he was able to enroll on the GI bill in what is now called the Art Center College of Design in Los Angeles. He returned to New York after graduation in 1958 and moved into his father's house, where he built a darkroom in the basement. He started his career as a freelance celebrity journalist, photographing premieres and parties, crashing them when he didn't get an invitation. "Ideally, I would like to have had my subjects come to me, like Steichen or Avedon did," he says today. "But I couldn't have them come up to the Bronx—the north Bronx, no less—so I had to go to them."

The world these three young men photographed was substantially different from the world today's paparazzi capture. For the Italians, its center was an elegant, wide, tree-lined street called the Via Veneto. It was home to expensive restaurants and bars that were the haunts of the wealthy and famous, including the film stars in Italy who worked at Cinecittà, the nearby Italian film studios favored by many American production companies because of the lower costs of shooting there. The famous bars and restaurants, such as the Café de Paris, Doney, and Harry's Bar, were frequented by a galaxy of glittering personalities—Anita Ekberg, Ava Gardner, Elizabeth Taylor, Richard Burton, Marcello Mastroianni, and Anthony Steele among them. They came to see and be seen (one of the attractions of the street was that it was wide enough to accommodate their expensive cars) and to show off their equally flashy companions. Magazine readers, in a period when the memory of the war and its grim aftermath was only too fresh, loved to see this ostentatious behavior.

FOOLS RUSH IN: Italian paparazzo Rino Barillari has been beaten up several times during his career. After he shot this picture of Frank Sinatra at the Café de Paris on the Via Veneto, he was saved from another such trauma at the hands of the singer's bodyguards only by a fluke: The tables were set up in such a way that they created a barrier that gave him enough time to escape.

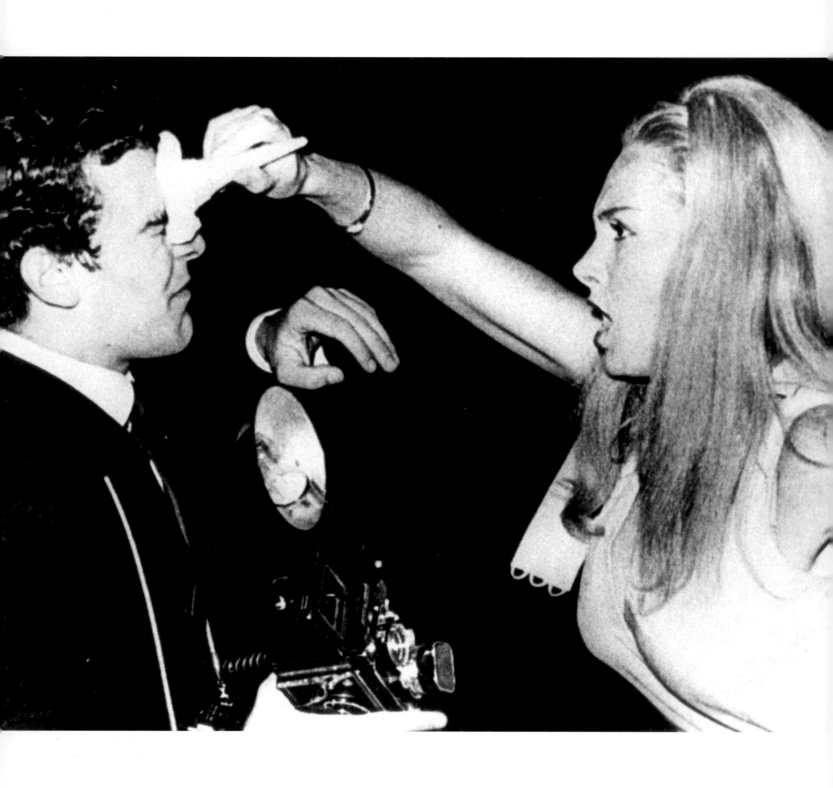

There was also a seasonal aspect to the work: "September was the best month for the Via Veneto," says Barillari, "because all these famous people were just coming back from vacation, so they were tanned, looking smart, and they went there to show off—you know, to just look beautiful. At the time, I didn't know all the stars, and I would often photograph someone who I thought might be important just because of the way he looked. I was working for an agency for eight dollars per week, and I worked in the Via Veneto full-time. More and more magazines started to specialize in this kind of picture, especially if the stars were there with their lovers. This was a time when there was no divorce in Italy, so it was scandalous to see American actors parading with their lovers or their second, third, or fourth wife."

> ## Celebrities create the monster, then they want to cage the beast. FRANK GRIFFIN

LATIN CURIOSITY

Frenchman Jean-Paul Dousset was a young photographer when he began working in Rome during this period. He found the Italian photographers to be pleasant and not at all aggressive toward others who invaded their turf. This may have been because the majority of them didn't depend on the craft for their sole source of income; they worked as office clerks or in similar occupations during the day and came out in the evenings with their cameras and waited in front of the most popular restaurants. There was a good bit of collaboration among them: Because the magazines preferred—and paid higher rates for—photos that showed confrontation with the stars, the first thing they did every evening was work out which photographer would start a fight with a subject and which would photograph it: "As the celebrity was walking down the street, you'd be walking backwards in front of him, shooting as you went, and you'd pretend to trip and fall on the sidewalk. He'd either trip over you or push you or do something, and then the other photographers would take the picture. They'd have the story, they'd sell it, we'd get our cut, and everybody was happy."

Everyone on the Via Veneto, photographers and subjects alike, knew that you got better sales if it appeared that a photograph was difficult to take. When telephoto lenses became available, photographers often used them on the opposite side of the street from their subjects even if it wasn't necessary, so that a tree or similar object would appear in the foreground of a picture to give it an illicit, stolen quality.

This fraternal relationship among the photographers was down to earth and very close. Dousset has a theory that paparazzo photography started in Italy because of the Latin temperament: Everyone wants to know what everybody else is doing, whether it's in a village or a city. This curiosity was all quite friendly, and because of it a close relationship developed between subjects and photographers; everyone wanted to know who was dating whom, who was happy with whom, all without hostility. "The photographer wouldn't say behind his camera as he was talking the picture, 'Look at that stupid rich guy,'" says Dousset. "At the same time, the subject might hide his face or stick out his tongue, but never like you have now, especially in England, with stars mooning the photographers or giving the finger or shouting abuse to you. It was a kind of dance, a nonaggressive dance."

OPPOSITE

CONE HEAD: Actress Sonja Romanoff takes her frustration with Rino Barillari into her own hands, cooling his ardor for pursuit with a well-placed ice cream.

PAGES 60 AND 61

FAT OF THE LAND: Secchiaroli shot this picture of King Farouk of Egypt at the Café de Paris in Rome, 1958. Although six years into his exile, the deposed king does not appear to be suffering from much deprivation.

CLASSIC AND CLASSY: Audrey Hepburn and her husband, Mel Ferrer, stroll down the Via Veneto, October 1961. Ferrer was in Rome to film *Charge of the Black Lancers.*

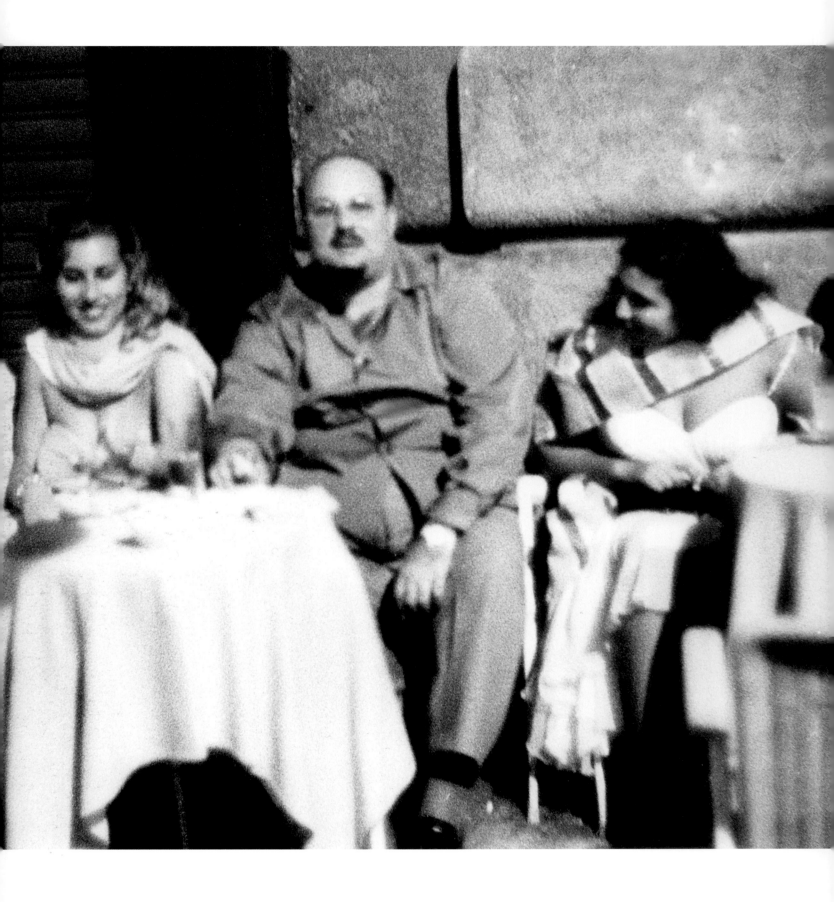

As the sixties wore on, the allure of the Via Veneto and of Rome wore off. The street was diminished by its own reputation, tarnished through overexposure, and increasing prosperity in Italy meant that more people could afford to dine in the expensive restaurants and drink in the fancy bars; it was no longer the exclusive domain of a shining elite. Italy also lost its financial advantage for the production of movies, and even Italian directors started shooting in Spain. Today the Via Veneto has the faded allure of Carnaby Street or Haight Ashbury, its glamour a thing of the past.

THE SENSATIONAL SEVENTIES

The 1970s was a generally freer decade than those that have followed; one of the most notable differences is that the role of the public relations professionals then was to get press coverage for their clients, not prevent it. There was also less concern about security—this was before the murder of John Lennon—so celebrities employed fewer men with big bodies and small brains. And not the least significant factor in making life easier for the photographer working the celebrity beat was that there was far less competition from other shooters.

As the market for celebrity photography grew with the arrival of *People, Star,* and later on *Us Weekly* magazines, more photographers saw the money that could be made from the increased competition. It got to the point where there were always too many of them to be accommodated at any particular event, so the organizers cut down on the number who would be allowed in. "You had to have an assignment to get on the list; you had to prove that you published," says Ron Gallela. "It became too controlled; you didn't have the freedom to get the good pictures that I like—pictures of

LEFT

EASY ACCESS, EASY EXIT: In the days when the job of the publicists was to help rather than hinder photographers, a photograph such as this one, taken at the Grammy awards in 1975, was relatively easy to get. As Ron Galella recounts, "The PR would set up a picture for you backstage—[David] Bowie, Simon and Garfunkel, Yoko and John Lennon, and Aretha Franklin—all in one shot, no security, no nothing. Afterward I got John and Yoko together in the corner, bounced light, beautiful. No problem getting pictures." Another reason the evening was memorable for Galella: "I didn't get thrown out—I walked out."

PAGES 64 AND 65

HANGING OUT AT STUDIO 54: Ali MacGraw and her boyfriend, Larry Spengler, leaving Studio 54, October 1978, after a night of dancing. Club owner Steve Rubell subsequently banned Ron Galella from the premises for distributing this photograph, which Rubell claimed upset the actress. It was one of several occasions on which the photographer was declared persona non grata at the famous nightspot.

ANOTHER NIGHT, ANOTHER AWARD: In May 1979, Elizabeth Taylor accompanies fashion designer Halston into New York's temple of the seventies in New York, Studio 54, where he was to receive an award from dance legend Martha Graham. Club owner Steve Rubell points out hazards beneath the feet of a distinctly chubby Liz.

people relating to each other, talking to each other, great shots like that. Nowadays you get posed pictures, people looking at the camera and static like statues. The photographers are all herded behind ropes, screaming the celebrities' names to get their attention. It's not the way I did it in the seventies."

PARIS, CITY OF FLASHLIGHT

Jean-Paul Dousset had left the South of France, where his father was in the military, for the allure of Paris. Though he found employment in an insurance company, this young man attracted to glitter and glamour didn't stay there long. His next job was at the other end of the employment spectrum, working for PMU, the French equivalent of off-track betting. This allowed him the time to follow his true calling. He could make money at his job in the morning and spend the rest of the day doing the rounds—staking out some celebrity's house during the afternoon. Aristotle Onassis, Maria Callas, and Catherine Deneuve were regular targets. In the evening the venues would change to some of the more expensive restaurants, and the night would end in front of a famous nightclub such as New Jimmy's in Montparnasse or Privé in rue Marbeuf.

"We literally lived at Maxim's," says Dousset. "A huge number of famous people ate there; we would wait at the door to see who was going in, then return later to shoot them coming out and make them pose in front of the restaurant. We got very friendly with the doormen because it was in their interest for us to be there—if we shot people like Dalí, the painter, as they left, they would be obliged to tip the doormen, which they wouldn't do if there were no photographers. So the doormen would tell us who was dining that night, and they'd arrange for us to eat there. There's still a small metal door that leads directly to the kitchens on the side of Maxim's, and it was here that we ate for nearly a year. Maxim's basic dish is *canard à l'orange,* and I can tell you that you would have to pay me to eat that at Maxim's now, because two or three times a week we would eat that sweet, syrupy meal sitting on the steps that led down to the kitchen."

FLAGSHIP ON A STEADY COURSE

The National Enquirer has been a remarkably consistent outlet for paparazzo work over the years. Originally a New York racing-form paper, it was purchased in 1952 by Generoso "Gene" Pope for $75,000. He immediately turned it into a popular weekly publication devoted to sex, scandal, murder, and mayhem, and to this day it remains remarkably close to his original idea. He would spend any amount of money necessary to get a picture, and in those days the photographers were earning so many day rates that the subsequent syndication of the pictures was merely a bonus. Everyone with information on a celebrity would call the *Enquirer,* which paid handsomely for even the flimsiest tips.

Dousset worked for the publication at the beginning of his career without realizing the character of the magazine. On assignment to photograph Robert Redford and his family skiing in the Swiss Alps, he found Redford on the second day after his arrival and introduced himself, saying he was a French photographer working for an American magazine. When the actor asked the name of the publication, Dousset told him that it was *The National Enquirer.* Realizing that the photographer was unaware of the magazine's reputation, Redford allowed himself to be photographed despite his wife's loud protests.

THE SHOOTER SHOT: French film star Catherine Deneuve and her husband at the time, photographer David Bailey, at Heathrow airport, 1966. Bailey, the archetypal sixties photographer on whom the character in Michelangelo Antonioni's movie *Blowup* was modeled, was said to make love daily.

However, there was always a dark side to the *Enquirer's* operations under Pope. Phil Ramey had been working on a story for the magazine, about two Hollywood stars who were rumored to be having an affair and had been meeting surreptitiously at the male star's house in Malibu. The publication wanted photographs of the woman's personal items in the house, for which they would pay extra. The oceanfront property was being remodeled, and Ramey pretended to be the owner of a house in need of similar improvement. The foreman of the construction crew was naturally eager to show him the work that had been done; through this deception, Ramey was able to get into the bedroom with a point-and-shoot camera and photograph the requested items. The magazine paid him handsomely for these shots, but to this day they have never been published, which leads Ramey to wonder what the magazine's motives were in the first place.

LOOKING BACK

Of the photographers mentioned in this chapter, Phil Ramey and Adriano Bartoloni are still actively photographing. Jean-Paul Dousset runs a photographic agency in Paris, and Ron Galella spends most of his time organizing his vast photo collection and publishing books from it. In his early seventies and anything but retired, he says of his life now:

"I'm living the rewards of all this work. What I love doing now is books. The one that just came out was my third, and the next one is almost done. I have great shots I didn't realize I had. For instance, I never knew I had Andy Warhol with Basquiat, the artist; I could have sold it a million times. I found another one of [Robert] Mapplethorpe with Keith Haring at the Tunnel disco. My files are like a gold mine. And now I can go through them because I have more time. I'm not shooting as much now, because the events are not that great—my file is greater than the events of today."

SWISS FAMILY REDFORD: Robert Redford and his family on a ski vacation in the Swiss Alps, 1976. Jean-Paul Dousset and his partner, Daniel Angeli, took the assignment from *The National Enquirer* to cover the actor, without realizing the magazine's reputation. Mrs. Redford was quick to forcefully educate them on the subject.

LIZ, RICHARD, AND THE RATS

In August of 1969, the Burtons had their yacht, *Kalizma* (named after their daughters Kate, Liz, and Maria), moored on the Thames. They would visit it on the weekends to see their dogs, which were quarantined on the boat because of British health laws. Next to it was a dock with a big five-story customs warehouse that stored sugar, cocoa butter, coffee, and stuff like that; the watchman would let you go in and shoot through the windows, but the building was closed from Friday afternoon until Monday morning, so you couldn't get pictures during weekends. As the Burtons were rarely on the boat during the week, I decided that I had to spend a weekend in the warehouse when I was sure they were going to be there. I managed to get information from one of the Portuguese sailors on the yacht that some event was planned for the following weekend, so I got a sleeping bag, bought a whole shopping bag of food and soda and stuff, and paid the watchman about $15 to lock me in the warehouse. At about four o'clock Friday afternoon, he locked me in, and he wouldn't be back until about nine Monday morning.

The warehouse had bars on the windows, so there was no way to get out. The worst part was the rats because it was right next to the water, so I went to the top of the building to get away from them. The first night I slept on the roof; after that I put my sleeping bag on the fifth floor on top of sacks of coffee, facing the window. The window was like my TV; I had to watch to see when the Burtons were coming on board. Nothing happened Friday, but Saturday afternoon they started parading in. There was Elizabeth Taylor; her lawyer, Aaron Frosch; and a bride and groom. I found out later Richard and Elizabeth were best man and maid of honor at the wedding of their secretary, Bob Wilson. The wedding took place at the Dorchester, which I missed, but of course I wouldn't have been able to get in there anyway. All I could have gotten was them coming out. But I did get exclusive pictures of them on the yacht, and the *Enquirer* ran a double-page spread.

But the best shot I got wasn't from the wedding at all. This yacht was like a landmark; tourist boats would pass by, and I could hear them say, "And this is the *Kalizma,* the Burtons' yacht, and when the American flag is flying she's on board, and when the British flag is flying, Burton's on board." I got a picture of a tourist boat coming by, and Elizabeth and the yacht's steward putting up gauze curtains for some privacy. The tourists were there with their cameras, unaware that Elizabeth Taylor was right in front of them. They didn't see her, but I saw her. ✳ RON GALELLA

CRASHERS AND STALKERS

YOU CAN RUN BUT YOU CAN'T HIDE

For the real paparazzi, there are two main avenues for photographing the things you shouldn't photograph in the places you shouldn't be: gate-crashing and pursuit. The first takes nerve, deception, and the confidence to make people believe that you're supposed to be there; the second takes cunning, knowledge, and the ability to anticipate a celebrity's movements.

The only time agency owner and onetime paparazzo Frank Griffin became agitated while being interviewed for this book was when I mentioned the word *stalker:* "It's a horrible word that has no bearing on what we do. *Stalker* implies the intent to do damage at the end of the chase, like hunting deer in Scotland, and shooting and killing. You can call me anything you want but not a stalker." After a moment's thought he reconsidered this offer. "I don't like *paparazzi,* either; I think it's a stupid word."

THE SMOOCH SEEN ROUND THE WORLD: Cameron Diaz kisses her boyfriend, Justin Timberlake, good-bye as he leaves her home in the Hollywood Hills, June 2003. This photograph is an example of the kind of long-lens trespass to which celebrities object. Hot stars in Hollywood today must assume that everything they do is liable to be photographed.

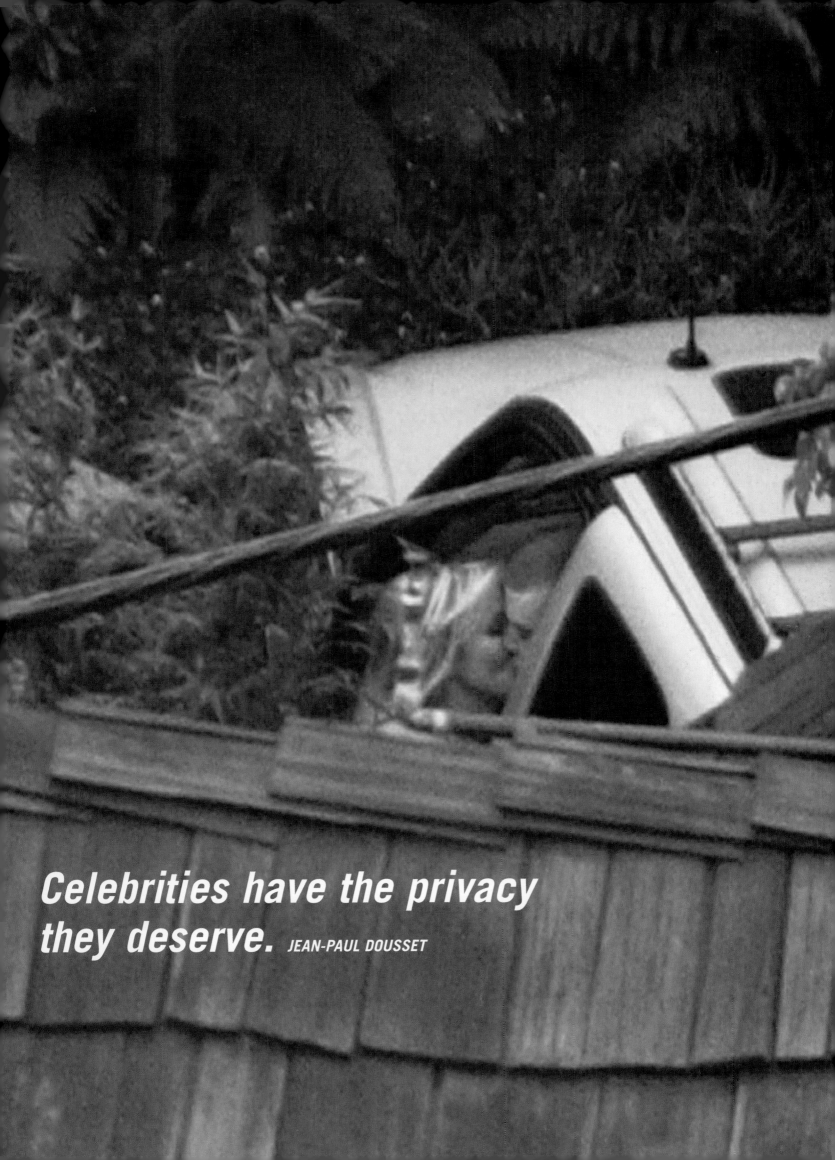

Celebrities have the privacy they deserve. *JEAN-PAUL DOUSSET*

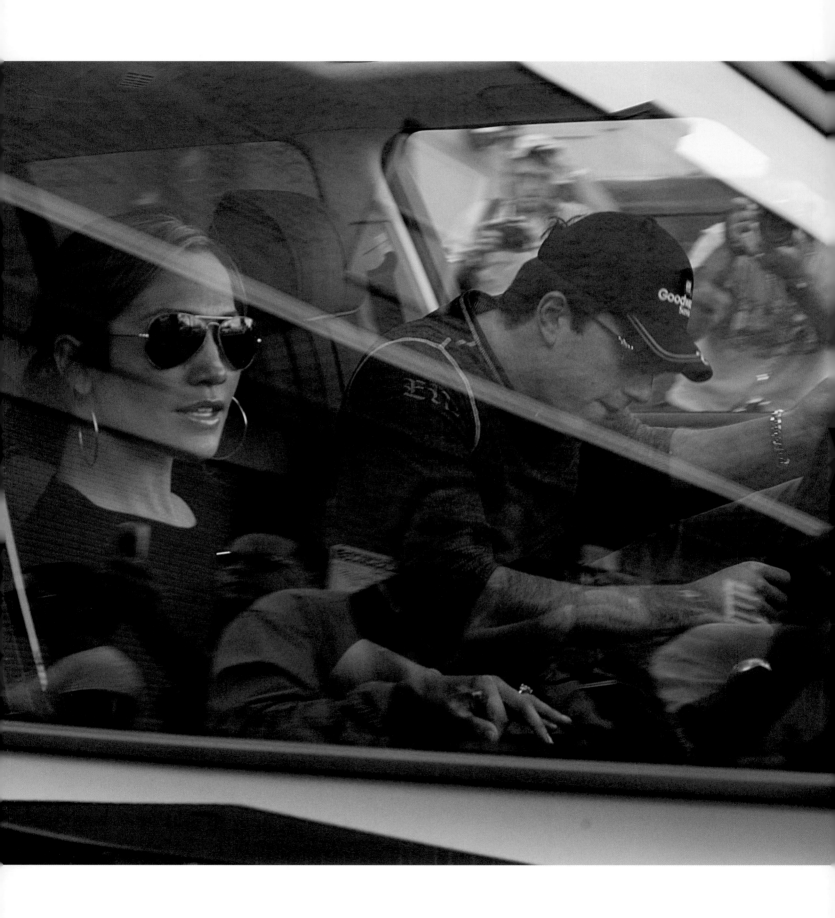

SOME LEAD, OTHERS FOLLOW

In the minds of the public, however, and certainly from the viewpoint of the celebrities at the other end of the lens, stalking is exactly what some paparazzi do to get their pictures; a word was even coined to describe these photographers: *stalkerazzi*. The pursuit of a celebrity is the most controversial and condemned part of a paparazzo's professional life, especially if it is done in a vehicle and especially after the death of Princess Diana. These chases, called follows by those who participate in them, can often devolve into dangerous high-speed convoys.

In 2003, when interest in the marital status of Jennifer Lopez and Ben Affleck almost reached a state of public hysteria, the quest for photographs of the couple produced several long and hair-raising incidents. Steven Ginsburg spent a considerable amount of time and energy covering this story in Georgia:

"Ben Affleck is driving a hundred twenty miles an hour—and I mean one hundred and twenty miles an hour. We thought the police might have been paid off because he's driving at that speed and they're letting him go while keeping all the paparazzi behind. They block off the freeway for half an hour, two cops driving at thirty miles an hour, tons and tons of cars behind them. And Ben and Jen are gone in the distance.

There's no ethical way of getting this stuff. BRITTAIN STONE

"We had to deal with decoy cars and driving like you wouldn't believe. You're in the left lane, they'll cut in front of all the traffic and make a right, a U-turn; it was the most insane driving ever. Ben is out of his mind. He drove in a way where really he put a lot of people at risk, like driving into a parking lot and then jumping the curb and back onto the road. After forty-five minutes, my hands were shaking. I called my partner and said, 'I'm done, I don't want to do that anymore.' It was ridiculous—I almost died ten times."

Mustafa Khalili prefers it when the celebrity he's following is unaware of his presence, and this often works better when there is a team of two or three cars on the follow. Sometimes they wait for hours outside a celebrity's house before anyone emerges. If it's a bad day, the wait can be as long as fourteen hours. Once the celebrity leaves, the follow is on, as discreetly as possible, of course. Now, you and I may think that it's difficult to be discreet when two cars are following another one, but if you know what you're doing, there are advantages to the greater number, especially in Los Angeles. Because of the way the city is laid out, it's very often possible for one car to follow at a distance while the other uses a parallel road to catch the target car at a cross street. "There are so many cars that people don't really notice," says Khalili. "There's always so much traffic that as long as you keep moving and you're not on their bumpers, you should be okay. Some people are very aware of it; Cameron Diaz will spend the first half an hour after she leaves her house pulling U-turns and going into underground carparks and coming back out and trying to lose you. If you know what she's doing, you hang back as far as possible."

The need for more than one car depends upon the awareness of the celebrity, as Steven Ginsburg explains: "Some celebrities are very easy; anybody can do them. But if you try to work on the stories that are worth good money, on those you need a couple people. You constantly switch positions—if they make a left and I'm directly behind them, I turn right, my partner takes the left. I do a U-turn and come up back behind. We know the ones who're difficult; we know they're looking in their mirrors; they're videotaping;

COPS STOP PAPS: At one point during the madness of the Ben-Jen period of Jennifer Lopez's love life, the actress and Ben Affleck were in Georgia together. One day, as he picked her up in a black Range Rover from the Savannah Day Spa, police and spa workers surrounded her to prevent photographers from getting shots. The couple then got a police escort to facilitate their escape, while other patrol cars, traveling at thirty miles per hour, formed a running roadblock to deter pursuing photographers.

they're going in neighborhoods to see who follows them in. For them we need two people, and I think actually two people are too few."

Follows become dangerous when several competing teams are after the same quarry. The driving becomes much more aggressive, discretion goes out the window, and the element of surprise is lost. Then several things may happen: First, the celebrity panics, and the follow becomes a chase, which is much more dangerous for all involved. Second, the pictures are no longer natural because the photographer is no longer unobserved. In fact, an experienced paparazzo will often hold back from taking particular photographs if it means risking discovery, relying instead on his instincts that remaining concealed will lead to something bigger and better.

Early in his career, Phil Ramey teamed with the photographer Russell Turiak to do a follow on Loni Anderson and Burt Reynolds:

"In the course of following them from Malibu back to Burt's house in the Hollywood hills, we did a two-car follow. Turiak raced ahead and positioned himself to get pictures through the windshield as they drove through the gate. I showed up shortly after to find him sprawled on the ground; Burt had slugged

It's absolute crap to say that celebrities hate the paparazzi. FRANK GRIFFIN

him, knocked his lens out, smashed the camera, and threw it on his property. But Turiak was very enterprising—he climbed over the gate, retrieved the camera, and filed a police report, with me as the witness. And I had the brains to photograph him all messed up. Within hours, everybody knew the story. It resulted in a big lawsuit by Turiak against Reynolds and an ongoing period of us staking out Burt endlessly, which in turn escalated into further incidents of us being shot at and restraining orders and madness that continued on long beyond the scope of this answer.

"I didn't tell you our trick, did I? We didn't do a two-car follow, we did a head-and-tail follow, which means that the best guy follows from in front and the other follows from the rear; if you've ever seen that done, it's quite nice. I followed from the front, so when Turiak made the turn onto Reynolds's street, I went straight on. I was slowed by traffic; otherwise I would have been there to get the whole incident on film. It's a technique I hardly see used anymore, but it works really well; it fools ninety-eight percent of the people ninety-eight percent of the time."

The security measures that some major celebrities take also become a complicating factor in follows. Many A-list celebrities, such as Britney Spears and Christina Aguilera, employ full-time bodyguards, whose job is to prevent not only physical harm to their employers but photographic "harm" as well. The judicious use of umbrellas on even the sunniest of days will prevent a clean shot of the star getting into or out of a car. And the celebrity may have another security car driving closely behind the one she's in—the "stick car," so named because its job is to stick to the car in front of it. Under these circumstances, the paparazzi are forced to stay much farther back. People like Tom Cruise, who according to Mustafa Khalili uses stick cars, do so because they assume, probably correctly, that they're being followed whenever they leave home.

In a car-obsessed town like Los Angeles, where people who walk are thought to be eccentric at the least and suspicious at the worst, the paparazzo's car is as important as his lenses and, given the time that

he spends in it, gets far more use. Most choose SUVs with darkened windows through which they can shoot unseen, but Khalili drives a Volkswagen Golf because nobody would suspect that it belonged to a paparazzo. He also prefers a smaller car for the greater maneuverability that it gives him; even on the congested streets of Los Angeles he rarely gets stuck in traffic, often moving between lanes to get through. Most L.A.–based paparazzi stay in their cars and shoot though the windows. The problem with this technique is that the tinting cuts down the light and can alter the color balance on the film. Khalili prefers to work the way he did in London—getting out of his car and hiding between parked cars, trash cans, bushes, or anything else that provides concealment.

WEST IS BEST

In New York City, where owning a car is an expensive and time-consuming liability, life tends to happen on the sidewalk. It's not unusual to see celebrities walking on the streets of Manhattan, so the paparazzi are generally on foot as well. Susan Sarandon tells of one encounter:

"I was up on the Upper East Side and a guy started following me, and I said, 'Boy, it's clearly not a busy day, is it? You've been following me for twenty minutes.' And he said, 'You know what would be really funny? A shot of you with these glasses with the mustache.' I said, 'No, that wouldn't be really funny.' This is insane. Here's a guy who has not only been following me for almost half an hour, but now he's also suggesting that I make myself funnier for a shot. I said, 'Please, that's enough,' and he did eventually leave."

TO PROTECT AND SERVE: Police hold back traffic as Brad Pitt and Jennifer Aniston make good their escape after shopping for furniture in Beverly Hills, October 2002. Complicity between celebrities and the police is a constant source of irritation for the paparazzi.

Us Weekly's Brittain Stone prefers to publish photographs taken in Los Angeles because the physical surroundings are more appealing. He finds New York backgrounds too gray, and the people too tense and overdressed, especially in winter: "They're probably just walking down the street on their way to a shop doing very little—they're not getting in a car, they're not doing stuff that's more human." The only Manhattan location he's happy with is Central Park, because of the greenery and the fact that everyone seems more relaxed. In Los Angeles, he says, "You've got backdrops and sunshine. People are half naked; Pamela Anderson's wearing her Uggs while she's in a bikini top. They're in a car, they're on their way to some errand, they're pushing the kid around and the kid's probably a little less swaddled than in New York. Even though it's suburban, it's a little more open when you photograph them."

KEEP WALKING, NOT TALKING

What can celebrities do in the face of this constant attention? Susan Sarandon's technique is to remain calm and disengaged. A paparazzo with a video camera used to stake out American Airlines arrivals at Los Angeles airport; his technique was to try to provoke the celebrities getting off the plane, just as the original Via Veneto paparazzi did. Sarandon's way of dealing with him was to keep smiling, walking, and not talking, and to always keep her temper. She thinks that men often have a harder time dealing with this kind of aggression because they tend to be more territorial than women. But even with her attitude, the unrelenting scrutiny does lead to unexpected problems:

"Bill O'Reilly showed some [footage] at the height of the attack on Tim [Robbins] and me for questioning going into the [Iraq] war. He did a segment with a voice-over that had a montage of us speaking, mostly at rallies and mostly in long shot. In the middle of this was me screaming, shaking my fist, carrying on, very close up, and I'm thinking, Where the hell's that from? What was I talking about? How could that be a political speech? And of course, when I looked at it more closely, I could see both of my sons on either side, and I realized that it was footage of me at a hockey game. So you don't even know where it's going to end up; it can be used in any way they see fit, and that's a little bit dangerous."

WITH THIS CAMERA I THEE SHOOT

A-list celebrity weddings will always bring out the paparazzi in droves, both on the ground and in the air, and the lengths to which they go to get a picture of the bride and groom are extraordinary. If there were an award for the most creative approach to illicit wedding photography, it would have to be presented to *The National Enquirer*. Their strategy for the 1988 nuptials of Michael J. Fox and Tracy Pollan was predicated on a herd of llamas that was contentedly grazing in a field that adjoined the wedding location, blissfully unaware of the important event taking place in their Vermont neighborhood. The publishers planned for the occasion in much the same way that generals prepare for combat: They set up a war room and took reconnaissance photos of the site from helicopters prior to the ceremony, which was to take place in a tent. From the intelligence they gathered, they realized that the only way for photographers to get close enough was to cross the field in which the llamas were grazing. Undeterred, they had llama costumes made up, and paparazzi in full daylight and full costume crossed the field into a position to shoot the

SOMETIMES IT TAKES A VILLAGE—ALMOST: On a big story, the cast of characters can become huge. To get pictures during the Jennifer Lopez–Ben Affleck epic, Steven Ginsburg was on a yacht moored in front of Lopez's house while his partner covered it from land. They also employed a man on a motorcycle to get them through heavy traffic, a trash collector, a guy in a golf cart, and a car and driver. This was the payroll for just two photographers; when you figure the competition on the story, the total number of people employed to take pictures of two celebrities boggles the mind. It certainly seems to have boggled Jennifer Lopez's, from her expression in this picture.

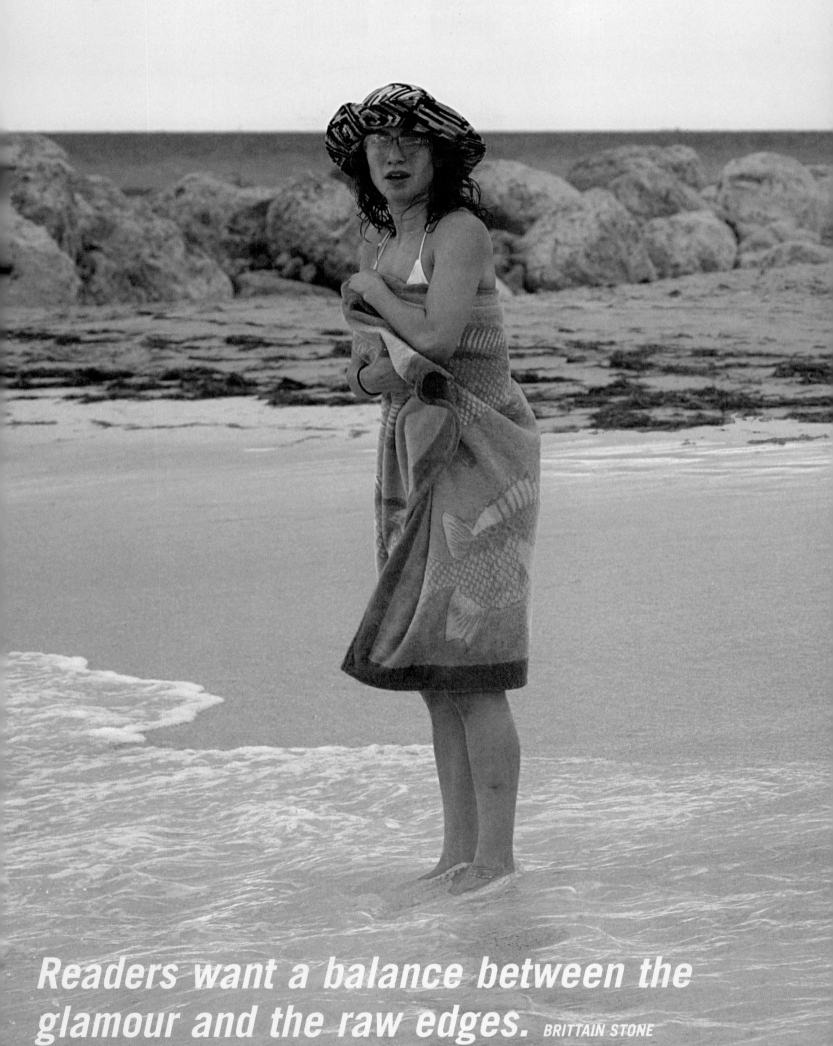

Readers want a balance between the glamour and the raw edges. *BRITTAIN STONE*

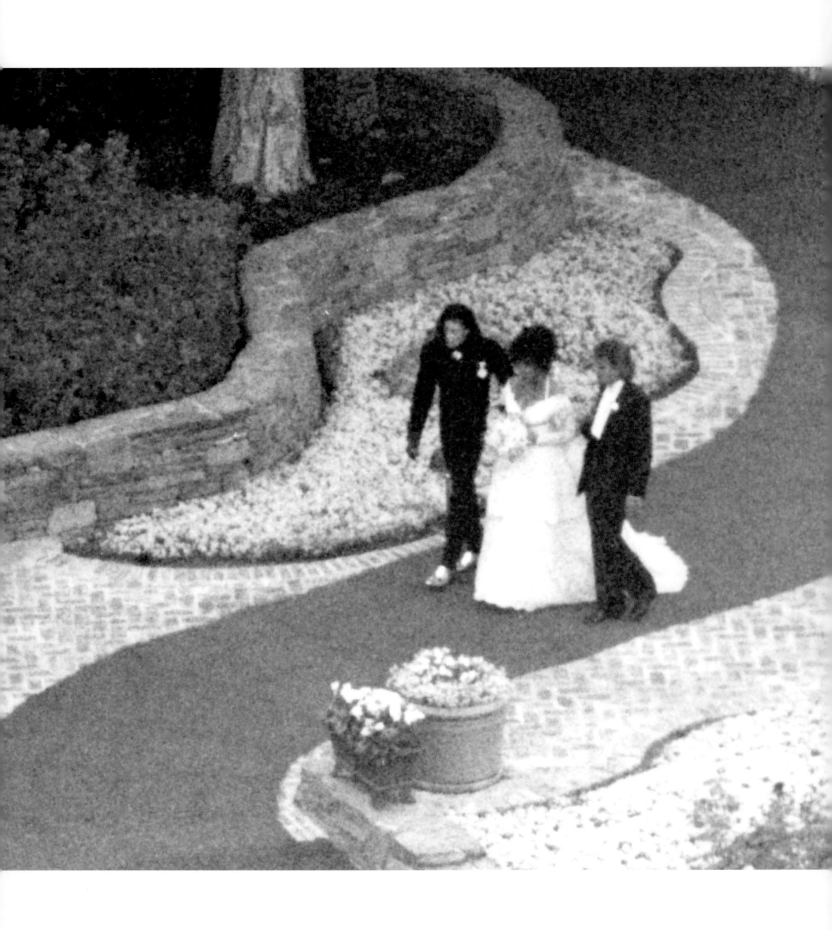

ceremony—only to find that, even on this very warm day, Fox had put all the sides to the tents down to prevent photographs from being taken. For the tabloid, it was a case of winning the battle but losing the war. It was also one case in which celebrities' contention that the paparazzi act like animals was indisputably justified.

When Liz Taylor married former truck driver Larry Fortensky in 1991 at Michael Jackson's Never and Ranch, the airspace above made Chicago's O'Hare airport seem deserted. Phil Ramey estimated that there were fourteen or fifteen helicopters—three of which were working for him—all filled with photographers trying to get pictures. "Liz could have run away and gotten quietly married, but she engineered the whole thing, trust me," he says.

DOES THE POPE WEAR SPEEDOS?

Helicopters also played a part in an operation conducted by Italian photographer Adriano Bartoloni in his quest for photographs of another hot international celebrity: the Pope. The length and complexity of the arrangements had all the flair and daring of a Special Forces assault. The goal of the subterfuge was to get pictures of John Paul II in the swimming pool of Castelgandolfo, his summer residence just outside Rome.

Bartoloni had to find out exactly where the pool was located, which he did using a helicopter. To counter the high level of security that surrounded the pontiff, he worked out from his aerial vantage point that the best way to get to the location was through a cemetery adjoining the property. Although two security vehicles continually patrolled the walls, he had timed them and found that there was a sixty- to eighty-second gap between them. He figured that would give him enough time to jump over the wall, even though he was carrying more than three hundred pounds of cameras and lenses, plus food and water for several days. (Once in, there was no telling when he would be out.)

In every security situation, there's a weak point that can be exploited. In this case it was a ditch that the patrols rarely checked. It was deep, both a disadvantage and an advantage for Bartoloni. The minus side was that it was difficult to get in and out of; the plus was that it was deep enough for him to build a little hut, where he slept. Under cover of darkness, he put a remote-controlled camera in a tree overlooking the pool, then camouflaged it with branches. He worried that there might be special protective glass surrounding the pool that would make it impossible to photograph, but that fear proved to be groundless. The whole operation took seven months to prepare and eleven days to shoot.

Bartoloni also took pictures of the Pope just after the 1981 assassination attempt. He knew the family of a young woman who worked in the intensive care unit of the hospital to which John Paul II had been taken after he was shot by Mehmet Ali Agca; through her he managed to get his name on a list of relatives of patients who would be allowed entry. The Pope was in a private high-security room; however, Bartoloni knew that he would have to be moved at some point for X rays and other procedures, so his plan was to wait. Then he noticed that there was a glass partition at the top of one of the walls of the pontiff's room, so he climbed up and shot through the glass. He was working with a very small camera and carrying a regular camera loaded with a blank roll of film as a decoy. Sure enough, he was caught by a security guard, who confiscated the large camera, but not before he slipped the small one to his assistant.

IS IT A BIRD? IS IT A PLANE? IS IT A PAPARAZZO?: Michael Jackson accompanies Elizabeth Taylor and Larry Fortensky during their wedding at Jackson's Neverland Ranch. Phil Ramey was one of the first photographers to shoot celebrity weddings from helicopters and has perfected the difficult techniques needed to use them successfully.

Although nobody had seen the handoff, the young assistant's nerve failed him, and he offered a nurse a million lire to look after the camera. Instead of taking the bribe, she called the police, and that was the end of Bartoloni's scoop.

WHEN EASY IS TOO EASY

Tracking down and photographing people who want neither to be found nor photographed is not an easy job by its very nature, so when things start to fall into place a little too smoothly, the paparazzi are always a bit suspicious. When Jean-Paul Dousset and his partner, Daniel Angeli, found themselves easily able to photograph Sarah Ferguson, the Duchess of York, on vacation, they began to wonder who was manipulating whom. Dousset explains:

"Saint-Tropez was our turf where we had been working for fifteen years, so we knew a huge number of people. One day I was at the port checking things when a guy I knew came up to me and said, 'A friend of mine who works with Europcar was contacted by the British embassy because one of their princesses is arriving next Tuesday.' So we checked it out with our English correspondent, and it was true: The Duchess of York was to land at a small airport called La Mole about ten kilometers outside of Saint-Tropez. I borrowed a car from a friend who owns the gas station in the port. He sells BP, the same as at the airport, and the car had a BP sign on it, which made it look authentic.

The reason the paparazzi are so disliked is that there are no standards of social behavior among them. *JEAN-PAUL DOUSSET*

"We went to La Mole and waited. Finally the plane landed, and we did a sequence of Fergie with a guy called John Barry, who nobody knew anything about. We tried to follow them—I was on a motorbike—but we lost them. We went back to Europcar and found the address they had been given, and two or three days afterwards we did all the pictures. It was so easy because the house and the swimming pool were only about fifty meters from the main road. You could have invited a hundred people just to sit there and watch."

Dousset is convinced that whoever set up the vacation for the Duchess of York deliberately made it easy for her to be discovered by photographers. Apart from the accessibility of the villa in which she stayed, the choice of Saint-Tropez in itself meant that there would be many hungry paparazzi in the vicinity with enough contacts and local knowledge to find her. He believes it's more than likely that Buckingham Palace knew about Fergie's relationship with Barry and had decided to expose it.

Unfortunately, the photographs in question can no longer be seen, because they were "bought out," as it is known in the profession—someone pays the photographer a large sum of money for the exclusive rights to the pictures in order to prevent their further publication. This isn't unusual—some publications will trade paparazzi photographs for an agreement with their subject to grant an exclusive interview or photo session. What is unusual is that for "legal reasons," the Mirror Group of newspapers, which published the pictures, wouldn't grant permission for reproduction of the pages of the newspapers in which they appeared. E-mails questioning the nature of those legal reasons went unanswered.

THE SOUND OF CRASHING

For those without the patience for doorstepping or the nerve for high-speed car chases, there's gate-crashing, and one of the masters of this art is British photographer Duncan Raban. His preferred way of covering a concert, for instance, was, not to get an official credential and comply with the control over his activities that went with it, but to opt for the greater freedom afforded by unauthorized entry:

"Even ten years ago they were searching you, but there are always ways of getting you and your cameras in. I'd get my ticket from a scalper and go through the turnstile where they searched you. Then I'd go to my seat and come back again, and say, 'Oh, God, have you seen a little girl with blond hair?' or 'I've left the lights on my car on,' and I'd go out again and make a bit of a scene at the turnstile so they'd notice me. I'd come back with some stuff under my jacket, and they'd let me back in without searching because they remembered me. When you do get back in, it's still really difficult to do the pictures because there are generally people walking up and down the aisles looking for photographers, so I'd have to take pictures at opportune moments. It's all a game, isn't it?"

One of Raban's most successful crashes was at the epic Live Aid concert held in Wembley Stadium in London in 1985. Raban suspected that there would be no way for him to get a pass, even if he wanted one; the publicist's hanging up on him on him when he called to make the request confirmed this. However, like all good paparazzi, he had a contact within the organization, an assistant to promoter Harvey Goldsmith. Raban had lunch with her about a week before the event and noticed that she was carrying the minutes of a meeting between Goldsmith and Bob Geldof; in themselves they were unimportant documents, but it was worth asking if he could copy them at a nearby newsstand, which he did.

> *We might be parasites, I suppose, but then so are the valet parkers at Spago—"Why can't you park your own car and walk a hundred yards?"* FRANK GRIFFIN

On the day of the concert, he turned up at Wembley at seven in the morning, before anyone else was there. A security guard told him that he couldn't go into the press area until nine o'clock, after he had collected his credentials (which, of course, he didn't have). He then employed a trick that has served him well on many other occasions: He pretended to be calling a picture desk, identifying himself on the fake phone call as the official Live Aid photographer. He also had the photocopies of the documents to back up this story if needed. (In the end they weren't.) The scam worked, and the guard let Raban, his assistant, and an 800-millimeter lens into the pressroom. There they waited until a few other photographers turned up so their absence wouldn't be noticed when they sneaked down onto the field. At 10:30 the gates were opened to the fans, and Raban and his assistant were able to hide among them. Raban shot the whole concert from the crowd, no mean feat in itself—an 800-millimeter lens is about three feet long, and crowds that large tend to move of their own impetus as much as six to eight feet in any direction.

The few occasions when Raban has been credentialed for an event have only served to reinforce for him the wisdom of crashing:

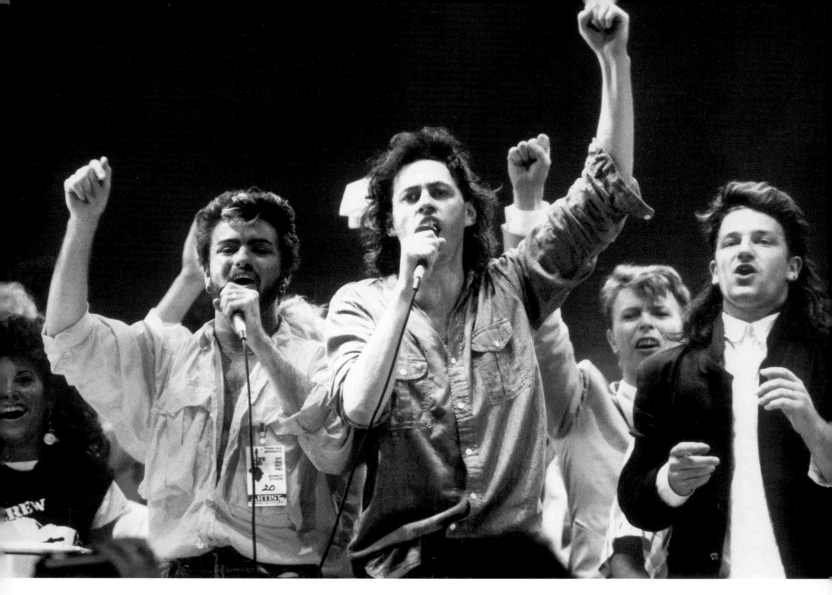

DON'T TIE ME DOWN:
A photograph of George Michael, Bob Geldof, David Bowie, and Bono that Duncan Raban "pirated" during his unauthorized presence at the Live Aid concert in Wembley Stadium, London, July 1985. Shooting from the audience under difficult conditions, but with greater scope than the official photo positions, Raban was able to get shots that were so good that they made it into the authorized Live Aid book.

"When something's organized so the photographers have to go here or stand there, I'll always be the one on the edge or creeping around the corner, or when they've all gone I'll still be there waiting. I'm always the one who hangs out until the last minute because you might get something; I've always been the one who sneaks around the side. I'm not one of the pack. I did Michael Jackson at Madison Square Garden officially, with a pass and everything. They get you together in the pressroom and tell you, 'We're going to split you into group A and group B. Group A can do songs one, two, and three, and group B can do four, five, and six.' Well, that's no good to me because I want to shoot the whole show, so I unscrew a lock on a door at the back of the pressroom and get into the audience. I was really close, shot the whole show, and the pictures were published all over the world. I had a double spread in the *Mirror,* and Michael Jackson's record company called me up and asked if they could get some of them.

"It baffles me why they don't let you do this stuff officially. I've got some corking pictures of Madonna at one of her shows, and I know no one else has them and that she would probably like them."

In many ways the paparazzi are first-rate reporters, because they never take no for an answer. Through sheer happenstance, Raban was able to use his gate-crashing techniques to photograph the site of an IRA bomb in the Canary Wharf area of London in 1996. He was driving home one day when he heard the bomb go off. He parked as close as he could get to the explosion, but when the police prevented him from getting any closer, he went to the Britannia Hotel, about five hundred yards away. The hotel was cordoned off, but he managed to get in by attaching himself to a guest, then went into the basement and out through a window. "I sort of sneaked along the waterfront, ducking and diving under fences," he recalls. "There weren't that many

police around; I bypassed a couple of them, went through a car park, and suddenly I was where the bomb had gone off. I also realized that there wasn't anyone anywhere—no police, no firemen. I found out later they had all gone to check out a possible second bomb in the area, which is why I was alone where I was." It was dark, but using his flash he managed to get some shots of the train station where the bomb had exploded, then made his way back to the hotel without being detected by the police helicopter hovering overhead. His next barrier was getting past the cordons and getting his photographs to the newspapers. This was on a Friday, and having done all this he repeated the whole thing on Saturday in order to get new material for the Sunday papers. Most news desks would kill for photographers with that much effrontery and tenacity.

THERE'S ALWAYS THE BACK DOOR

The front door is nearly always the worst entry point for an event at which your presence isn't welcome; for Ron Galella it was rarely an option. In Paris, on the trail of Elizabeth Taylor and Richard Burton, he discovered that an after-

> *Once the fun leaves, that's when we leave. I love the money, but you have to enjoy what you're doing.* FRANK GRIFFIN

premiere party was to be held at a club called the Ambassador and checked out the layout of the place beforehand. His entry point was, of course, the back door, which led into the kitchen. He told the kitchen staff he was a photographer from New York employed to cover the event. As it happened, on the night of the party, he was allowed entry through the front door, which he attributes to his training at the Art Center College in Los Angeles. ("Even if you're not a *Life* photographer, walk like one, with confidence.") Once inside, he was free to shoot all the celebrities to his heart's content—except one: "I got all the stars except Virna Lisi, and the problem is that you always want the one you didn't get. I ran outside to try to get her there; when the French paparazzi saw me, they said, 'How did you get in?' 'I just walked in,' I answered. But when I tried to get back in, security wouldn't let me, so I used my ace in the hole—the kitchen. It worked!"

Phil Ramey believes that the willingness of some photographers to take risks engenders the wrath of those who play by the rules:

"The sanctimonious attitude towards the paparazzi started among the more conventional photographers. We always would try and crash events or premieres because we could never get credentialed anyway. One time in Beverly Hills, Ron Galella showed me the secret way into the kitchen at the Beverly Hilton and how to get into parties that way. After Grace Kelly died, there was a big ball for her daughter at the Beverly Wilshire. I snuck up into the room that was directly above the ballroom where the guys controlled the spotlights, gave them some money, and sat up there all night snapping pictures of everyone at the table. The same night, I got someone who was more properly dressed than I was to take a little point-and-shoot and dance up close to Caroline and Robert Wagner and snap a couple of frames. We used to crash a lot of those kinds of parties because that's where all the pictures were. They were pictures other photographers wouldn't be allowed to go in and shoot."

PAGES 86 AND 87
DON'T FENCE ME IN: Because of restrictions that publicists impose upon officially sanctioned photographers, crashers such as Duncan Raban prefer the greater freedom of shooting from unauthorized viewpoints in the audience. Typically, a publicist will divide the accredited photographers into two groups, each of which is allowed to photograph a small number of designated songs. For both of the pictures on the following spread—Madonna during the In Bed with Madonna tour at Wembley Stadium in 1991 and Michael Jackson at Madison Square Garden—Raban declined the privilege of accreditation.

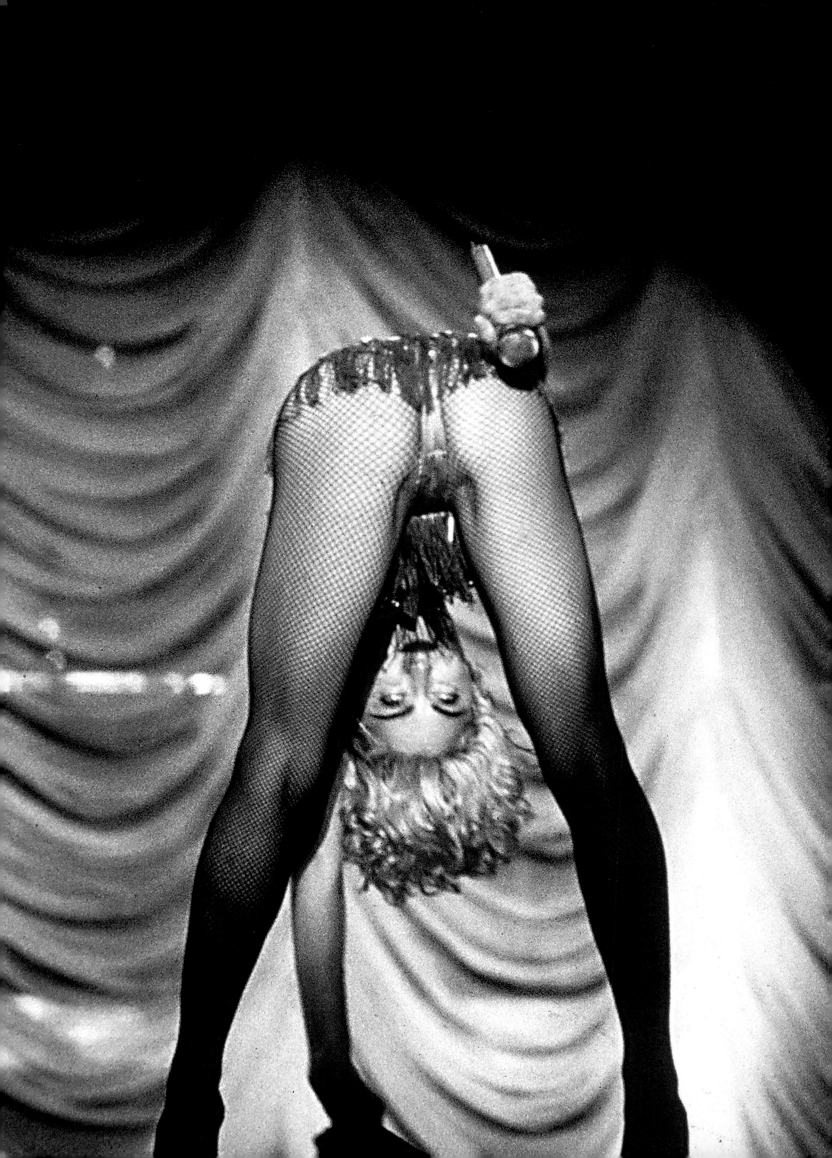

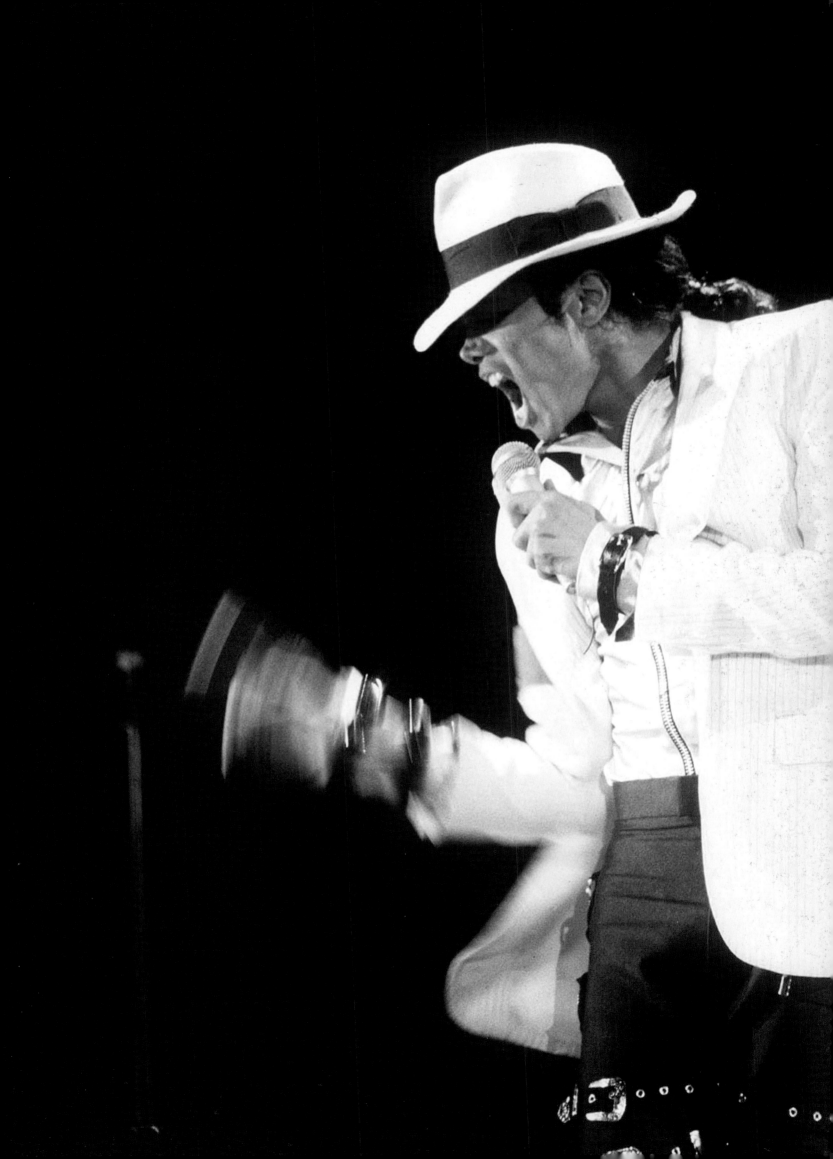

UP THE CREEK WITHOUT A PERISCOPE

When Princess Di's two kids were still very young, she started going to Necker Island as the guest of Richard Branson. It was no big secret, and it was a chance for all the English photographers to get their day in the sun on the company. They were only interested in spending a week in the Caribbean, hanging around drinking beer and going to a prearranged photo op, which is basically what Diana did to get rid of the press—"If you don't harass me, I'll be at a certain place at a certain time with the kids, you can pull up in boats and make some pictures." Basically, the photographers wind up filing all the same stupid-ass pictures and make money. There's nothing wrong with that; I enjoy it, too, but I needed more and better.

I was working for a TV show at the time, with an unlimited budget that enabled me to hire helicopters and buzz the island to try to get pictures. I'll spend money if I think I can make a picture, so I rented a research submarine for about $16,000 a day. Initially we didn't bring it to Necker Island, but to an adjacent island, where I got on it for the first time. It's small and it's beautiful and I think, The video footage alone will put the ratings on the show through the roof. So we take it out for a practice run to see how close we can get to the beach. There was a lot of coral, but the captain knew his way around. We submerge with a video crew and a reporter on board, maybe six or seven people in all. I said to the captain, "We have to figure out what the optical quality of the periscope is, and how much dispersion effect it's going to have. We're going to have to do some film tests. Video you can compensate for, but if you shoot stills through a periscope, you can get a very diffused image because of the angles and mirrors. If you surface, even quickly, the element of surprise will be lost."

I'm saying all this to the guy, and he's giving me the oddest, blankest stare. "We want to shoot through the periscope and do tests," I tell him, and he says, "This is not a warship, this is not World War Two. This is a nautical research vessel. We have no periscopes. We look at things through these huge portholes."

I looked at the producer and she looked at me, and we just stood there; if there ever was a time when I actually went white, I think that was it. No fucking periscope! We ended up putting the crew in the helicopter and sent the submarine out to submerge near the island to make tons of beauty shots so that it looked like we'd justified the expense. We never told anybody back at the studio about "no periscope"; they would've killed us

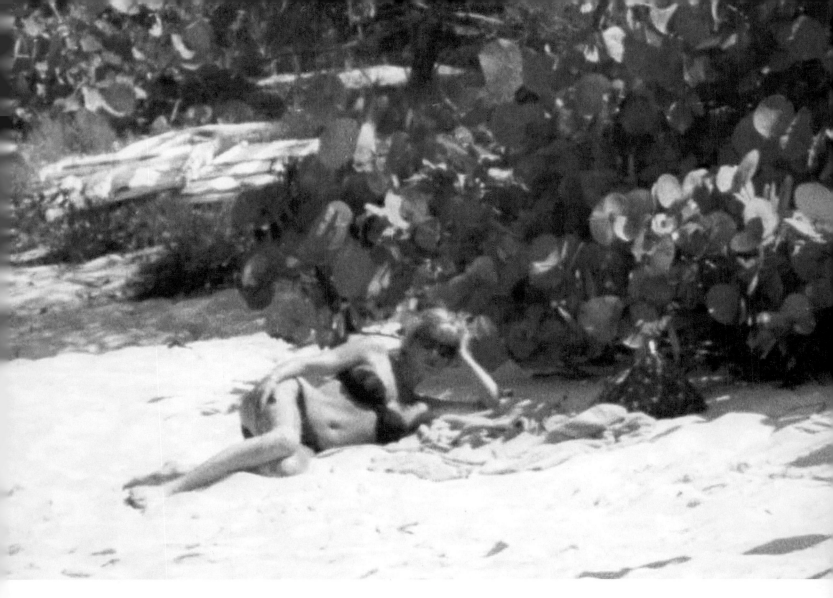

all on the spot. They would've revoked our return tickets, taken away our per diems, my $10,000-a-week retainer, and my spot on the show.

Eventually, we had to go out on the photo call. The Brits were on two boats, but I had my own. We went to the prearranged spot and Di trots the kids out and plays with them in the sand, and that's it. After it's done she packs up, goes away, and the Brits turn the boats around and head out. Well, either to screw with the press or just to be playful, as soon as the boats are out of shooting range, Diana pops back out of the bushes without the kids, wearing a red bikini—totally the antithesis of the "mummy dear" outfit she was wearing—and sprawls out on the sand. By that time everybody is screaming for the boats to turn around or stop, and of course they won't. The photographers pull out the longest lenses they have and try to make the shot. I shot as much as I could before they sent somebody out to run us off.

I think she intentionally tried to stick it to them; she knew what she was doing by that point; she knew how to play the game. And that's how I ended up with a mediocre red-bikini Princess Diana on Necker Island. ✳ PHIL RAMEY

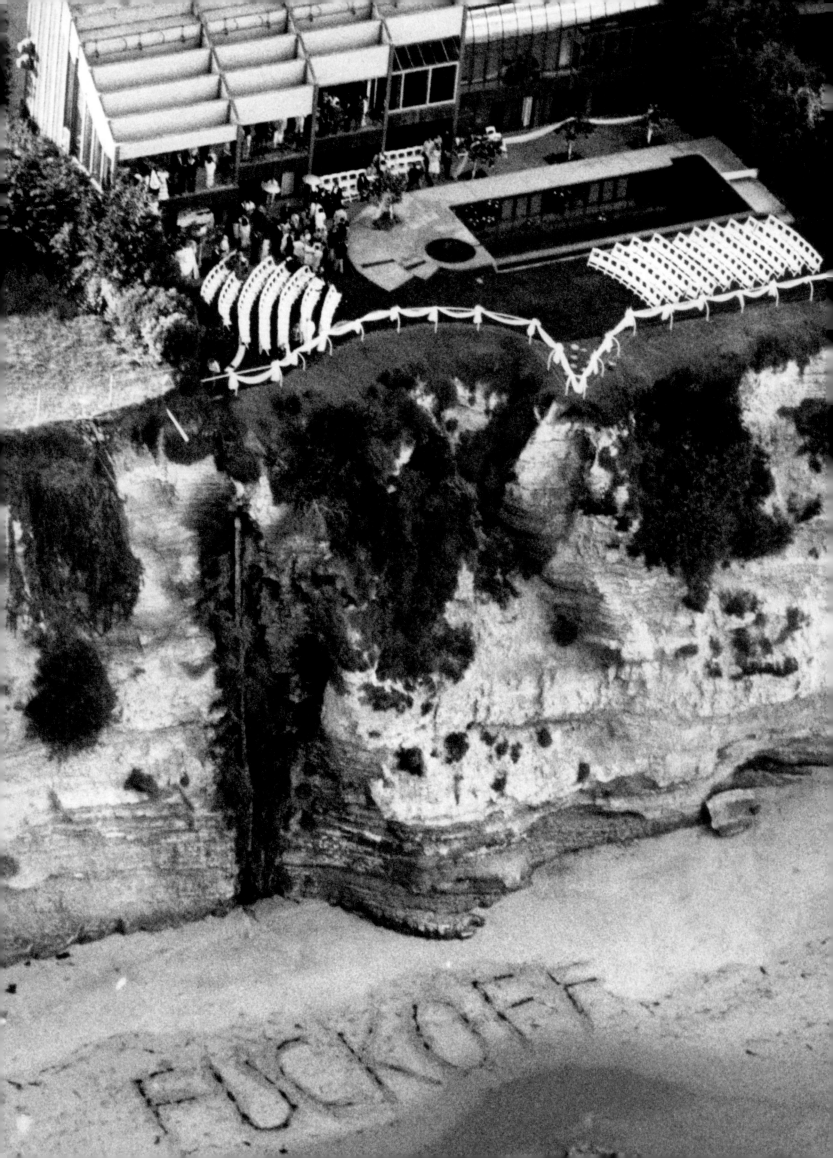

THE CIRCUS WITHIN A CIRCUS

I ferreted out the guest list and location for Sean Penn and Madonna's 1985 wedding from Madonna's trash. We went to one of the tabloids with the information, and they resourcefully rented the house next door to where the wedding was being held for $7,000—a perfect spot for me to hide in and shoot. On the day of the wedding, even though the writer was standing there with cash, the owner of the house threw us out on the street. It was noon, the wedding was supposed to be at two, and we were all in a frigging panic, me most of all because I knew the points of view; I knew there were no other

points of view from which you could shoot the wedding without renting a helicopter, which I did. Of course, as soon as I turned up in one, someone else got the same bright idea.

Well, the wedding wasn't at two, the way we thought, but several hours later, so it seemed we were droning up there endlessly. There were about seven or eight helicopters in all, completely ruining the element of surprise. I had a real bush-league pilot who was too afraid to go in close and get into a hover; he insisted on flying circles, which meant we could only make pictures from the shooting position on the pass every three minutes. It was almost the end of the day; I shot black-and-white and chrome with a Leica one-eighty with a converter. As daylight was disappearing, I got the whole wedding ceremony and the couple on the balcony, as well as "Fuck Off" written in the sand, which made another great picture to sell.

I didn't get the best pictures—the best stuff was shot by L.A. News, and they shot video—but I got the second-best pictures, and I had better marketing, so mine sold everywhere before the day was done. ✳ PHIL RAMEY

PRIVACY? WHAT PRIVACY?

THE PUBLIC LIVES OF PUBLIC FIGURES

LOOSE LIPS SINK MARRIAGES: Mick Jagger, 1992, kissing a woman who isn't Jerry Hall, his wife at the time. The photograph was taken around a pool in Beverly Hills a mile away from the camera. Jagger was in Los Angeles working at a recording studio; when his publicist got wind of the fact that the photographs had been taken, he offered to buy them out from photographer Phil Ramey. But Ramey had already made a deal with the British paper *News of the World,* known in the U.K. as *Screws of the World* because of its salacious content.

In this age of computer cookies, identity theft, and the Patriot Act, the idea of personal privacy may be as old-fashioned as chivalry, one of those concepts whose passing we recognize and mourn.

But if you find it offensive to have a Transportation Security Administration employee rummaging through the underwear in your overnight bag at the airport, imagine what it must be like to know that your every movement and activity will be recorded, every trip you take in your car will be followed. And even though airport security may not rifle through your underwear, because you're flying in a private plane, you'll surely be photographed purchasing it in a store on Rodeo Drive if the opportunity arises.

If you're an actor, professional athlete, or popular musician, this is part of the price you pay for success in your chosen career.

If you take a picture of a mailman, he has more rights to privacy because he's not a celebrity. Celebrities are paid to be famous. And once you're famous, it's like a faucet you can't turn off. RON GALELLA

Is it intolerable? Sometimes. Is it inevitable? Probably. Is it unfair? "Every celebrity knows, or should have known going into it, that he's going to be the focus of media attention" is the answer that Randy Bauer gives. "You don't take the career route that they've taken to say, 'You know, I'm going to have gold records and Oscar-winning movies, but no one's going to care about me.' It doesn't happen."

The attitude of the paparazzi toward the invasion of celebrities' privacy runs along several different lines:

- We don't care, we've got a job to do and money to earn.
- These people earn a ton of money because the public pays to see their movies or buy their music, therefore they're public property.
- Celebrities are quite happy to be photographed when they have a movie coming out.
- Celebrities bring it on themselves by behaving badly.
- We make celebrities more famous, therefore more successful.
- Celebrities actually like being photographed, but they pretend that they don't.
- Celebrities want you to photograph them when they're on the way up but not when they're stars.
- We don't care, we've got a job to do and money to earn.

THE GENIE AND THE BOTTLE

While *Us Weekly*'s Brittain Stone is skeptical of much of this reasoning, he agrees that when the genie is out of the bottle and you've become a public figure, only failure will return you to anonymity:

"I think that one of the beliefs in paparazziland, and it's sort of grumble, is that 'We're the street people, we're more blue collar; these people have all the money, and if they want to be famous, we're making them famous.' You can say that Julia Roberts deserves more privacy, but the truth is she's just not going to get it. It's not about merit; it's just pure market. Pictures of her are going to continue to sell, and she's going to continue to be followed no matter what she does until she becomes old and obscure or has a series of flops and nobody cares about her anymore.

"I also don't buy the whole 'celebrities misbehave, therefore we pursue them' justification, as if the photographers are a moral check

to their crazy, wild behavior. I think a lot of these people are being followed and watched because they're famous, not because they're scandalously famous. The kind of imagery that we at the magazine like isn't negative or scandal-filled. What drives us is sort of that slightly happy approach to the celebrities' normalcy, while at the same time, if they show up at a premiere, you have pure star worship. Our Golden Globes coverage is completely fun and not necessarily sycophantic, but it talks about these people as the celebrities they really are. Our attitude isn't that we want to see them misbehaving and that we want to take them down; it's not a negative thing but more a continuation of our slight idolatries."

Randy Bauer and Frank Griffin have found that there is very little market for photographs that display homosexual behavior, any kind of sexual perversity, or anything to do with drug use. The readers want to see the boyfriend-girlfriend-walking-down-the-street-holding-hands pictures. Although there are several actors who photographers know are gay, they don't "out" them, not because of the inherent good nature of the paparazzi but because the revealing pictures won't sell.

The National Enquirer, on the other hand, has always flourished on scandal rather than fan worship, so its approach to issues of privacy is somewhat different. Editor Barry Levine is of the opinion that the celebrities are usually the cause of the often unwanted attention that the magazine pays to them, and that if they behaved themselves there would be no story to follow. The consensus of opinion among the paparazzi is that the celebrities get the privacy they deserve, and that if you really don't want to be photographed, then you don't go to eat at Mr. Chows or The Ivy, where there are always photographers. The fact that Britney Spears or Justin Timberlake still do is regarded as a mixture of stupidity and complicity; in Jean-Paul Dousset's words, if you raise hell you will show hell also.

Furthermore, Levine thinks that the public has a right to know: "The fact is that the people who buy their records, who pay their ten dollars at the box office to see their movies or spend the night at home watching the television shows are interested in the private lives of these individuals and want to know who that person is behind the screen." He believes the reason for that interest is often more a case of identification than condemnation. The stories that do well in his tabloid are about the difficulties a celebrity is facing with alcohol, drugs, marital discord, or health problems—many of the same hurdles the readers themselves are facing. Here are celebrities who have a great deal of money but who still have the same pedestrian problems that everybody deals with. The condemnation doesn't arise when the celebrity is open about his problems, but rather when he denies them.

Surprisingly, Susan Sarandon, who has often been the figure in the paparazzi's lenses, agrees. She, too, sees some of her fellow celebrities thriving on the attention from these photographers: "There are ways to get married without people all over the place. Gwyneth Paltrow did it, and she's someone who has a huge paparazzi following. I think that a lot of celebrities flirt with it; it becomes an expectation."

Mustafa Khalili has what may be a unique justification for intruding into the lives of famous people: "When twelve-year-old children open the magazine and see these images of their idols looking so perfect and so beautiful, little do they know that the picture's been airbrushed and that's not how they really look. Those kids want to start looking like that and dedicating their whole lives to being like that, which is so destructive. The work of the paparazzi shows the other side of stars' lives—disheveled, hung over, tired, stressed, and so

PRETTY WOMAN, PRETTY POPULAR: Julia Roberts (opposite) in Manhattan. The very private actress suffered greatly from the intense press scrutiny that followed her Oscar-nominated role in the 1990 movie *Pretty Woman.*

OUR WOMAN IN HOLLYWOOD: Actress Susan Sarandon (below) at the Council of Fashion Designers of America awards, June 2004. Even though she's a strong supporter of freedom of the press, she believes the paparazzi often needlessly cause discomfort.

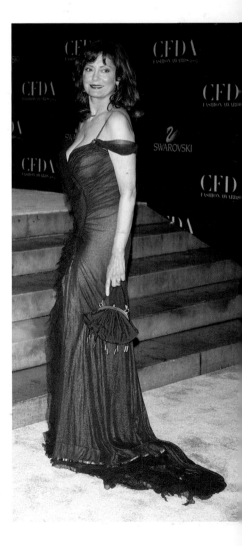

far from a state of perfection that any young person attempting to emulate their appearance would realize that they are in many ways ordinary people who just happen to lead extraordinary lives." Khalili thinks that the people who criticize him and his fellow photographers should consider the balance that their work brings to the way young people view the stars, and that this may help counter the bulimia and anorexia that many young people—women in particular—suffer as they attempt to emulate their heroes.

Britney Spears sells, no matter what she's doing, what she's wearing. STEVEN GINSBURG

Khalili's boss, Frank Griffin, thinks the work of the paparazzi also gives the reader an emotional balance against the grimmer stories in magazines and newspapers: "People were sick of seeing dead bodies and the Iraqis blown to smithereens. They'd seen all the gore and the gruesome stuff, and suddenly there's Britney Spears in a bikini sunbathing in Las Vegas. The *Star* zoomed in on that little pink crotch, and there were a thousand foxholes vibrating in the desert in Iraq when they got the newspapers."

REMEMBER THE KILLER TOMATOES

The relationship between the paparazzi and the celebrities is a complex one, not the least aspect of which is that the photographers sometimes wonder who's chasing whom. When someone as reclusive as Tom Cruise suddenly appears in public with a new girlfriend, having dinner at The Ivy and shopping on Rodeo Drive, you know, without consulting *Variety,* that a new movie of his is about to be released. There's a core group of Hollywood megastars who really don't want to be photographed or, more precisely, want to control the times when they are—Cruise and others such as Michael Douglas and Catherine Zeta Jones—and to get them without some cooperation on their part is virtually impossible. This double standard, including a markedly different attitude toward the paparazzi when the actor is on the way up and when he's an established star, is something the photographers have to accept, although it does drive them crazy.

Frank Griffin isn't immune to this frustration: "The celebrities create the monster and then they want to cage the beast. When George Clooney was doing *Return of the Killer Tomatoes* in 1988, he'd have jumped through hoops; he'd have done cartwheels without any knickers on all the way down Ventura Boulevard. But catch him kissing his girlfriend now and suddenly it's, 'What are we going to do about these people?'" His partner, Randy Bauer, suggests that an interesting exercise would be to look at the kind of publicity stunts in which those on today's A-list participated at the beginning of their careers; Brad Pitt on Malibu beach shirtless and posing in a pink bandana is a good example.

WHAT TO DO ABOUT THE KIDS

If there's one thing that most paparazzi agree is a problem, it's whether to photograph the children of celebrities. This doesn't mean they won't or don't; it means that they recognize it as an issue. Duncan Raban recounts an incident with Tom Cruise in London's Hyde Park, when he was photographing the star playing with his children on the swings. Cruise, spotting him shooting from behind a tree, approached him and asked him if he had children of his own. Raban replied that he did. "Well, would you like me to be

MORALE BOOSTER: Britney Spears and her bodyguard at the pool of The Palms in Las Vegas, April 2003. Agency owner Frank Griffin believes that photographs like this one provide readers with an emotional antidote to bloody images from the Iraq war. "We sold these pictures like you wouldn't believe," he says. "It's a real social necessity, a release, to have that lift of turning the page and seeing something like this."

doing this to them?" Cruise asked. "I told him that I wouldn't," the photographer replied, 'but that pictures of him as a dad were something that people really wanted to see. He said, 'Yes, but I'm over here with my children, just being me with my kids.' It really got to me, and I didn't do any pictures after that. But I had captured him as a normal guy with his kids. At the end of the day, we're all normal, and the sad thing about these superstars now is that it's so hard for them to be. Does the pap stuff makes them into bigger stars? I guess it does, but I really do genuinely feel sorry for them."

Steven Ginsburg holds the opposite view. His job is to take the most bankable pictures, and if a photograph of a celebrity with his child is going to sell better than one without, the case is closed. He was in Aspen one time when he overheard someone

There's nothing I won't shoot. Just not children. MUSTAFA KHALILI

on a cell phone say that she had just seen Bon Jovi in a ski shop. He and his partner ran to the store and saw the singer with his daughter some distance away. He got into position to shoot when Bon Jovi yelled at him to stop. The singer offered to be photographed—even to make a snow angel for them—if they would agree not to photograph his daughter. Ginsburg's partner agreed, but Ginsburg shot her anyway: "If you want to be a paparazzo, this is what we do. We're not in this job to make friends with them. It doesn't mean that you have to do it in a way where you're confrontational, but how can you shoot pictures that you know are worthless? You have a picture of Bon Jovi, let's say it's a thousand; you have a picture of Bon Jovi and his kid, let's say it's eight thousand. How can you play with that kind of money when that's what you do?"

In the end, even though he had taken the pictures, Ginsburg didn't put them on the market because of the commitment his partner had made.

Newborn babies are always in great demand for the magazines but are generally hidden from the lens of the paparazzo. Frank Griffin thinks this isn't the way to handle the interest that a major celebrity's new baby always arouses. He cites Sarah Jessica Parker as having done it the right way, by posing for a pack of assembled photographers as she left the hospital. He also points out that this kind of cooperation reduces not only the value of those pictures but of any that a photographer may subsequently try to take.

Brittain Stone has no clear-cut answer: "How do we respond to the issues around showing kids? It's probably something we don't torture ourselves with, partly because we don't really torture ourselves with any of this stuff, and that's one of the reasons we don't have relationships with a lot of celebrities anymore. We do things they don't think are right and they cut us off. But they're going to cut us off for some other reason anyway, so with the license that we have and the legality that we have, we go ahead. There are a lot of celebrities out there who display their kids—Angelina Jolie, for instance, drags hers all over the place—so because there's no clear-cut 'Oh, you can't show my kids' voice screaming at us all the time, we just ignore it."

Susan Sarandon, however, recalls an incident at Los Angeles International Airport that she found very upsetting, one that shows the distress that such activities can inflict upon the children:

"I was sitting by myself in an airplane going back to New York when Jane Curtin's daughter, who was an adolescent at the time, came on the plane hysterical because the paparazzi had been right in her face. Unfortunately, Jane had said something that had compounded it, and I ended up talking to this little

SUFFER THE CHILDREN:
Tom Cruise pushes his son in a stroller in Hyde Park while exercising on in-line skates, August 1995. In the market-driven world of the paparazzi, the children of celebrities are deemed to be fair game because there is so much demand for them. The photographers also point out that the celebrities themselves expose their children to publicity if it suits their purpose.

girl for a good hour, trying to calm her down. That's when it gets really upsetting, when your kids are affected. I just kind of accept it as something that just comes along with the territory, but when you're out with your kids and it goes on, and they follow you all over, and you think, Haven't they got a shot? Does it have to go on now for two hours so that the kids are actually distressed? that's when it bothers me. Otherwise I just put my glasses on and act very boring."

THE FULL FORCE OF THE LAW

In the United States, the laws that control whether or not a photograph can be taken and published revolve around two concepts: expectation of privacy and fair light. The first hypothesis is that if the subject of a photograph can reasonably expect privacy in a specific situation, such as inside his home, photographs of such situations cannot be published without permission. The idea behind fair light is that the photograph must not portray the subject in a way that is untrue—for instance, looking drunk if he's not. In the outcry after the death of Princess Diana, and the role that the paparazzi were thought to have played, the laws of privacy in both France and California were strengthened. The 1998 California law attempts to protect subjects from being photographed or recorded while "engaging in familial activity" if an act of trespass was committed to obtain such photographs or recordings. The law defines familial activities as including, but not limited to, "intimate details of the plaintiff's personal life, interactions with the plaintiff's family or significant others, or other aspects of plaintiff's private affairs or concerns." This law prevents the publication of such pictures in the United States by holding the publishers as well as the photographers accountable, but it can not prevent them from being printed in foreign magazines.

A June 2004 ruling by the European Court of Human Rights may also be rapidly closing these markets for photographs taken under such circumstances. Princess Caroline of Monaco brought a case to the court over the publication of photographs taken of her everyday life—her picking her children up from school, playing sports, going to the market. The ECHR ruled in her favor on the basis that, even though she is a public figure, the publication of these photographs did not contribute to "a debate of general interest." The court made a distinction between "reporting facts capable of contributing to a debate in a democratic society and "the reporting of details of the private life of an individual who does not exercise official functions." Thus, if photographs are printed purely for entertainment purposes rather than to advance public debate, they violate Article 8 of the European Convention on Human Rights, which pertains to respect for private and family life. This ruling could have a huge impact on the kinds of images that appear in European magazines, especially in the United Kingdom, one of the major markets for the work of the paparazzi.

It is unlikely that celebrity magazines will put up much of a fight if courts continue to issue adverse rulings. Barry Levine says that *The National Enquirer* will be as competitive and aggressive as any other publication, but not to the point where it risks having its reporters, both print and photographic, sued or jailed. "At the end of the day, we're talking about celebrity coverage, we're not talking about finding a cure for cancer."

SHOOT QUIETLY, THEN LEAVE: Sarah Jessica Parker and Matthew Broderick show off their baby son to waiting photographers as they exit Lenox Hill Hospital in New York, October 2002. By allowing limited access, the couple neutralized the intrusion of exclusive-seeking paparazzi and reduced the sales value of subsequent photographs.

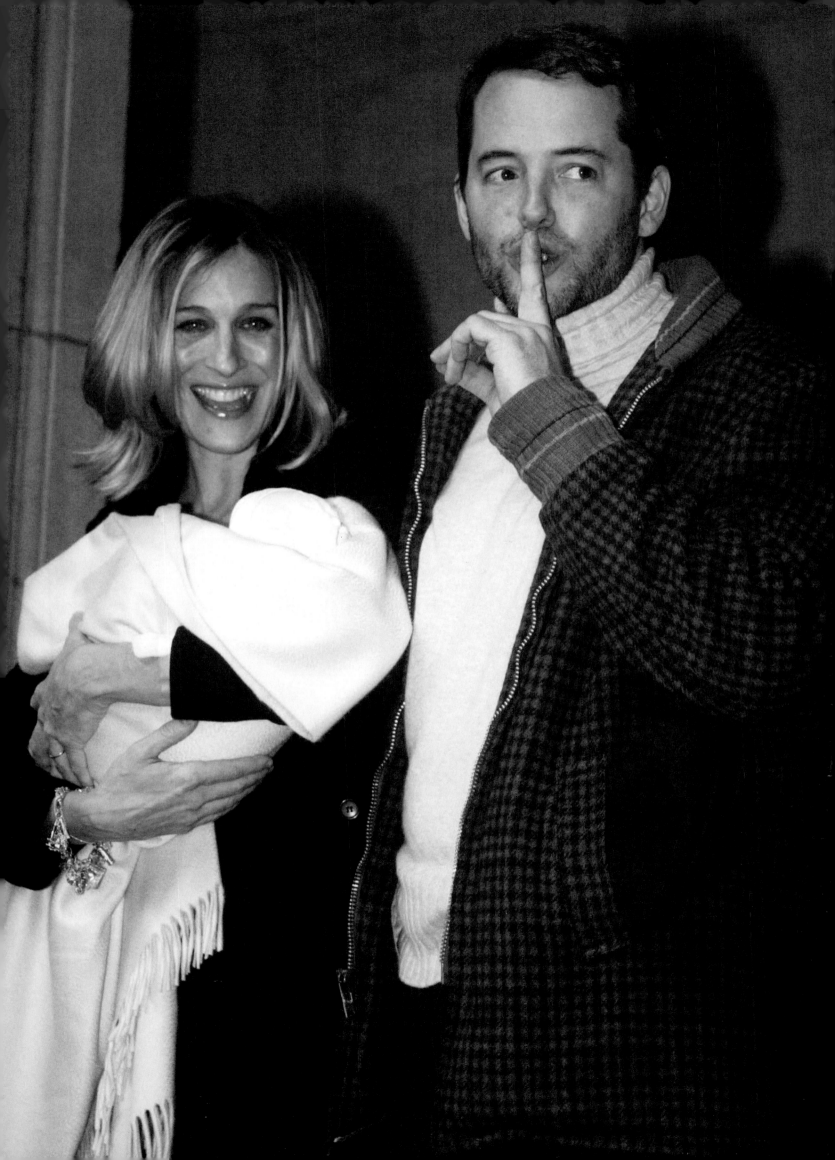

DEATH WILL NOT US PART

In 1990 Stefano Casiraghi, the second husband of Princess Caroline, was killed in a speedboat accident. I immediately went to Monaco to get pictures of the funeral; when I arrived at the church where it was to take place, I found about five hundred photographers confined to bleachers that had been set up outside. It would have been just another picture to shoot under those conditions, so I decided I had to get into the church. I was dressed completely in black and went to the main entrance, pretending that I had lost my invitation. There was such a mass of mourners trying to get in that I was pushed through in the crush. I had cut a hole in my tie and had a small camera hidden behind it that was operated by a cable release in my pocket.

As I moved to the front of the church where all the royals were seated, security and Caroline's personal bodyguards spotted me and tried to catch me, but luck was on my side. One of the mourners was a man called Amedeo d'Aosta, whose daughter's wedding I had photographed and who was the first cousin of Vittorio Emanuele di Savoia, an Italian aristrocrat. When he recognized me he said, "Massimo, what are you doing here?" and then he introduced me to di Savoia. There were hugs and kisses all around, the security men calmed down, and I managed to take photographs of the princess standing by her late husband's coffin. ✳ MASSIMO SESTINI

THE SAD PRINCESS

Princess Stephanie is prototypical Eurotrash. When she was living in Los Angeles, she was heavy on the party circuit, running around, playing around, having boyfriends. Then her sister Caroline's husband died in a violent boating accident, and Stephanie rushed back to Monaco in a typical scatterbrained, disheveled fashion. There were about a half a dozen crews and photographers staking out her house, and we followed her all the way to the airport; it was a merry chase. Her two French bodyguards covered her with a jacket as soon as they took her out of the vehicle, and then ran her through the airport until they got to the security gate, at which point the photographers couldn't go any farther. I bought a ticket that got me through security, leaving all my camera gear except for one point-and-shoot camera. I knew that they had her in the first-class lounge, and I was at the gate and separated by several hundred feet of moving walkway. Using my binoculars, I saw them come out of the lounge and then get on the walkway. There was no way I was going to be able to kamikaze her; there were two big bodyguards, so instead of walking down the walkway I let the walkway carry me. I leaned so that my back was positioned to them, so I was never facing them. The point-and-shoot had a wide-angle lens, and of course I had the strobe on. I knew from experience that I would only get one shot, because the strobe takes ninety seconds to recycle. I waited until we were practically on top of each other; there was only a distance of a couple of feet. They were still fearful of her being followed, and she was still buried up against the bodyguard. I waited until the position was exactly right, and without turning around I shot her. Of course they went ballistic, covered her up and ran, but I knew I had it. It was the quintessential tragic moment: She was disheveled, she'd been run through the airport, she was out of control, and the picture showed her emotion. ✳ PHIL RAMEY

THE THREE DIVAS

There are people the camera loves, and that love is rarely unrequited. And there have been no greater objects of its affection than Elizabeth Taylor, Jacqueline Kennedy Onassis, and Diana, Princess of Wales. Although to be a film star, first lady, or princess confers automatic glamour, these three transcended their roles to radiate an irresistible allure. Ask any photographer who shot them, and he'll tell you that photographing them was a two-way affair: They may have reacted at times with anger and frustration at the constant attention, but they all flirted with the camera and understood its power.

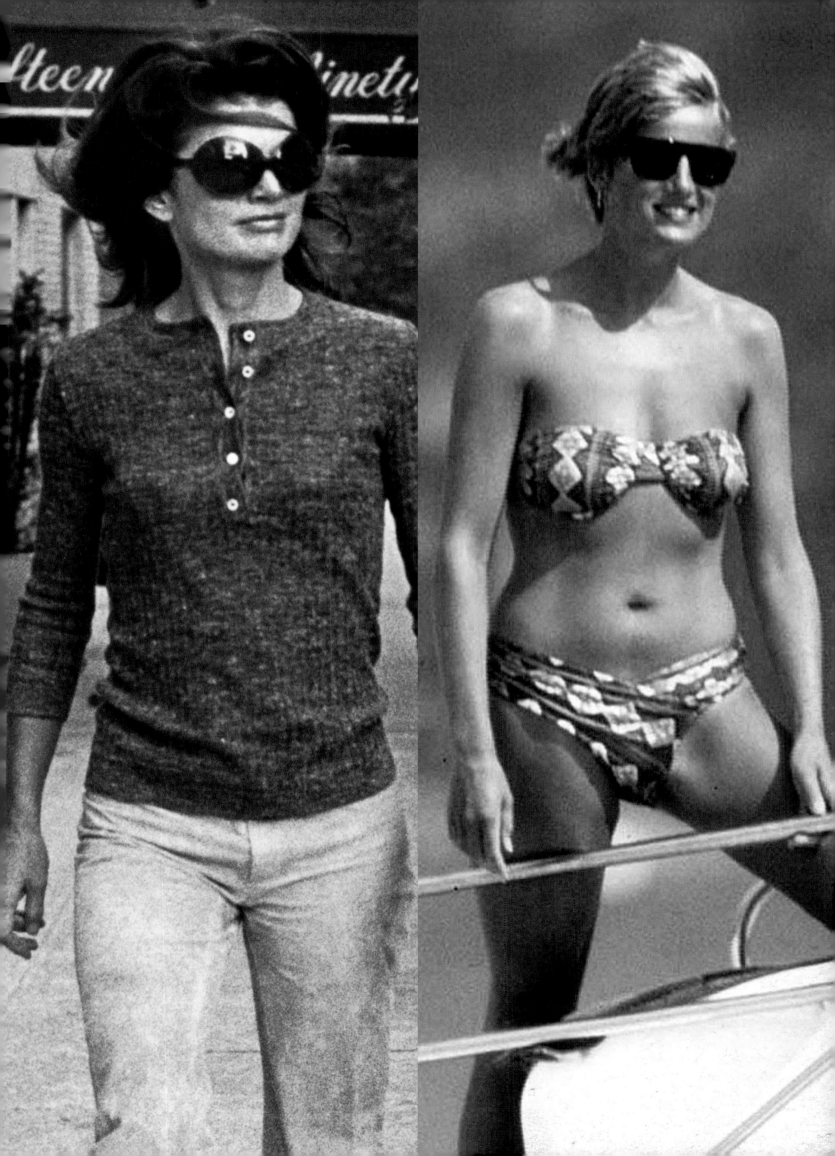

AROUND THE WORLD WITH LIZ

PHIL RAMEY ON ELIZABETH TAYLOR

LIKE GUM ON A SHOE:
Liz Taylor and Phil Ramey in
China during her global vacation,
1984. His refusal to go away,
and his persistence in following
her around Japan and China, paid
off with her cooperation in a
six-week exclusive, during which
time he shot twenty thousand
photographs of the star.

In 1984, Russ Turiak and I spent over a month and a half
staking out Elizabeth Taylor at the Betty Ford Clinic, which
resulted in my famous shot of her leaving with a parrot on her
arm. After that she vanished. I read in a gossip column that
she was going to take an around-the-world tour, but even with
the substantial sources of *The National Enquirer*, we could make
no headway. On the longest of long-shot possibilities—which
shows how little I had to do with my life in those days—we staked
endlessly staking out her house from an adjacent construction
lot. After a few days, I saw a limo pull up and thirty pieces
of luggage being loaded into it, if you can believe that. Instead of
waiting for Liz herself to leave, we decided the safest bet was
to follow the limo with the luggage.

When it stopped at the bottom of Sunset and Bel Air, I got out and banged on the driver's window to get him to open it; meanwhile we were in front of him blocking him from leaving. I told him I was from out of town and was trying to get to the airport. The driver was sympathetic for some reason, and he said, "I'm going to the airport—follow me." Before he pulled away, I looked in the back of the car and saw the luggage with tags that said Royal Viking, but it meant nothing to me.

We found out what airline she was taking and that she was going to Tokyo, so we just parked ourselves in the terminal like a couple of idiots. She showed up eventually—always late, always with people running around her. She was wearing a bright red dress and heavy gold rope chains. Her hair was frosted, so she didn't look like Liz Taylor. We made some nice full-lengths of her; she was reasonably accommodating. We shot her all the way to the ticket counter, just counting our money. I started to chat her up and asked her where she was going. "Well, I'm going around the world. I'm going to Tokyo," she said. I sent Russ back to L.A. with the film, and I decided to get on the plane with her. I was dressed like a semibum, with only two hundred dollars in my pocket, a passport, and a credit card, but I bought a ticket and boarded. Unbeknownst to me, because she was up front and of course I was in steerage, she was already complaining that I was on the plane.

When we landed in Tokyo, I tried to clear customs quickly because she was going to be escorted through and I had to follow her on the fly from the airport. I had no luggage, just the camera gear and the clothes on my back. I had no visa, either, thinking I could get one there, but the immigration guy said, "No, you have to have one before you enter the country; we'll have to put you under house detention." So there I was, detained at an airport hotel until the next day, when they offered me my choice of where I wanted to be deported to. We had figured out that Royal Viking was a cruise line and that Liz was going to leave Japan by boat, go to Korea, then land in China, so I got myself deported to Hong Kong. Through friends there, and by paying money to the right people, I managed to get myself not only a visa for Japan but an open thirty-day tourist visa for China not tied to any one itinerary, which was very hard to get in those days.

I ended up catching up with Liz in Nagasaki. By this time, Turiak had rejoined me, and we photographed her in one of the tramway cars that traverse the city. She went bonkers and tried to prevent us from getting in it. The next day we found out that her boat was sailing from Kobe, so I rustled up some money from one of the American tabloids—about twelve grand—to buy a first-class ticket. We had followed her right up the gangway; the people at Royal Viking thought we were with her. She screamed when she saw us getting on the boat, so I went to buy a ticket, but even though they had space they wouldn't sell me one because she had made such a stink. We managed to walk right into her stateroom anyway and photograph it before we left.

We flew into Beijing and checked into the hotel where we'd found out she was going to stay. The seaport town where she was coming in was eight or ten hours from Beijing, and in those days you didn't just go to Avis, get a car, and drive. You had to have an interpreter and a driver with a special permit to leave the city. But by paying some money and doing what we needed to do, we got the car, a nice big Fiat. When we got to the seaport, the Chinese cultural affairs minister was there with about a hundred kids singing to welcome Liz. He assumed, and we let him continue to assume, that we were there to cover her

A FIRST-CLASS ROMANCE:
Liz Taylor and her boyfriend at the time, Mexican lawyer Victor Luna, relaxing in their first-class seats during one of the plane trips on their global vacation. Although Ramey didn't shoot typical paparazzi photographs on this trip, he needed a paparazzo's tenacity and resourcefulness to convince the actress to allow him to accompany her.

arrival. Nobody in China, apart from the government people, knew who Elizabeth Taylor was; her movies hadn't been shown there since before the revolution. We were wearing stupid little coolie hats that we'd bought from the kids, and as she came down the gangway there we were, getting her first step in China. She went from smiling at everybody to seeing us and the flashes going off, and her jaw just dropped.

Her boyfriend, Victor Luna, a Mexican lawyer, was a real class act, perhaps the nicest boyfriend she ever had. He took a liking to us and tried to calm her down a bit; she was having one of her typical little hissy fits. The government had prepared a railway car for her, which she refused to take, because she said traveling by train made her sick. Then she pointed to our chauffeured Fiat and said, "Isn't that my car?" A government official replied, "Oh, no, Miss Taylor, that came from Beijing. We can get you a car like it, but it will take twenty-four hours." She said, "I want to take that car," at which point he had to let her know that it was our car. So hi ho, hi ho, it's off to work we go—what it came down to was that if she wanted to go to Beijing in a car, she had to ride in ours. It was a bit cramped even though her luggage went separately, but that's what we did. There wasn't a lot of small talk, although Victor kept trying to make some. When we got to the hotel, I said, "You're on the tenth floor," and she said, "Why did I figure that you would know that?" and I said, "Because I'm on the tenth floor, too."

Meanwhile, we didn't have any time; this was before digital, so we were shooting film and had to haul our ass to the Associated Press office, which didn't even know that she was there, the dumb bastards. We had contracts with two major London newspapers and wired five pictures to each of them, which took all night. We got back to the hotel at about five in the morning, and at about eight or nine Turiak got a phone call—Liz Taylor inviting us to go see the Great Wall of China with her. I nearly died. I thought it was a dream. We dragged ourselves up, not knowing what we later knew—that if you're supposed to go see the Great Wall of China at eleven with Liz Taylor, she'll never be there before one. She once kept the king and queen of Thailand waiting for lunch for an hour and a half. But the wait was worth it—the Great Wall is spectacular, even if you climb it backwards with forty pounds of camera gear. Unfortunately, the blunderers from the wire service showed up as well. They made a few frames, but they were no competition.

We stayed with Liz for the whole trip, which took six weeks, from China to Hong Kong to Taiwan to Bangkok to India to Switzerland. It was day after day of great exclusive pictures in a million different places. I think I shot twenty-two thousand chromes. I had to literally force myself to keep putting more and more film in the camera, because I knew it was the opportunity of a lifetime. It was like shoving grain down a foie gras duck's gullet. I shot and shot and shot and shot. We heard lots of war stories from Liz and produced some phenomenal pictures.

JEWEL OF INDIA: Phil Ramey says of this photograph, "It was taken in India, about a month into the trip. It's perfectly backlit, radiant, properly exposed, with Liz just walking toward me, smiling. The backlight makes her hair glow, and *she's* glowing. It's a non-paparazzi picture, but paparazzi is often just a catchall phrase. Paparazzi is any picture you take the initiative to shoot, whether it's discreet or indiscreet, whether it's secret or not. Any picture you take on the fly—that's probably a better definition."

AN *OBSESSION* CALLED JACKIE

RON GALELLA ON JACQUELINE KENNEDY ONASSIS

CUT TO FIT: One of Ron Galella's contact sheets of the person he describes as his Mona Lisa—Jacqueline Onassis. Because the paparazzi have so little control over the circumstances under which they shoot, the art of cropping is a vital tool in their skill set. Galella's famous photograph of Jackie on page 117 is shown here in its full frame on the left-hand side of the contact sheet, with Galella's crop marks.

Because she wasn't cooperative and she didn't pose or stop, for me Jackie was an ideal subject. I like people like that; I like motion. To me it's life. Life is moving, and Jackie moved. She did things—went to the ballet, jogged, went to the theater. She was active, an ideal subject for a photographer who wants to capture the essence of human emotions and expressions.

Her glamour was a mystery. Most stars aren't mysteries; they expose everything. Celebrities sort of pull out their souls, leaving little to the imagination. Jackie was soft-spoken, but she was very alive. She created an aura, a mystery that drew me to her and made me want to capture it on film. The first time I shot her was at the Wildenstein Gallery on Madison Avenue in New York in 1967. It was impossible to get pictures at the gallery because

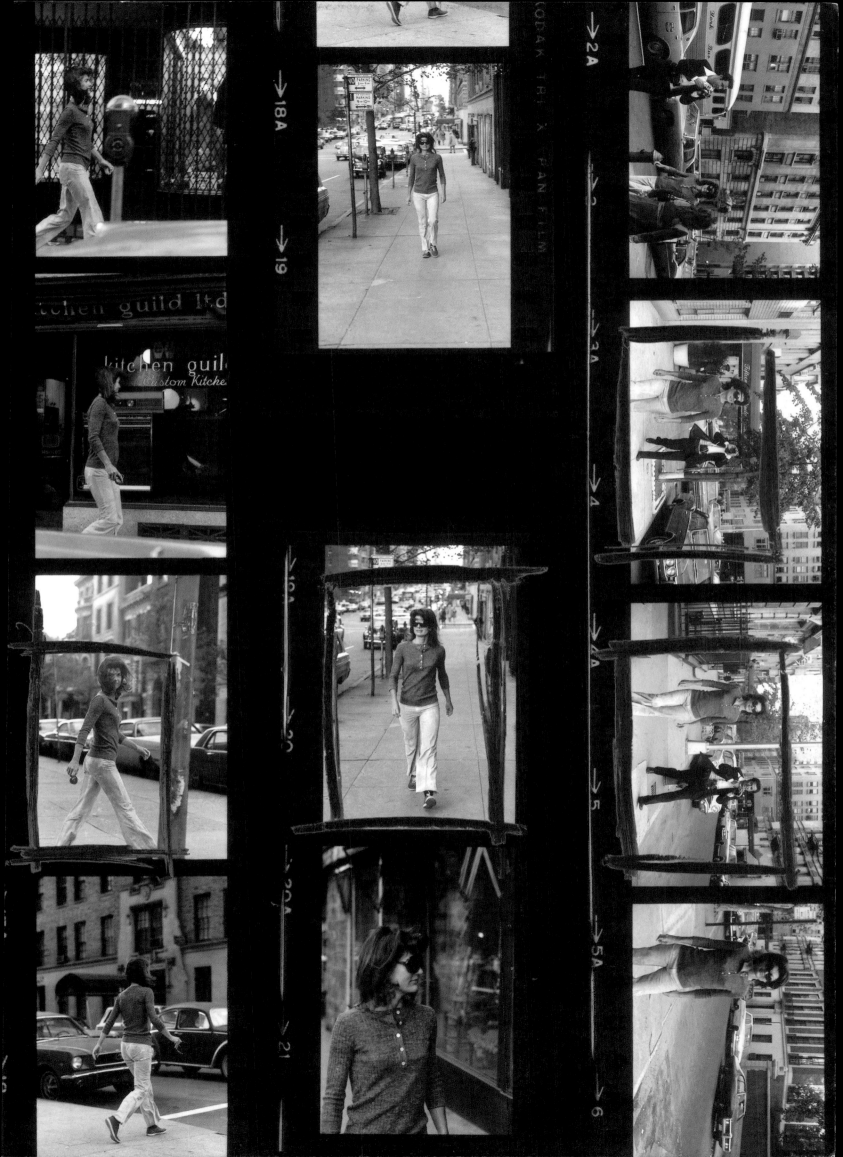

it was too crowded, so I waited for her to come outside to get into her limousine, and at that point I got her. Then one of the other photographers said, "Let's go to her apartment," and there we got nice clean shots with nobody in the way. Once I learned where she lived, it was easy pickings. You just had to stake out at the right times, like six-thirty to eight—dinnertime, ballet time. That's when I started photographing her regularly.

In December of the same year, I crashed a $500-a-plate benefit dinner at the Plaza Hotel. I waited until after the dinner, when people loosened up and it was easier to get in. I got Ted Kennedy with Robert Kennedy, and I got Jackie with Averell Harriman as he escorted her out. My first picture published in *Newsweek* was a head shot of Jackie at this event; it made me realize what a market there was for her, and in 1968 I started photographing her more frequently when she was in New York. It was easy—I'd wait for her in my car or across the street on a park bench. Another factor in my favor was that when I followed her, the driver would have to go up Madison Avenue, make a left on Eighty-sixth Street, and come around—that made two lights where he might have to stop. I was on foot, so I could make a left on Eighty-fifth and get to the corner before the limousine and wait for her. I got a lot of pictures from that corner, and also right in front of the apartment house. This went on from 1968 to the first court battle, which was at the beginning of 1972.

What happened was that I photographed Jackie and John Jr. coming down the pedestrian trail on their bikes in Central Park, right across from their apartment house. Acting on a tip from the doorman of the building next door to hers, I went up the hill and saw them a distance away. I ran and hid in the bushes, behind a tree, and as they came towards me I got a couple of good shots of them on their bikes. They never knew I was there until I came out of the bushes. "Oh, it's you again," Jackie said to me. I was taking a few more shots when suddenly a Secret Service agent came from behind and said, "You had enough?" "Smash his camera," Jackie said to him, but he didn't.

I started to walk very fast to my car, but she got the attention of the head of the detail, John Walsh, and another agent, James Kalafatis, and they ran after me, caught up to me, and demanded the film. Naturally I said no and proceeded to put it in the trunk of my car. Walsh said, "She's breaking my balls. If you give me the film, I'll let you go." I said, "The pictures aren't good—they were down the hill too far away," but he put me in his car and took me to the police station, the nineteenth precinct on Fifty-seventh Street. Kalafatis kept me in the car while Walsh went in to see what they could arrest me for. The film was still in the trunk of my car, and I was worried that the car might be towed. I said to Kalafatis, "If you're going to arrest me, why don't you take me in and get it over with." He told me to wait, but as I went to open the door, he said, "Okay, let's go in." Walsh was with a detective, trying to find out what they could get on me; in the end, they gave me a summons for harassment; that was the first court thing I had to answer. At the hearing, the agents were there but no Jackie, and the judge said, "Mr. Galella's a celebrity photographer and she's a celebrity. There's nothing wrong—dismiss the case." But he did say that Jackie should pay my lawyer's fee, which was about $500. I billed her for it, but she never responded.

There were a lot of small incidents where I was pushed around and Secret Service agents were getting in my way—crazy stuff. They knew who I was; I had a police press card. They would block me,

MONA LISA ON MADISON AVENUE: One of the most beautiful pictures ever taken of Jacqueline Kennedy Onassis. For once, photographer Ron Galella was able to catch her outdoors in New York without the ever-present sunglasses that she used to hide behind, and for once, she turned toward the sound of his camera, not away from it as was her wont.

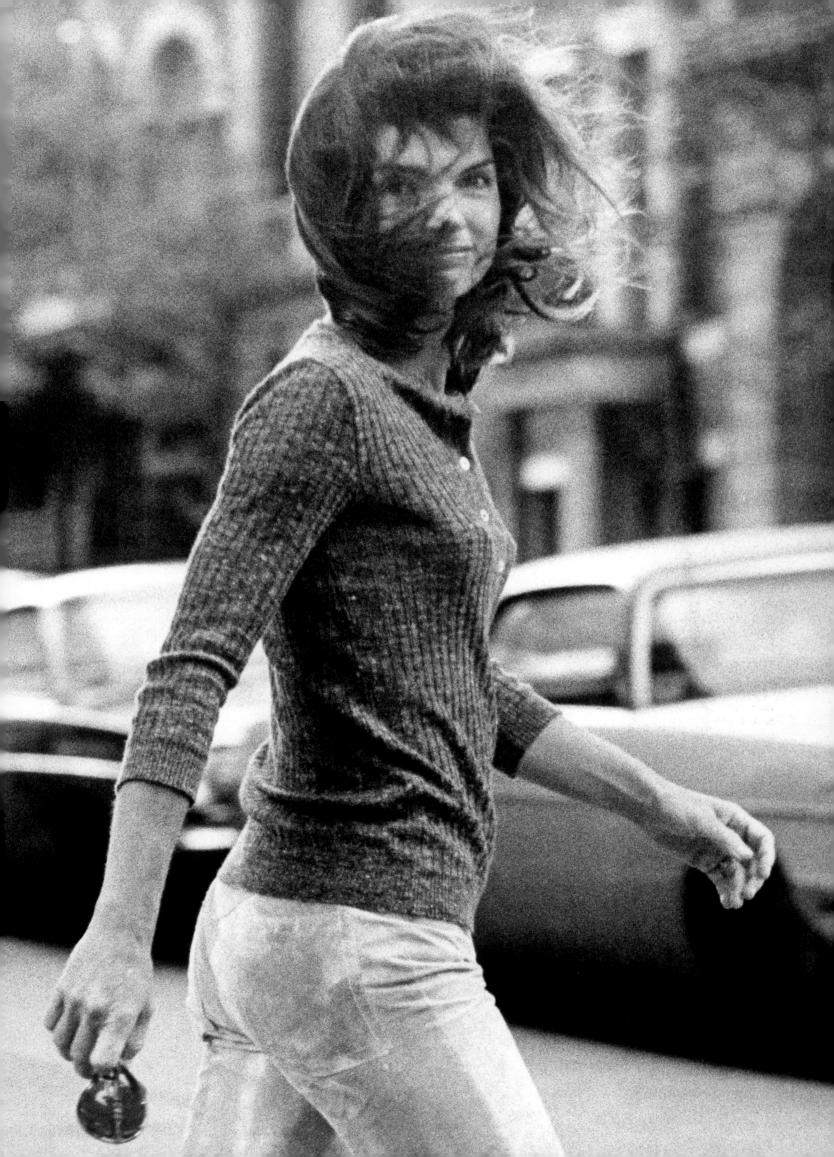

yet let strangers on the sidewalks pass by. She was after me because I was photographing her children. She was a very protective mother, trying to keep them private and normal. That's why she resented me—not for running pictures of her, but of her children.

It got so bad towards the end of 1971 that I sued her for interfering with my livelihood. I also sued the three agents—Walsh, Kalafatis, and I think Connolly; I thought she would settle out of court. Aristotle Onassis talked to me about the lawsuit one night. Generally, when they returned to the apartment from an evening out, she would run inside and he would go for a walk. He would talk to me—he was very nice and friendly. He liked the paparazzi and he liked publicity. "I hear you're suing my wife," he said. He suggested that we could settle this for a couple of thousand dollars out of court. My lawyer thought we should ask for five or ten thousand dollars. But Jackie was strong-willed; she went to court and countersued for invasion of privacy and harassment. If it wasn't for Ari's fortune, I don't think she would have sued, because she was very tight with money. The trial lasted twenty-six days, and she was there for twenty of them. She testified, as did Caroline, but not John. The judge was Irving Ben Cooper, who had been appointed by President Kennedy. He shouldn't have heard the case, but he didn't want to recuse himself, so for me it was a no-win situation. He threw everything at me: I couldn't go within a hundred yards of Jackie's apartment; I couldn't photograph her closer than fifty yards and the children seventy yards. My lawyers appealed, but during the three-year appeal process I couldn't photograph them. In 1973, when the decision came down from the judges in the appellate division, two were in my favor and one was against. The outcome

was that I could photograph Jackie from twenty-five feet and the kids from thirty feet, with no restriction of the apartment.

I resumed photographing her, and what I found out was that twenty-five feet is too far in situations such as at the theater because people get in the way, so I started breaking the injunction, feeling her out. She didn't seem to mind; I got as close as five feet at a party at the Carlyle Hotel, and she was even smiling for the camera. But then I photographed her at Martha's Vineyard with Maurice Tempelsman, whom she was dating at the time. They went out on a boat in [Long Island] Sound off the Vineyard; my wife, Betty, who was also a photographer, and I hired our own boat so that we could photograph them. The distance was much more than twenty-five feet; it was all long-lens stuff, but they knew I was on the boat. They reported me to the coast guard, which escorted us back and issued a summons to the boat owner for something stupid like his bell not working.

The pictures of Jackie and Tempelsman in the boat were published all over the world. Tempelsman didn't like the publicity, so he got back at me: One night in the fall of 1981, about a month after the Martha's Vineyard incident, I photographed the two of them at the Winter Garden Theater. They separated going in and coming out, so I followed her, figuring that I might eventually get them together, because that was the shot that would sell. Tempelsman took Jackie to the same Fifty-seventh Street police station, and I knew there was trouble. He told Jackie to press charges on the grounds that I broke the injunction of twenty-five feet. This resulted in a second court trial in May 1982, and there was no question that I was guilty. I brought a stack of about two hundred pictures to court to show the judge that sometimes she didn't mind and was smiling for my camera. I also pleaded that twenty-five feet wasn't practical for me to shoot with obstacles in the way. Once again Irving Ben Cooper was the judge; by now he was in his nineties, and naturally he was against me. I was facing a fine of $120,000 and seven years in jail, so I said I was willing to give up photographing Jackie and the children for the rest of their lives to get out of this. My lawyers and her lawyers agreed to that, and to a $5,000 fine, but the judge said to make it $10,000. I paid the fine and never photographed her or Caroline again. John was an exception. I applied for credentials to a press conference in New York for the launch of his magazine, George, stating that I need written permission in order to be able to shoot. He agreed, and I photographed him for the first time since the second trial.

I think Jackie liked being a challenge for me. One night at the "21" Club with Ari, she grabbed me by the wrist and pinned me with an elbow against her limousine. "You've been hunting me for three months now," she said, but she didn't protest in anger; I think she liked being pursued. She was my favorite subject of all time. When a star stops and poses, you take the picture, say thank you and good-bye, and that's the end. With Jackie there was no end, until the court said so. In a way she did me a favor, because now I could have a more balanced life. It was an obsession. Not a sexual obsession; it was more an obsession with photography.

I WANT TO BE ALONE: The fiercely private Jackie entering her Manhattan apartment building, literally covered from head to toe. Galella always claimed that the lady protested too loudly, and that she didn't mind being the object of his attention as she pretended. But she did protest enough to get a court order that ultimately ended the photographer's pursuit of her.

THE DIANA FACTOR

LIFE AND DEATH UNDER THE LENS

A PRINCESS AT PEACE:
A pensive Diana on the yacht *Jonikal,* in which she and her lover, Dodi al-Fayed, were cruising the Mediterranean, at Portofino, Italy, August 1997. The luxury vessel belonged to Fayed's father, the multimillionaire owner of Harrods department store in London, Mohammed al-Fayed. After a ten-day vacation, and partly because of the constant press attention, the couple left the yacht club and went to Paris, where they were to meet their tragic end.

On August 31, 1997, at four o'clock in the morning, Diana, Princess of Wales, died in a Paris hospital of injuries she sustained when the Mercedes in which she was traveling crashed at high speed in a narrow tunnel. First reports indicated that photographers on motorbikes and scooters were pursuing the car, and the police immediately arrested seven of those alleged to be part of the chase. Eyewitnesses at the scene claimed that at least one photographer was taking photographs of the wreck shortly after the crash.

The tragedy unleashed a flood of grief and a backlash against the paparazzi. Even news photographers were assaulted while shooting pictures of the mountain of flowers left outside the princess's residence and Buckingham Palace. Celebrities in the

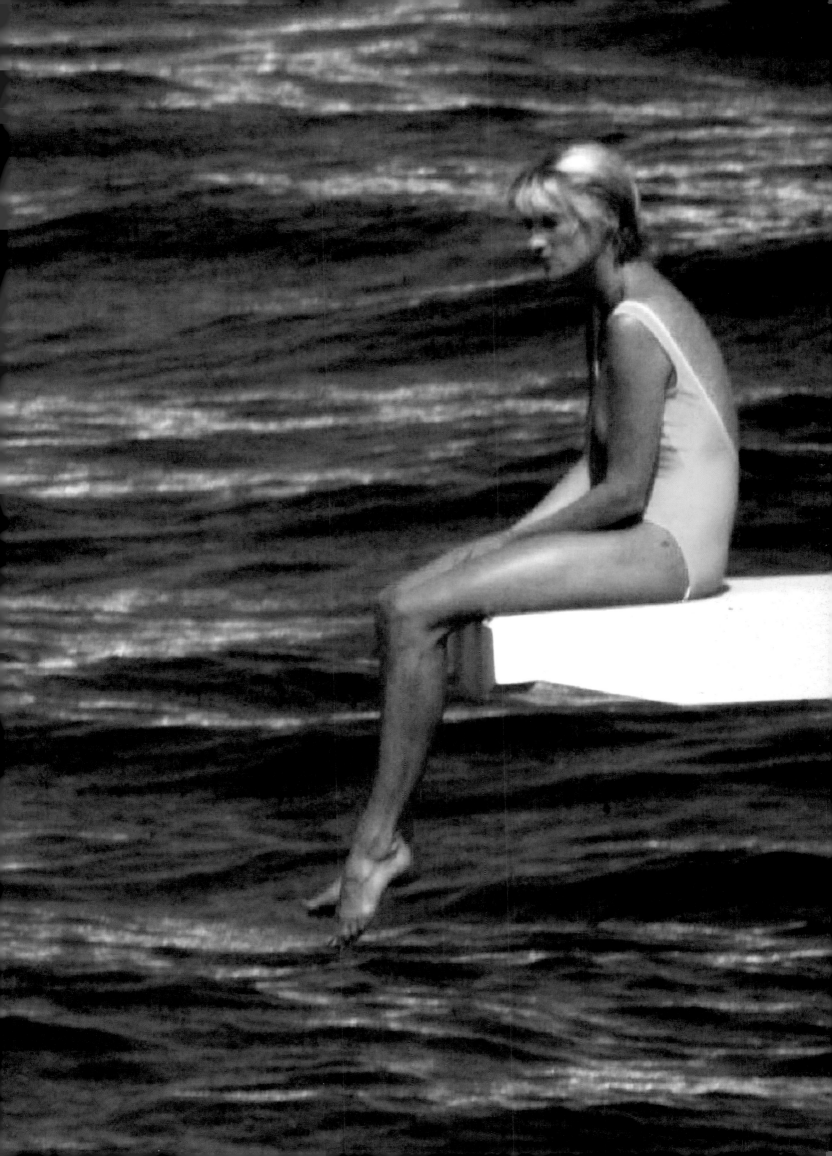

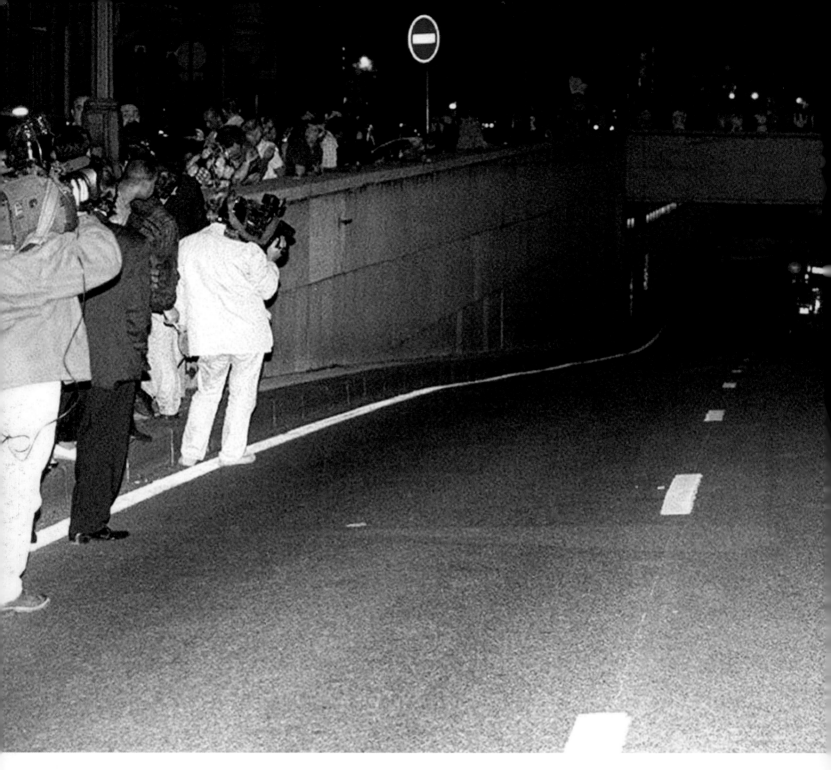

United States immediately condemned the activities of the paparazzi and called for stronger laws to protect the famous from aggressively intrusive practices.

Since then the picture has changed somewhat. The autopsy of the driver of the car revealed a blood alcohol level three times that permitted under French law. He was also taking medication to combat depression and alcoholism. Anecdotal evidence suggests that he had been drinking for hours before taking the wheel of the doomed car. Furthermore, the photographers who were alleged to be chasing the princess were not all paparazzi. Some of them were regular news photographers, at least one of whom had distinguished himself in coverage of dangerous combat zones. Criminal cases against them brought by the French government, as well as a civil case filed by Mohammed al-Fayed, the father of Diana's companion, Dodi, were all dismissed.

Even today, however, most people still bring up the subject of Diana's death when the word *paparazzi* is mentioned, and most still blame the photographers for it. The two immediate results of the

incident were a temporary collapse in the market for paparazzi photography and the introduction of new privacy laws in California and France.

"To me, Diana's death didn't really matter on a personal level; it was just unfortunate," says Phil Ramey. "From a business point of view, it wiped out the market; we took a beating as long as two years. It radically shifted across the board for any kind of intrusive pictures. It created problems, some of which we live with to this day. You couldn't replace Diana in the U.K. market and endlessly go to the Caribbean after her with an open budget, and thirty guys on one island! We lost pages and pages that we can't replace.

"The constitutionality of the antipaparazzi laws that were enacted afterwards has never been tested, either by the conventional or the unconventional media. The *Enquirer*, under its old leadership, was prepared to contest it but never did. Being actionable for certain activities will stop you from doing a certain amount of things. It certainly put a crimp in it in the state of California."

TUNNEL OF NO RETURN:
The Alma tunnel in Paris following the fatal crash. The accident has inspired a host of conspiracy theories: Fayed's father believes the couple was murdered by unknown agents of the British royal family or government; ten months before the crash, Diana supposedly predicted that it would occur; witnesses claim to have seen a white Fiat there immediately after the incident, and flakes of paint used on Fiats were found at the scene, but the car has never been found.

THE FINAL DAYS: Fayed and Diana during a walk in the French Riviera resort of Saint-Tropez a few days before their deaths. There was speculation that Diana was pregnant by Fayed, but the autopsy by French authorities disproved the possibility.

That there were photographs taken of the crash is unsurprising, given that news photographers are trained to photograph such events, irrespective of who the victim is. The fact that the more graphic of them have never been published can certainly be viewed as proof that the editorial filters are working; the closest they came to public distribution was when the CBS program *48 Hours* showed photocopies that were attached to French evidence files.

Brittain Stone thinks that the effect of Diana's death was felt more by the traditional news agencies than the new businesses that specialize in the work of the paparazzi, because in a declining market for news photography, the older businesses made up lost revenue through the constant demand for pictures of her.

MANIPULATION AND MAYHEM

Agency owner Frank Griffin sees a more sinister undercurrent as a contributing factor in the accident:

"There was the initial response from the people like George Clooney who blamed the photographers for her death without looking deeper into it. I did eight hours of radio that night, rather than TV, because I wouldn't go on camera. I talked to some of the guys who were there in France; the lessons to be learned from that tragedy were 'Wear a seat belt and don't be driven by a drunken drug-taking driver at a hundred miles an hour on the Périphérique.' I've driven the Périphérique, and it ain't easy at the best of times. Also, if you don't want to be seen, don't go to the Ritz Carlton. Diana had an agenda that week; she knew that Charles was going to go out in public with Camilla Parker Bowles, and she just wanted to steal her thunder. First of all, she allowed herself to be photographed sitting on Dodi al-Fayed's boat—there was that beautiful picture of the seagull, and she's sitting on the bow pulpit. Secondly, everybody knew where she was going. So you look behind the facts: She wasn't pregnant; the driver was drunk; and she wasn't wearing a seat belt—the only guy who lived was the bodyguard, and he was.

"The celebrities used her death as a massive excuse. It was just before I joined up with Randy [Bauer]; I discussed the situation with my partner at the time, and we decided to go after the B-list girls and boys who were cute and good looking, and try to make very happy stories that counterbalanced her death."

Certainly anyone who covered Princess Diana during the height of her fame will tell you that she had an ambivalent attitude to the press, and to photographers in particular. She became very adept at using her power with them to advance her own agendas. "Diana used the press," says Phil Ramey. "Not in the beginning, not even in the middle period. She only became sophisticated later on. I hear from all my friends in the British press that in the end she was quite good at it; she learned."

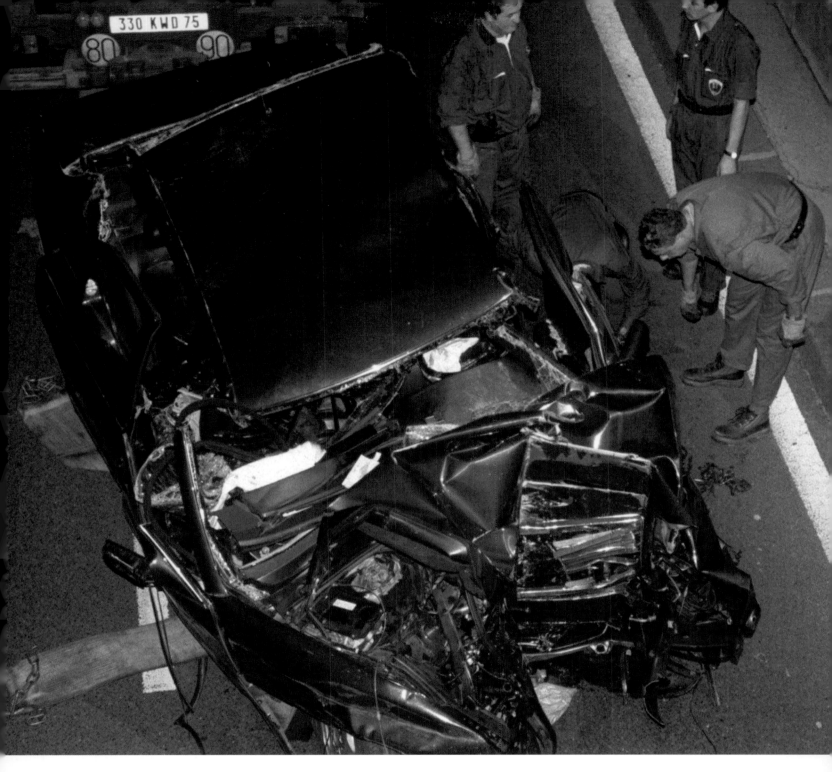

THE BENEFITS OF NOT BEING BRITISH

Non-British photographers such as Jean-Paul Dousset often had an easier time trailing Diana because they knew there would be no reverberations from Buckingham Palace:

"We started shooting Diana with the British bunch when she was on vacation. It was quite fun, actually, because it was a kind of hide-and-seek situation. To give you an example, she would start out staying at Vaduz Castle in Liechtenstein, then leave in a different car, and we would have to guess whether she was going to Saint Moritz or to a lake in Austria. The British—I'm speaking about Buckingham Palace, the Firm—couldn't blackmail us, because we were the 'dirty French photographers,' and we could do the good stories. British photographers were much more manipulated than we were because the palace had

CLEARING THE WRECK:
Police prepare to remove the remains of the Mercedes in which Princess Diana and Dodi al-Fayed died on the morning of August 31, 1997. It took two years for the French authorities to completely clear the photographers of any involvement in the crash.

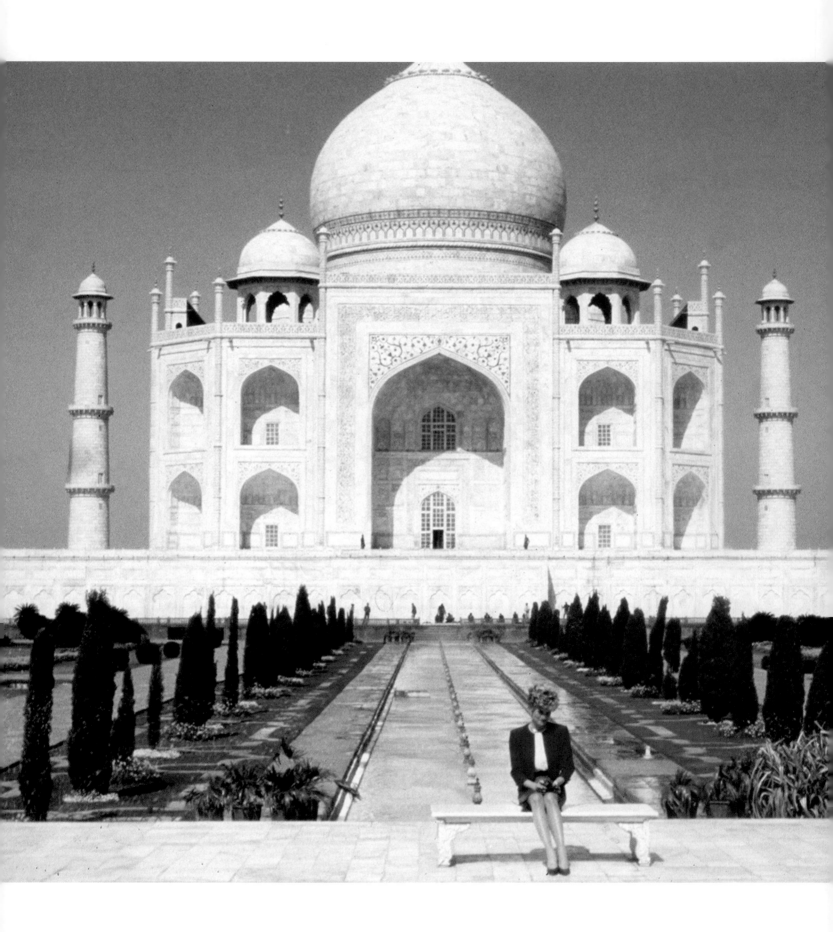

leverage on them. Both Diana and Sarah liked photographers. Lots of Sarah's friends pointed us out, and she knew perfectly who we were, that we were the photographers who had done the toe-sucking pictures, but she was intelligent enough not to mind. With Di, she made us feel that she minded when [being photographed] didn't serve her purpose. She used us in that way. If she wanted to be glamorous or pleasant because it annoyed somebody else in the family, she would do it; if not, she would be unpleasant."

DINNER OR DIANA

Pressure from the palace didn't, of course, prevent the British paparazzi from following her whenever possible, and for a photographer as determined as Duncan Raban, that was almost anytime she left the royal apartments. On one occasion, he even gave up dinner with the Rolling Stones in Ireland in order to pursue her:

"It was around five or six in the evening, and either Keith or Ron said to me, 'Do you want to stay the night and have some dinner with us?' Just as I was thinking that you don't get to have dinner with the Rolling Stones too often, my mobile rang; it was a taxi driver who often gives me tips. He said he'd heard that Diana was going to be at a go-cart track with her kids down in Kent the following day. I thought, Do I want to get up early in the morning and try and do some pictures of her and her kids or do I want to stay with the Rolling Stones? I sat there for about fifteen minutes trying to decide what to do; the last flight was in an hour and a half.

"I decided to go home, and I got down to the go-cart track at four in the morning and hid in the woods. As it turned out, I wasn't alone; there were about four or five other photographers. When the royal protection squad arrived, they found all of us and threw us out. The others seemed content to do what they were told, but I just slipped off, pretending that I was leaving. It was still early in the morning, before Diana turned up. The go-cart track was in a small natural crater with chalk walls, and around the edge of the crater were trees. One huge tree had fallen over, and it was sticking out about twenty or thirty feet over the edge. I climbed out on it and just hung on, for maybe three hours. I shot the whole thing of her and the kids on the track with an 800 lens; I got about fifteen or sixteen pages in *Hello!* out of it. It's a bit like an animal looking for its prey, isn't it?"

PRINCE AND PRINCESS BOTH GONE

Had she lived longer, there's no doubt that interest in Diana would have continued. She had a quality about her that not only appeals to the general public but that the camera adores. There are very few bad pictures of Diana, and in her way she wasn't unlike Jacqueline Kennedy Onassis, but for Barry Levine the closer comparison is to Jackie's son: "The two greatest celebrities that have generated the most interest, Princess Diana and JFK Junior, were both sadly taken from us well before their time, and their deaths have hurt the tabloid culture, because they would have continued to generate reams and reams of stories."

For Susan Sarandon, however, Diana's untimely death was an example of what not to do when under the pressure of the public obsession: "The thing with Diana was really shocking, but then again I think you have to set your own pace. That was an example of allowing a situation to get you into as much of a crazy place as they were. Where are you going to go in a speeding car?"

THE LONELY PRINCESS:
In 1992, during the much-publicized breakup of her marriage to Prince Charles, Diana allowed herself to be photographed in a sadly wistful pose in front of the Taj Mahal, a mausoleum the emperor Shah Jahan built to the memory of his wife and inseparable companion, Mumtaz Mahal. The symbolism of the princess by herself in front of a monument to eternal love was not lost on Diana.

HOW MUCH FOR THE ONE OF HIM DRUNK?

THE EDITORS AND THEIR CHECKBOOKS

DRUNK LIKE US: Although there's no doubt that Harrison Ford would have preferred not to see these pictures on the front page of *The National Enquirer*, they do have the benefit of increasing reader identification with him. The single quality that readers dislike most in their idols is aloofness; whatever else the actor may be in these pictures, aloof he's not.

These are the best of times for the paparazzi. Our increasing and seemingly unending fascination with celebrity has fueled a surge in the publication of magazines devoted to the subject. While the established tabloids, such as *The National Enquirer*, still successfully purvey their traditional mixture of shock and scandal, the emergence of a revitalized *Us Weekly*, as well as other products such as *In Touch*, *Hello!* (the U.K. version of the Spanish *¡Hola!*), along with *OK!* (it seems to help a celebrity magazine to have an exclamation mark in its title!) and another Brit publication, *Heat*, makes this a seller's market. Many have taken the format of the now thirty-year-old *People* magazine and extended it to suit the contemporary market.

SCOTT TOLD ME HE PLANNED TO KILL LACI

ELIZABETH SMART Her NEW torment

THE NATIONAL ENQUIRER

America's Newspaper

www.nationalenquirer.com

FEBRUARY 3, 2004

HARRISON FORD's WILD BINGE!
— AFTER $85 MILLION DIVORCE DEAL

The women, the booze & the nights without Calista

MORE SHOCKING PHOTOS INSIDE!

$2.35 US / $2.89 Canada

0 71658 51026 5

05>

UNDER THE COVERS:
Because of the nature of their content, tabloids have a harder time getting advertisers than do other kinds of publications. This makes newsstand sales vital to their profitability and increases the importance of the images on their front pages. *The National Enquirer* with Elvis in his open coffin sold over seven million copies, still its largest sale of any single issue.

They have, in effect, replaced the old, much more respectful, fan magazines of the 1930s and 1940s, moving from being inside promoters to outside enthusiasts—fan magazines with attitude. *People* alone has spun off two alternative versions: *Teen People* focuses on teenage obsession, and *People en Español* caters to the strengthening Hispanic market. The elderly tabloid *Star* has also been given the editorial equivalent of a face-lift and liposuction by former *Us Weekly* editor Bonnie Fuller and is now prepared to compete with its younger rivals.

Supplying illustrations for these magazines is a huge business, and the market—you and I—governs not only which celebrities are photographed, but also how and when their photographs are taken. This is where the differences between the readership of the *Enquirer* and *Us* are clear. In an early 2004 issue of the former, the cover story was of Harrison Ford drunk and draped with women, none of whom was his girlfriend, Calista Flockhart, in a bar in Mexico. That set of photographs was almost certainly not taken by a professional photographer but by a camera-toting barfly. *Us* decided against publication; Brittain Stone explains why:

"Those pictures are such a train wreck, and for us, running them is a much harder decision than for the *Enquirer*. In the end they're probably more innocent than they seem—Ford probably wasn't partying with those women, but he probably did have too many drinks, like any of us might. Then you can create the story that Calista's going to leave him, they'll never get married, so it's not a real scandal, it's a fake scandal. It's not like they're misbehaving, it's that you're creating the misbehavior."

THE POWER OF "JUST LIKE US"

One reason the work of the paparazzi has such a strong appeal is that it brings the celebrities down to earth and places them on a level where the public can identify with them. Although we like to see the designer gowns and jewelry at events such as the Oscars, those events distance us from the celebrities because they're so far outside of anything we will ever experience. Frank Griffin's take on the Harrison Ford story reflects this: "You couldn't get arrested with him, could you? You couldn't sell Harrison Ford for years despite all his success, and then he hooked up with Calista Flockhart, and now if he burps you can sell a picture. Suddenly he's human again—he's left his hundred thousand acres in Montana; he's seen staggering out of a seedy little bar in San Felipe, Mexico; he's leaving Melissa Mathieson, his wife of God knows how many years. People love to see a celebrity doing the same things they do. It's not a morbid desire; it's a desire to see the everyday life of the silver screen megapeople—you wonder what their kitchen looks like."

"Just like us" pictures can't be boring ("Supermundane doesn't work, but colorful mundane does," says Stone), but the day-to-day activities that would produce dull pictures if you or I were doing them become fascinating if performed by a celebrity: You simply don't expect Cameron Diaz to go to Kinko's or Jennifer Love Hewitt to pick up her own dry cleaning. Another strength of this kind of coverage is that each successive photograph builds a picture of the celebrity's life and becomes a continuing narrative that will extend over many issues of the magazine. *Time* and *Fortune* make sure that a cover subject isn't repeated for many months; the covers of *Us* and *People* deliberately show the same people week after week, thereby engaging the reader in the print version of a soap opera, or maybe more accurately, as

COPY CAT: Cameron Diaz (left) using the copier at her local Kinko's in West Hollywood. Photographs of stars doing everyday tasks are the pictures that sell the best.

DOWN AND OUT IN BEVERLY HILLS: Mike Tyson (right) takes delicate pecks at his lunch at the expensive celeb eatery The Ivy in Beverly Hills, October 2003.

GO, BRUINS: Renée Zellweger in Beverly Hills, March 2003. The shabby chic look is not only more comfortable for celebrities, but increases the identification the public has with them. Although your average Jane Doe may not get the opportunity to look as glamorous as Zellweger in an evening gown, she probably looks exactly the same in Bruins sweatpants.

Stone describes it, a comic strip. Phil Ramey calls it "a different form of Walter Mittyism, a vicarious living of the vagaries of your life through the peccadilloes of somebody else's."

PLAIN VANILLA, PLEASE

There's very little scope for the paparazzo to be photographically creative. This is partly because of the difficult circumstances under which most of the images are taken: It's hard enough to get anything on an 800-millimeter lens through the bushes, and almost impossible to be concerned with the aesthetics of style. It's also because creativity would likely decrease the value of the photographs. "Nice pictures with good skin tones, and the subject looking at the camera as if you've said, 'Excuse me, sir, can I have a shot of you going out with that woman who's not your wife?' are the components of a good pap photo," says Frank Griffin. "They like the clean pictures, a touch grainy, and a little bit illicit looking—there might be an elbow or a twig in the way because that adds to the candidness."

GOOD-LOOKING, RICH, AND YOUNG

The number of celebrities who turn up on the pages of the magazines every week is relatively small, and the names are fairly consistent. At the time of writing, the list would include, and probably be topped by, Jennifer Aniston and Brad Pitt, as well as Cameron Diaz, Johnny Depp, Gwyneth Paltrow and Chris Martin, Charlize Theron, Jennifer Lopez with or without Ben Affleck, Ben Affleck with or without Jennifer Lopez,

Britney Spears, Tom Cruise, and Demi Moore and Ashton Kutcher. Phil Ramey recalls asking the editor of a major magazine for the names of the top ten personalities he would like the photographer to shoot. The editor came up with six—all good-looking young women. Ramey sees a danger in having an ever-increasing number of photographers chasing such a small number of double-A-list celebrities. "By endlessly relying on a small core group of celebrities to sell magazines," he says, "these people are being hounded to death, and the shit will hit the fan eventually. There'll be another stupid incident—Jennifer Lopez's driver will drive at eighty miles an hour and get killed or kill somebody, and of course it will be the photographers' fault."

Even photographers with Ramey's years of experience guess wrong sometimes. He was the only independent photographer invited to a show on the Elton John tour in 2004, an unusual situation for him. Taking advantage of the freedom he was afforded, he photographed John in front of a fifty-foot screen that showed Pamela Anderson, in a feather boa, practically topless and gyrating on a lap-dancing pole. It was a situation someone like Ramey dreams of—except that he couldn't sell the pictures anywhere because they had no appeal to the youth market. "Elton John, Pam Anderson practically topless—how could I have missed?" Ramey wonders. "I think I'm the best marketer of pictures that exists on the face of this earth; I really have my finger on what will sell in every major market and what won't. I don't make my living being wrong, but I was certainly wrong then."

Paris Hilton does appeal to the youth market; she's also a perfect example of what the historian Daniel Boorstin means by his famous aphorism "people well known for their well-knownness." The heiress to the Hilton hotel fortune has achieved fame simply by showing up at any event that's photographed. Brittain Stone is a big fan, not just of her looks—he describes her as having a "slightly sinister kind of sultriness"—but because she satisfies a need at *Us Weekly*. "She's always wearing something colorful," he says, "and she's always pretty much half naked. If you're a magazine, you run colorful pictures, and she just pops on a page: She gives good magazine."

HEAT: WHO'S GOT IT? WHO'S LOST IT?

Stone has a theory that the celebrities the public likes vary according to where you are and who you are. Jennifer Aniston is more likely to appeal to young women on Long Island or in the Midwest than those in Manhattan. If you think of yourself as a nonconformist with a rebel streak, then Cameron Diaz is the one for you. There are some A-list celebrities who just don't appeal to the (mostly) women who buy celebrity magazines. Catherine Zeta Jones, Nicole Kidman, and Gwyneth Paltrow are perceived as too perfect; they come across as cold, even when they're smiling, and elitist. "Gwyneth is superfabulous, and I think she moves fashion magazines because she's elegant," says Stone, "but there's no warm, sympathetic story there that our readers particularly like. Our readers think she's cold and aloof."

CLOTHES LOOK GOOD OFF HER: Paris Hilton at a rock festival in Reading, England, 2003. Brittain Stone of *Us Weekly* believes that Hilton achieved her fame by turning up at every event, attending every party, and always being half naked.

COUPLES CAUGHT IN THE FLASHLIGHT: Halle Berry and Eric Benet at the Screen Actors Guild awards in Los Angeles, 2003. They filed for divorce in 2004 amid rumors that he was being treated for sexual addiction.

John F. Kennedy Jr. and his wife, Carolyn Bessette, in Milan, Italy, May 1997, two years before their deaths. The nearest thing to royalty the United States has ever had is the Kennedy clan.

Prince William and his first serious girlfriend, Kate Middleton, in Klosters, Switzerland, March 2004. He and his brother are the last of the British royal family to attract the attention of the paparazzi, and it's more because of their mother than their grandmother.

For Barry Levine at *The National Enquirer*, the hot celebrities today are all cold and dull by comparison to preceding generations. They still put on the tuxedos and designer gowns for big events like the Oscars, but they don't live the way people like Frank Sinatra or Elizabeth Taylor used to. Even one generation earlier had more glamour; Levine recalls an Academy Awards night when Michael Jackson escorted Madonna: "As the two of them emerged, it was an incredible moment; you felt that heat. Here were two huge, huge celebrities with one another, and as they came out of Spago it was a classic, incredible celebrity moment. You don't feel that way now with Britney Spears."

Today even royalty is pretty much a noncontender. The only viable personality to come out of the British royals soap opera is Prince William, and the interest in him isn't because of his membership in the royal family but because he's Diana's son and therefore heir to the intense following she had, whether or not he becomes king. According to Levine, readers of *The National Enquirer* were fascinated by the Monaco royals when Princess Grace was alive; there's still a slight interest in Princesses Caroline and Stephanie, but it's a declining curiosity. The only other "royal" family that still gets the pulses of the *Enquirer* editors pumping is the Kennedy family. As with the British royals, the premature death of one of the leading lights of the clan, JFK Jr., curtailed much of the obsession, although like Diana he produces almost as many stories for the publication after death as he did when he was alive.

While Queen Elizabeth may welcome the decline in media coverage of her royal family, for those celebrities wanting to increase the space that they get in *Us Weekly,* here are a couple of pointers from the magazine's Brittain Stone:

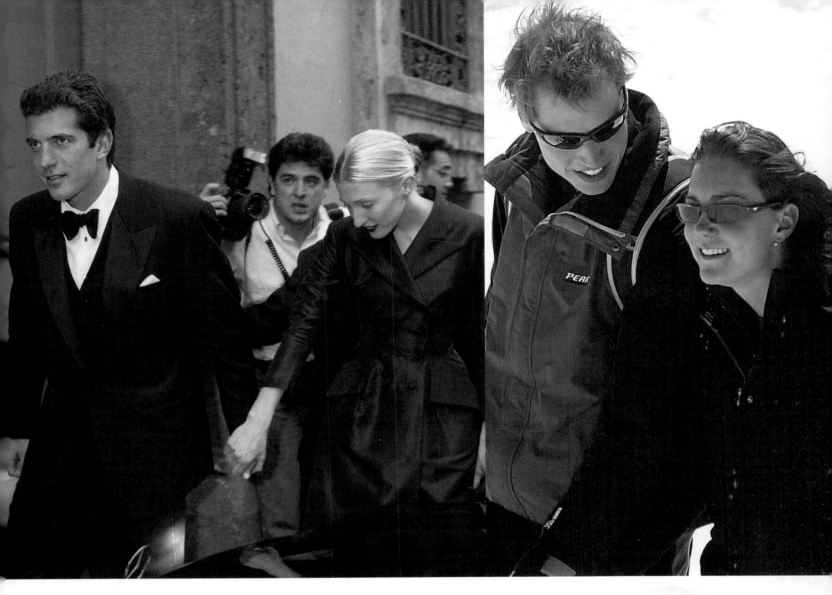

"If you're a celebrity and you date another celebrity—for example, Cameron Diaz and Justin Timberlake—you're vaulted to another level. Halle Berry was married to Eric Benet, who was a fairly famous but not a superfamous guy, so at that point the big interest in her revolved around her career, because nobody really cared about her husband. But if it's Jennifer Aniston and she goes out to dinner with Brad Pitt, that's huge news, and any kind of thing they do at all is watched, tracked, and followed."

Stone also warns that whatever you do, don't become a musician. There are popular musicians but not glamorous ones; Stone thinks they lose heat by constantly performing, being on tour, and actually coming to your town. Film stars make a movie, appear in public when it's released, then disappear again until the next one, whereas someone like Sheryl Crowe, for whom there was a lot of interest at one point, performs so much that she's lost all the mystery that she once had.

IMITATION: THE SINCEREST FORM OF PROFIT

Nowadays the work of the paparazzi appears in even the most mainstream publications, and journalistic practices for which TV shows such as *A Current Affair* were criticized over a decade ago are now in common use in prime-time news programs. In 1991, when Barry Levine worked as a reporter for the *Star*, Dana Plato, the young actress of the TV series *Diff'rent Strokes,* was arrested for robbing a video store in Las Vegas. It was the type of story that today would be featured on the cable news channels and even the networks' nightly news, but in those days it warranted only a paragraph in the *Los Angeles Times.* Levine went to Las Vegas "with a suitcase full of money. Plato's attorney let me into her jail cell with a photographer,

PAGES 136 AND 137
THE VIEW FROM BEHIND: Even from the back, you know who they are—the reigning (at least for now) prince and princess of Hollywood, Brad Pitt and Jennifer Aniston. Here they are posing for photographers as they arrive for the screening of Pitt's movie *Troy* at the film festival in Cannes, May 2004.

SIGN OF THE RAISED HAND: The elevated middle finger and the hand over the camera lens are the most frequently used gestures to register disapproval of the paparazzi. Nicole Kidman protests their presence at a gallery opening for the artist Julian Schnabel in Manhattan, October 2003.

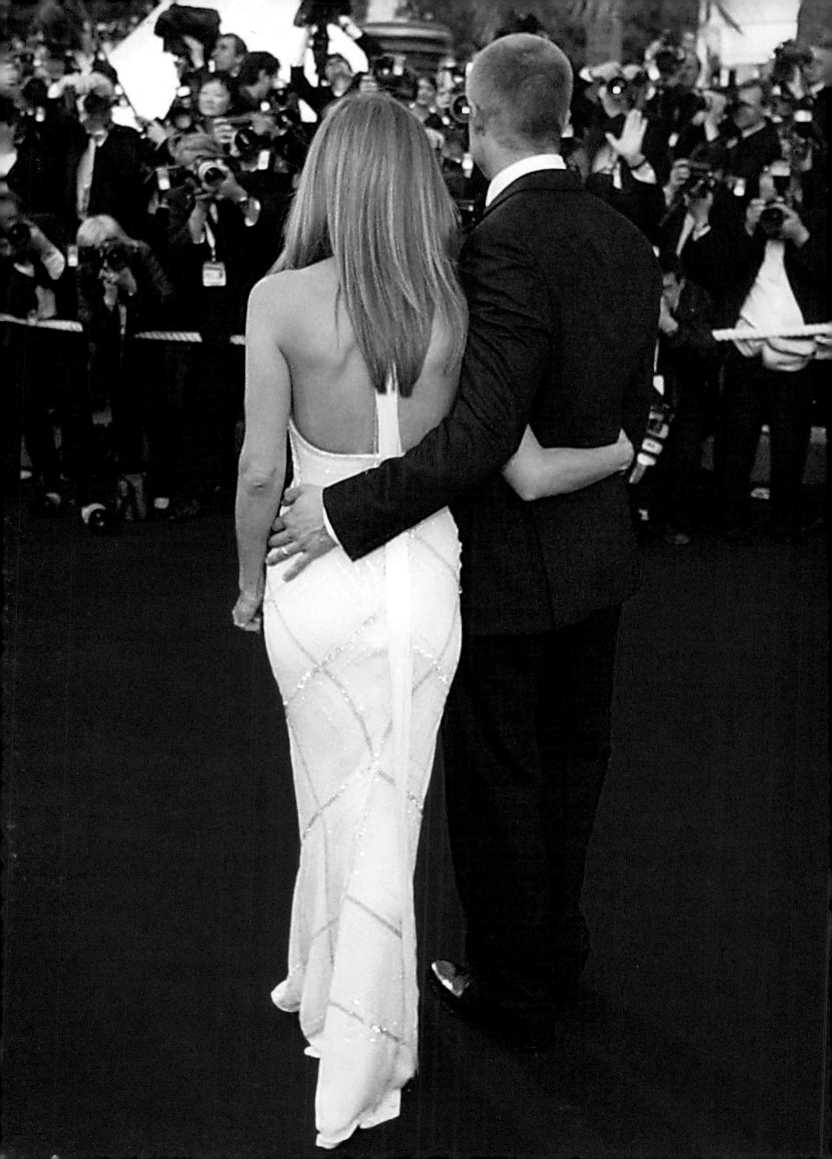

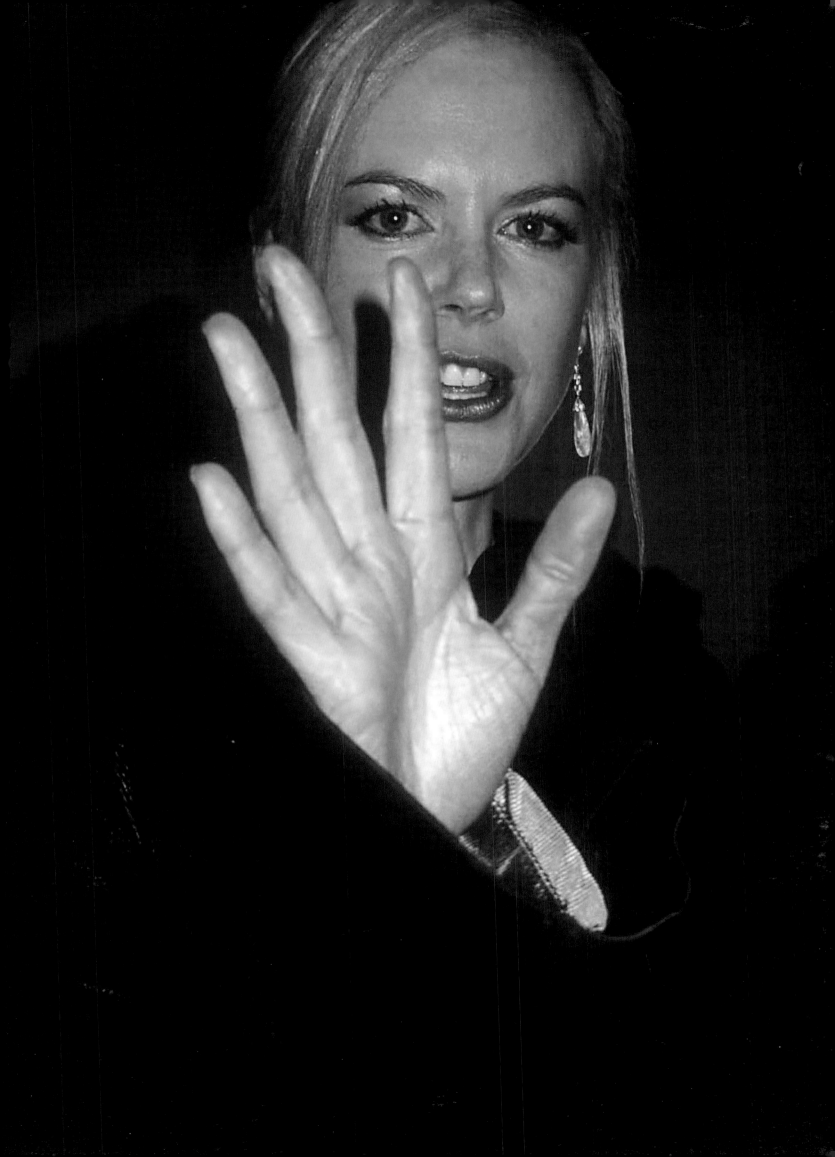

WHEN FAME GOES BAD:
Former *Diff'rent Strokes* actress
Dana Plato was photographed
by the Las Vegas police
department in January 1992
after getting caught forging a
Valium prescription. At the time
of her arrest, Plato was serving
a probation term stemming from
her guilty plea to charges that
she robbed a Sun City video store
in 1991. The actress committed
suicide in May 1999 at the age
of thirty-four.

and we got a story and pictures of her. We were the only ones who cared about the story at the time, but now her arraignment would be live on Fox News. It's a completely different ball game."

The trial of O. J. Simpson was, in Levine's words, "pivotal in showcasing what's under the rock of a celebrity's life." All the elements were there: One of the murder victims was the beautiful blond wife; the accused was a glamorous sports legend; those of the accused's friends who weren't celebrities before the trial were celebrities at its conclusion. Because the proceedings were covered live on television, and even though twenty-four-hour television news and Court TV may have increased the appetite for such stories, in the end they have probably hurt the tabloids. At one time, the only source for coverage of events such as the wedding of Elizabeth Taylor to Larry Fortensky at Michael Jackson's estate was the supermarket tabloids. When Elvis Presley died, the issue of the *Enquirer* with a photograph of his corpse on the cover sold more than seven million copies, the largest single sale in the publication's history.

To Phil Ramey, the reason the mainstream media have emulated the techniques of the tabloids is very simple:

"Back in the fifties, there were magazines that were more unscrupulous than anything you could imagine today, like *Confidential* magazine where they used to do wiretaps and break in and all kinds of shit. They were eventually driven out of business, but there's always been that level of interest in celebrity escapades, something that goes beyond the sterile setup stuff. The simple reason the other magazines emulated the tabloids was because it was financially viable. It worked for the *Enquirer,* and it worked for everybody else who adopted it in whatever watered-down version they wanted to.

"You know, a celebrity these days can't commit any transgression without it being on the nightly news, and that wasn't the case even fifteen years ago. The bottom line is that the tabloidization of American publications and television occurred simply because it sells. Until *Hard Copy* came along, television was the slowest to recognize that. Now every nightly news has a gossip section whether you want to see it or not; even when you cover noncelebrity subjects like politicians, the same tactics work. The *Enquirer* has broken more important political stories than *The New York Times* ever will in their biggest dreams."

THE TRUTH ABOUT REALITY

As if life now weren't difficult enough for the overworked tabloid reporter, the new millennium heralded yet another breed of celebrity to vie for the public's interest and therefore the publications' attention. The success of CBS's reality TV series *Survivor,* first launched in 2000, spawned a succession of look-alike shows, each with a group of instant celebrities the reporter had to keep abreast of. Previously unknown people were catapulted into the dizzy heights of stardom, only to flame out and return to obscurity a few months later. (Can you honestly say that you remember much about Joe Millionaire today?) Realitytvworld.com lists more than 150 shows that are loosely included in the genre, although that number includes all six series of *The Bachelor,* four of *Big Brother,* and some that may have gone under your radar, such as *Second Chance: America's Most Talented Senior.* Whatever the number, it's a lot, and it has made celebrity coverage much more complex.

From both the paparazzi's and the tabloid reporters' point of view, the instant celebrities spawned by these shows may not have a long life span in terms of sales, but it's easy to get access to them. For the most part, they don't have all the layers of protection that "real" celebrities use, such as agents, publicists, lawyers, security; Barry Levine describes them as "sitting ducks." And for the brief window of time in which they capture the public's imagination, they will sell magazines and are therefore worth pursuing. The first million-sale issue of *Us Weekly* was the one that featured Bob Guiney from the reality show *The Bachelor.*

HOW MUCH IS TOO MUCH?

The sheer number of images that a magazine like *Us* has to look at each week is staggering. Brittain Stone does the calculations:

"When we first started as a weekly, it was the dawn of the whole digital age, and we were getting maybe 5,000 pictures a week, so it was pretty easy. I think we saw about 200,000 images our first year. Now on average we receive about 45,000 to 50,000 a week, but on a busy week like during the Golden Globes, that number goes up to 60,000 or 70,000. About three quarters of these are on spec—work that agencies

REALITY FOREVER: Bob Guiney, aka Bachelor Bob, the "star" of the reality television series *The Bachelor.* Although reality TV is thought to be a new phenomenon, it can trace its roots back to *Candid Camera,* which debuted in 1948. Crime shows of this genre, such as *America's Most Wanted,* also have a long history; the original, *Wanted,* was first seen in 1955.

want us to see; the rest is research. The material that comes from amateur photographers comes through e-mails, phone calls, and us chasing them down if we hear about it. We pretty much pursue every lead, and actually a lot of good stuff comes from those people. If a civilian shoots a set of pictures and the paparazzi find out about it, they'll offer $10,000 in cash on the spot. The civilian will usually take the bait; then they don't have to bother about calling and doing the dirty work and all that entails. The Britney Las Vegas wedding pictures were from a civilian, and a very happy civilian now because he's about $300,000 richer after all his sales. He did an incredible job, this guy; these were the most expensive pictures I saw all year, and not shot by a paparazzo. He happened to be getting married right before Britney got married, and he was very sophisticated about the way he handled the sale."

> ## With the overrunning of the business by mostly lame idiots with autofocus cameras, celebrities are endlessly hounded. PHIL RAMEY

If they have already have a good selection of one subject, most photo agencies that cover hard news won't shoot any more unless there's a compelling reason to do so. Celebrity agencies such as Wire Image, on the other hand, always have a compelling reason: the market. They shoot thousands of pictures of Britney Spears because hers is the number one image downloaded from their site. "Every time Jennifer Aniston walks down the red carpet, we do a little dance here, because it means new Jennifer Aniston head shots," says Stone. "We're so thrilled; we show them to the art director, and she says, 'Thank you so much, this is so great.' It's kind of hilarious because we all know a great Jennifer Aniston head shot is hard to find; we know where they all are, and they've all been used so many times, so every time she shows up in public again, it's fantastic. You're feeding this huge demand for a new Jennifer Aniston picture."

Frank Griffin thinks that technology has also played a large part in increasing the appeal of the images: "The demand increases because you're not looking at murky, gloomy pictures of some Italian lover boy necking with an aging actress around the back of the trattoria. Now you're getting very clear images in conditions that you couldn't have gotten before, and the speed with which you can deliver those images has increased dramatically."

The escalation in prices has been rapid and is seemingly limitless. The price tag for a video of Britney Spears's Las Vegas elopement was $1,000,000. Although it was never sold, the mere fact it was demanded means that one day in the not too distant future this sum will be realized, and like the six-figure photo, once it's established, it will become the standard for a world exclusive.

RETURN ON INVESTMENT

"I don't think you can justify a hundred-thousand-dollar picture in terms of newsstand sales," says Stone. "We got our Britney wedding photo and the issue sold great, but it didn't put us over the edge, and I don't think we fool ourselves into thinking that it does. In general, you have these pictures as a sort of promise to your readers; you have to have something to show them, because if you just do a rehash of this story with old images it looks like a rehash. It's that constant delivery of good photography to the readers—to

QUICK WEDDING, SHORT MARRIAGE: For a brief shining moment, Jason Alexander, far right, was the husband of pop princess Britney Spears. They were married in the Little White Chapel in Las Vegas in January 2004. The marriage lasted fifty-five hours. A very quick-witted amateur photographer who was getting married at the same time and in the same location took pictures of this bizarre event. Their subsequent sale proved to be a valuable and unanticipated wedding present for him.

THE MORNING AFTER:
Nicolas Cage and his third wife, Alice Kim (above), enjoy a late breakfast in a Chinese restaurant in San Francisco on the first morning of their marriage, July 2004. The couple had wed the previous day at the house of his uncle, Francis Ford Coppola.

THE WEDDING BEFORE:
Nicolas Cage and his second wife, Lisa Marie Presley (opposite) at their wedding in Hawaii, August 2002. The marriage ended in divorce in May 2004. The quality of paparazzi photography does not have to be great provided that the content is of sufficient interest. In this case, however, conventionally poor quality gives the photograph an almost painterly feel.

show them that we have the most current stuff around—that's important. The readers don't understand, necessarily, that you didn't get a certain picture; but if you do get it, and you're constantly getting it, that's what they appreciate."

Most magazines nowadays rely on advertising to generate the revenue they need, but the tabloids rely on newsstand sales for their income because only a limited number of advertisers are willing to take space in them. As a result, *The National Enquirer* can get a direct return on its investment in paparazz photography. A good photograph on the cover can bring hundreds of thousands of additional readers that week, which translates into millions of dollars. Barry Levine cites one incident: "We were the only ones fortunate enough to have pierced the veil of secrecy when Lisa Marie Presley married Nicolas Cage, and we were the only publication on the newsstands with an exclusive photo. It was a long-distance photo—not by any means a great photo—that reproduced relatively well, but because it was exclusive it generated a very, very good sale for us that week." (It should be noted that only someone who's worked for the tabloids as long as Levine has would use a phrase like "pierced the veil of secrecy" in everyday conversation.)

Photographers' agents give other reasons these photographs should command the prices that they do. The photographs are often costly to get, especially if the subject is at an expensive resort where the photographer has to blend in. Furthermore, as Jean-Paul Dousset, a former photographer who now runs an agency, knows, "It's not a job where you arrive and have a drink under a palm tree, do the pictures, and off you go." To get the right shot at the right moment often takes days of waiting.

The trick to running a successful agency is to produce a constant supply of bread-and-butter earners in the face of much increased competition. When Frank Griffin and Randy Bauer started their business in 1997, they bumped into only a handful of photographers every night. Now there may be as many as ninety in Los Angeles alone, "out there every single day making celebrities' lives a misery," according to Griffin. Furthermore, he says, it's not the big sales that are the lifeblood of the agency. "We get spikes caused by certain events, but they're the sales that pay for our toys. Anybody can sell Angelina Jolie with Colin Farrell on a camel three days after Christmas hand in hand at the pyramids in Egypt. You've got the set, it's exclusive, they've already left Egypt, and they'll never be back again. You just wait for the highest bidder. To consistently produce and sell the thousand-dollar picture is much harder."

Often the highest bidder is Brittain Stone on behalf of *Us Weekly*. "This stuff is worth what it is because someone's going to pay, and in the end that's all it is, just money."

"It's kind of like playing a twenty-four/seven lottery," says Steven Ginsburg. "You're out there and anything can happen. You go from a day when you have nothing and then you're following Brad Pitt and he gets into a car accident. If you get pictures of him coming out and looking at the car, you just came across a $70,000 story. It's like finding $70,000 on the ground. That's a pretty amazing thing."

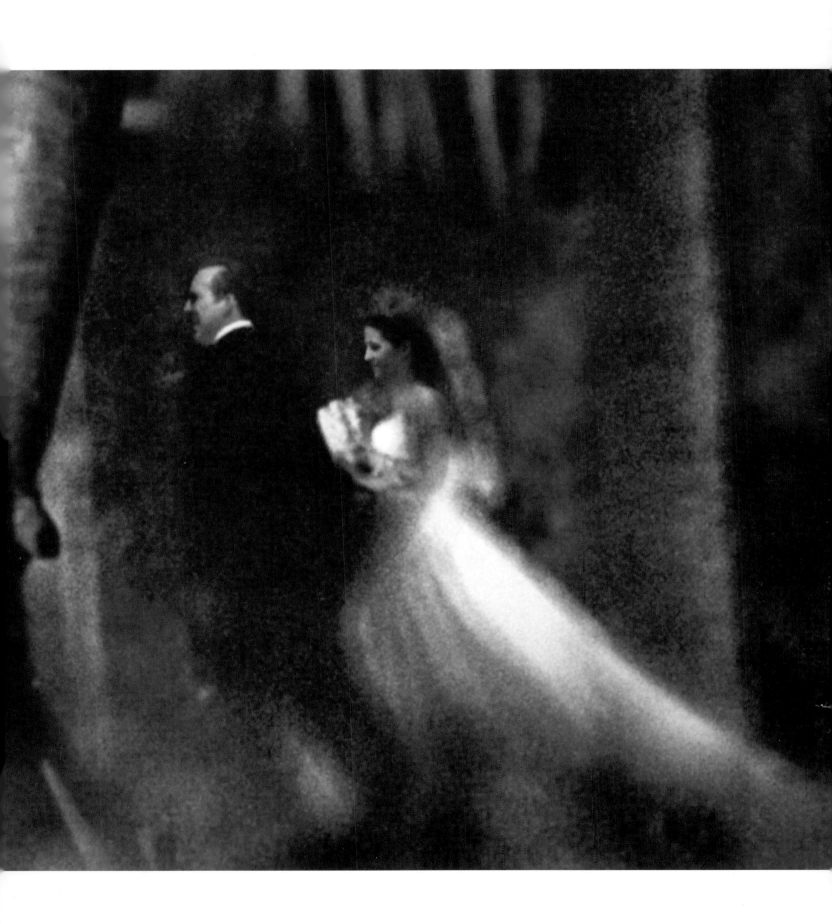

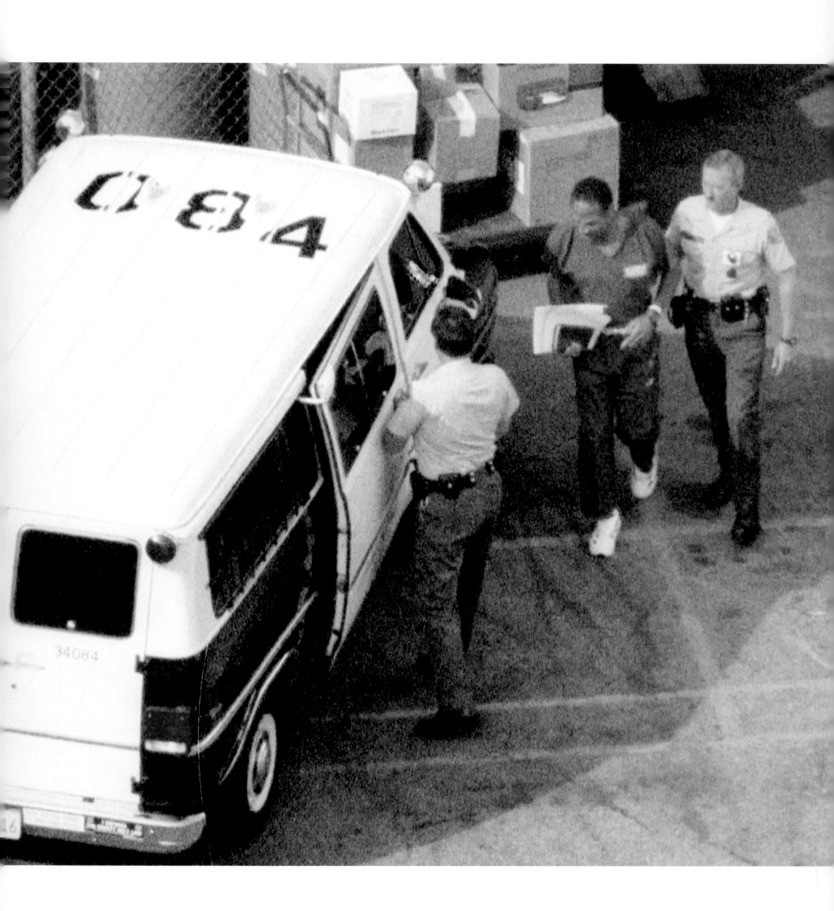

O.J. IN CUFFS

I got a call on a Sunday morning at seven from my friend in the Santa Monica Police Department saying, "O. J. Simpson's wife has been murdered; the body's lying in front of the house. We're heading over there." I put the phone down and said, "We're doing something else. Who cares about O.J.?" You can tell how smart I am, right? A fact that I lived to regret for about a year and a half. Then, when I was having dinner with six friends, the car chase started. Instead of going up in the helicopter with my regular crew, I sent somebody else—and he didn't get one frame of the chase.

So after those two brilliant moves of mine, the trial starts. I was watching it on TV, like everybody else, when I realized that I never saw a picture of O.J. in handcuffs. I used to work the courts all the time, and I always saw people brought in wearing handcuffs and prison suits—Brando's kid was always brought in a suit and led away in handcuffs. There was only one picture of O.J. like that, when they arrested him; somebody made one frame and licensed it completely to TV and one magazine group. Nobody else had pictures of him in handcuffs. I made inquiries and found out that he was being kept in the medical ward and was escorted out of prison in prison blues and in handcuffs. After doing some investigating, I figured out where they were going to bring him out of the infirmary. We tracked the van they used, from the air, and knew we had a window of about an hour. We took the helicopter with a video cameraman and myself to the position that, based on my informants, I knew would work.

Believe it or not, a half hour after we were up there, we saw a van pull up and back in. I knew it was one of the two they used to bring O.J. out. We went into a hover and crept in as close as we could to the jail, without giving ourselves totally away, and with a thousand-millimeter lens with a gyro stabilizer, shot the first pictures and video of O.J. being led away to court in handcuffs. Of course, two days later after I had published it, every idiot in a helicopter was up there, and the picture became essentially worthless. By that time I'd sold it everywhere anyway, so it didn't matter. But it's a great case in point of the herd mentality—not doing any thinking, not looking for the obvious missing picture, and certainly not getting it. Anybody can shoot from a helicopter— if you know where to be; if you can position it right; if the wind doesn't blow you off the mark; if you have enough lens; if you know which van. But I did it. ✳ PHIL RAMEY

A TAIL FROM THE CRYPT

It all started when the Lawford family couldn't or wouldn't pay the rent on Peter Lawford's crypt at the Westwood cemetery and he was going to get evicted. We staked out the cemetery and got pictures of Lawford's widow, Patricia, taking the urn out of the crypt. She was immediately spirited away by a *National Enquirer* staff reporter and an *Enquirer* lackey photographer. (Although I worked for them a lot, I wasn't one of those people they could order around.) We smelled something happening, so we followed them to the marina and saw them get on a boat. I knew they were going to disperse the ashes, so I called my friends at L.A. News, who made a helicopter ready; being as ballsy as they were, they landed the helicopter near the marina, and I jumped in. We chased the boat out to sea and eventually found it, but it wasn't as easy as it sounds.

At the appropriate moment, we went into a hover, really close, about thirty feet over the water and less than one hundred feet from the boat. We put up so much wind that we found out later that some of the ashes kicked back into the sandwiches the family had brought along to eat.

I broke the *Enquirer*'s exclusive, which made them extraordinarily unhappy because I sold it to their competition and all around the world. I sold video I had shot that night to TV, which made them even unhappier because their competition wasn't just another magazine, it was also the nightly news. I did make the token phone call for them to buy our stuff off the market, but they wouldn't. ✳ PHIL RAMEY

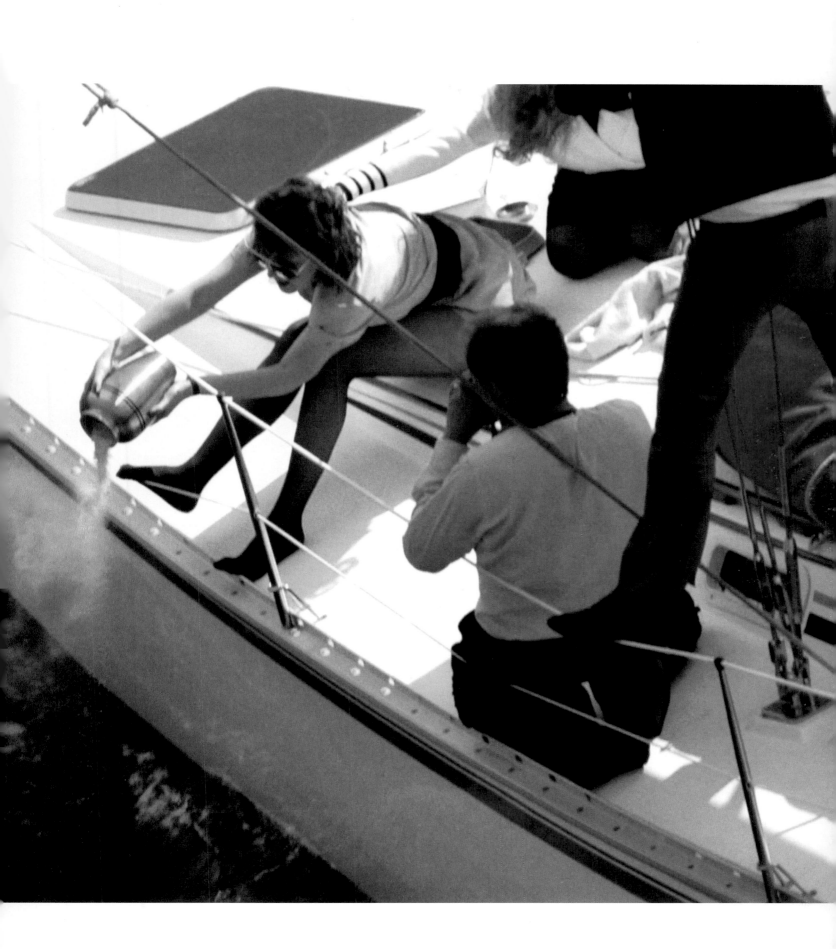

MORALS, ETHICS, AND OTHER HURDLES

YES, IT'S THE SHORTEST CHAPTER IN THE BOOK

KISSED THE GIRLS AND MADE THEM CRY: Film director Roman Polanski in Saint-Tropez, France, shortly after he was accused of statutory rape in 1977. According to police reports, he took a thirteen-year-old girl to Jack Nicholson's house while the actor was away in order to photograph her for the French edition of *Vogue.* After taking the pictures, the two shared a hot tub and Polanski allegedly plied the girl with Quaaludes and champagne, then had sex with her. He later claimed the sex was consensual. He was charged with rape and five other felonies, but pleaded guilty to the lesser charge of unlawful sexual intercourse with a minor. Before he could be sentenced, he fled to France, where he currently lives. He was forty-four years old at the time of the incident.

Although most of them certainly don't realize it, the paparazzi have a lot in common with the German playwright Bertolt Brecht, who once said, "Grub first, then ethics." They believe that money in the bank has more value than the good opinion of the celebrities, their publicists, even the readers who so avidly consume their work. But this doesn't mean that they don't think about morality and their place in the grand scheme of human existence, as you will discover in this chapter. What it does mean is that the likelihood of these thoughts influencing their actions depends primarily on how badly the magazines want a picture of the person they see in their viewfinder.

Their focus on morality follows.

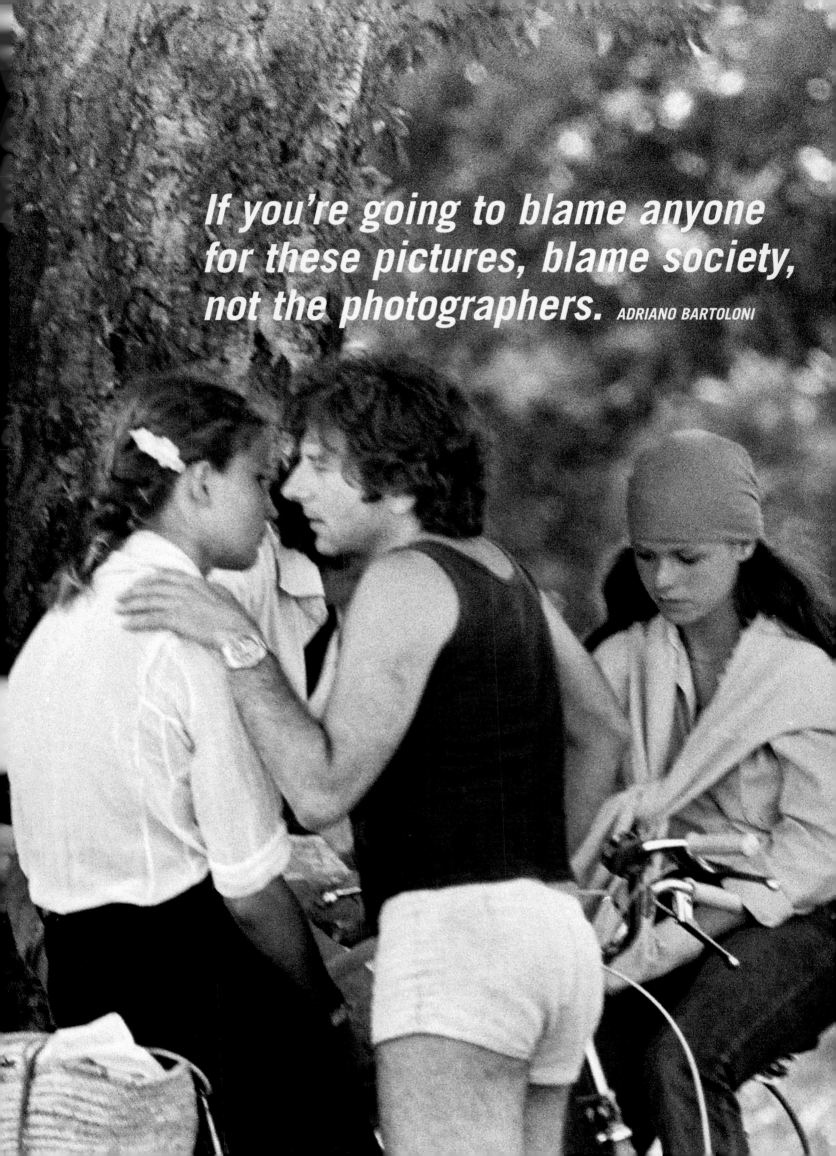

If you're going to blame anyone for these pictures, blame society, not the photographers. ADRIANO BARTOLONI

JEAN-PAUL DOUSSET When I'm hunting someone, I never look for sleazy things; I just wait for whatever happens. If they kiss, they kiss; if they slap one another, they slap one another. Once we were hiding on the same beach as Ryan O'Neal and his daughter, Tatum; they had an argument and he slapped her, and we got the picture. And when there was the problem with [Roman] Polanski and the girl in the States, we took pictures of him talking to young girls in Saint-Tropez two days after that story broke. We didn't tell him to do that and we weren't hiding in a back street. It was plain for all to see.

FRANK GRIFFIN There's a misconception that it's the photographers who decide what goes in the book; it isn't. They have to shoot everything. In war photography you're faced with this quandary, this moral decision: Should you save the life or should you photograph it being taken? Is that more of a moral issue than taking a picture of Kate Hudson's baby? I don't know, but it's not the photographer's decision. The photographer goes out and takes the picture, and what goes in the book is the decision of the picture editor and the editor and, ultimately, the buying public. People can say that the paparazzi are sleazebags, but it's not their call. They're commissioned by their superiors to go out and take a picture that tells a story, and that's all.

STEVEN GINSBURG It takes a little craziness to do this. There are a lot of small things that enter into the job—you know, like morals: when they say, "Please don't take a picture of my kids," but you know that's what the magazine wants, what they're going to pay you the money for. So are you the kind of guy who'd say, "Well, they didn't want us to take a picture of the kid," or are you going to say, "Sure, thanks," because that's what you do and you're going to take the picture anyway?

MASSIMO SESTINI I try to keep very clear in my mind that I'm doing my job, and my job is to take pictures, to document events that happen. It's got ethical limits, but they apply afterwards, when it's a matter of distributing the picture. I might take a picture and decide not to publish it. There is a difference between a photo-reporter and a reporter. A reporter's got time to think and write; a photographer has no time. The picture is there now, and it won't be there in a couple of seconds. So you take the picture and think later. When two famous Formula One drivers died within a day of each other during the San Marino Grand Prix in 1994—one was [Ayrton] Senna, the famous Brazilian driver, and the other was the Austrian [Roland] Ratzenberger—I was offered pictures of their corpses taken by someone working in a hospital in Bologna. I bought them, but then after looking at them, I thought it wasn't right to publish them. What I did instead was to call *Panorama*, a well-known Italian magazine, and I said to them, "Look I've got these pictures, and I don't think they're fit to be published, and I think you should print an article saying why *Panorama* isn't publishing them." They asked me to write it, which I did. We never published the photos.

PHIL RAMEY I'm not going to jump up and photograph Robert Downey in his face while he's having breakfast. For one thing I can't sell the picture, and anyway you don't make good pictures by jumping in someone's face. This whole nonsense of jumping out of the bushes with flashbulbs popping is such a load of rubbish, a myth that just gets propagated over and over, and somebody's got to put it to rest. I've made thousands of pictures from bushes, and I don't ever remember when jumping out of one made me a picture. Whoever came up with that should be made to listen to it endlessly and have the flashbulbs go popping in his eyes all day.

BRITTAIN STONE The only ethics I see coming out of all this is the "honor among thieves" that we all have. There are people you trust and people you don't, and even the people you don't trust you still have to work with. That's where the ethics lie, that sort of pack mentality: Who's one-upping who? Everyone gets hurt; everyone gets wounded and pissed off with one another, blows an exclusive, leaks information, or doesn't get the shot. You get vindictive for about a day, then it goes away and you have to work together again. It's really the Warner Brothers cartoon where the sheep and the wolf check into the little pasture, and on the way in when they punch their cards it's "Hey, Sam," "Hey, Jed, how're you doin'? Ready for work today?" They punch the clock and they're off chasing each other, and then they check out and it's fine.

JEAN-PAUL DOUSSET I don't mind being called a paparazzo, although at the beginning I found it quite negative. The general public will say, "How can you take these kinds of pictures?" and then you say, "I've got a picture of that actress nude on the beach," and they'll say "Show it to me." If I go to dinner with friends and there are other people there, they'll say, "Oh, give me the latest gossip." Unfortunately they're not going to say, "What's the latest news on Chechnya?"

There are a lot of small things that enter into the job—you know, like morals. STEVEN GINSBURG

STEVEN GINSBURG My partner Joe and I, we're both good people. We're really not trying to piss anybody off like the European photographers do. They'll get in your face, and they can stay in your face all day. You can't really do anything about it. I think that's why the Los Angeles–type paparazzi are better. We try to stay in our cars, we try to hide. We don't even want celebrities to know we're there. We want them to go about their day; we're not trying to scare the kids. My partner and I do care. Sure we're doing it because of the money. It's a lot of money, it's not illegal, and it's very interesting. But I'm very respectful. I've had a pregnant actress who said, "Look, I'm just nervous because I'm having a baby." No problem—I say, "Good-bye and have a nice day."

BARRY LEVINE A good picture is just capturing the essence of whatever's happening in front of you. It could be something mundane like pushing a shopping cart, but if it's Liz Taylor pushing the shopping cart it becomes less mundane. The people who buy the publications that use paparazzi photos want to see celebrities doing something that they themselves would do every day, like carrying out the trash, pushing a grocery cart, or looking like they haven't shaved or put on makeup for four days. It's not all blood, gore, death, and destruction.

MUSTAFA KHALILI I have to do my job. I'm a journalist. If something happens in front of me, my initial reaction will be to take a picture. Even if it's a car crash and someone's been injured, I have to get the picture first. It was the same in Palestine. If kids were getting shot or bombed or shelled, my mum would ask me, "Don't you want to help them?" Well, I'm here to work. First I'll do my pictures and then I'll help. There hasn't been a situation yet with the paps where I've thought, Oh, I don't know if I should shoot that. Not yet, and I hope it stays that way.

People can say that the paparazzi are sleazebags, but it's not their call. They're commissioned by their superiors to take pictures that tell a story, and that's all.
FRANK GRIFFIN

PHIL RAMEY The photography business on any level, not just paparazzi, is intrusive by nature. There can be no holier-than-thou attitudes, and that includes all the wire service guys, all the news guys, all the guys who pontificate, "Oh, we're news, we don't do that." The most intrusive examples I've ever seen are right there in the Pulitzer Prize list—death, destruction, and agony, and there's the guy with the camera three inches from their face. It makes what we do pale by comparison. At least we get celebrities, and they're entertaining. When you're photographing somebody in the core of extreme agony, death, and destruction, there's no entertainment value there and it's ultimately more intrusive.

JEAN-PAUL DOUSSET The basis of press photography is money, sex, and blood. You mix that together, you have a magazine. And it's not that there's more interest in it today than before; it's always been that way. Paparazzi photography is gossip in pictures, but the pictures are true. You can get things wrong, as Gamma did when their caption identified an old lady next to Roman Polanski as his grandmother when in fact his grandmother had died in a concentration camp. That was a stupid mistake, but the fact is that Polanski was with this old lady, and Gianni Agnelli did jump nude into the ocean, and John Barry did suck Sarah Ferguson's toes. I've done things in Italy just for the fun of it, like taking a parking ticket and putting it on the screen of the film star to see what he or she does with it. That you could do, but you would never fake a picture. It's completely unheard of.

RON GALELLA I don't mind being called a paparazzo. Well, I have to qualify that, because I think that I'm a good photographer who could shoot anything. I've shot architecture, done portraiture, and to me paparazzo is a tool that you use when a celebrity doesn't want to be photographed, such as Jackie. One thing I will not do is provoke, like some of the European paparazzi. Sean Penn didn't like photographers. There were about ten of us on one occasion, so he blew up, spit at us, and swung. When incidents like that happen, it's both good and bad—good because controversy sells, bad if you provoke it. When I see a celebrity, let's say at the beginning of a new romance, I shoot first. Then when they see you and they say, "Oh, we don't want pictures," you stop, because you've got the picture anyway. I won't shoot any more if they say stop, but I never ask at the beginning. I remember a photographer asking Sidney Poitier if he could take his picture, and Poitier says no. But the photographer takes it anyway. What'd he ask for? Get the picture first; later, when they say stop, you stop.

JEAN-PAUL DOUSSET The reason the paparazzi are so disliked is that there are no standards of social behavior among them. If you go to Los Angeles or London and watch the photographers, you'll see all sorts of different people who yell, "Show us your knickers, show us your boobs," that kind of thing. That's not our work. The photographers I work with pay a thousand pounds per night at the Four Seasons on any Caribbean island; they're dressed in Armani and they speak two or more languages. It's a different way of conducting yourself.

ADRIANO BARTOLONI If you're going to blame anyone for these pictures, blame society, not the photographers. These are the kinds of pictures that people want. And people who publish magazines and newspapers want to print pictures of celebrities rather than pictures of poor people. By showing photographs of these people day after day, readers become familiar with them, almost as if they know them very well, and they like to talk about them and share information about them. It's almost like a comic strip, where you want to see each day's episode—"Oh, you missed that picture, I'll tell you about it, and you tell me about . . ." and so on. Then it becomes gossip with people. A photo taken in a professional studio where the actor is posing doesn't mean a thing to the public, because it's not real.

MUSTAFA KHALILI Sometimes I feel sorry for the celebrities, especially if they've spotted you and they're trying to get away. I'm surprised that more people haven't attacked us. We've been called parasites and fleas, and I can understand that. If I always had paparazzi on my ass, I'd be in prison now. We should respect the celebrities and give them their space, which is what I think they ask for more than anything: "Fine, be there, but just give me my room. I don't want a whole load of photographers outside my house every day." That's what happened with J-Lo—hundreds of photographers every single day, fifteen cars on a follow. Imagine fifteen cars bombing through town, jumping red lights; that's when it gets dangerous.

CURTAINS FOR ROCK

The world was on Rock Hudson deathwatch for so long that we actually rehearsed the route the van carrying his body would take to get to the cemetery. We rehearsed which roads they would take from where he lived in the hills, how they might get there, how long it might take. Everybody knew he had AIDS, because he had appeared with Doris Day at some benefit in Carmel looking like death warmed over, and about a month or two prior to his death he returned from treatment in Paris on a chartered 747. So we were all there planning how we were going to get this picture. When the time came, I think I was first on the spot; I got inside information that he had died. I had the whole place to myself, for about an hour, during which time the van actually came in. It wasn't a coroner's van but one supplied by the funeral home. They backed into the garage and didn't come out for hours. By that time there were, without exaggeration, forty crews surrounding the house.

There were lots of bodyguards and security, and what happened was—and this is all captured on video—they started to bring the van out surrounded by security people. They were going very slowly, about five to ten miles per hour, and everybody was shooting and crowding around. I knew from lots of experience of shooting through car windows that I had the possibility of making a shot through the front windshield by taking the strobe off automatic and dumping its load, which would allow me to make probably one or two frames. As they turned to come out of the gate, I went to make a shot. I didn't go head-on but from an angle, and of course a bodyguard was right there. Unfortunately the videotape shows me driving my elbows into his kidneys, and him moving away long enough for me to run around him and shoot dead-on through the front windshield of the van. I got two frames.

After I did that, I didn't stand around. I ran for my car, as did everybody else. The van used another way out than anticipated, not to lose anybody but because they didn't know their way around. There was another photographer, a wack job driving a Rolls-Royce, and we were the only two following the van over the hill into the valley. The driving got pretty aggressive, to the point that the Rolls-Royce guy smoked his brakes coming down the far side of the canyon on the way to Forest Lawn and lost his brakes. The van was completely curtained in the back, but I noticed that whenever it stopped for a light, the curtains that covered the back windows weren't fastened down, and they would separate, leaving the tiniest of gaps. I knew what I was going to have to do. They

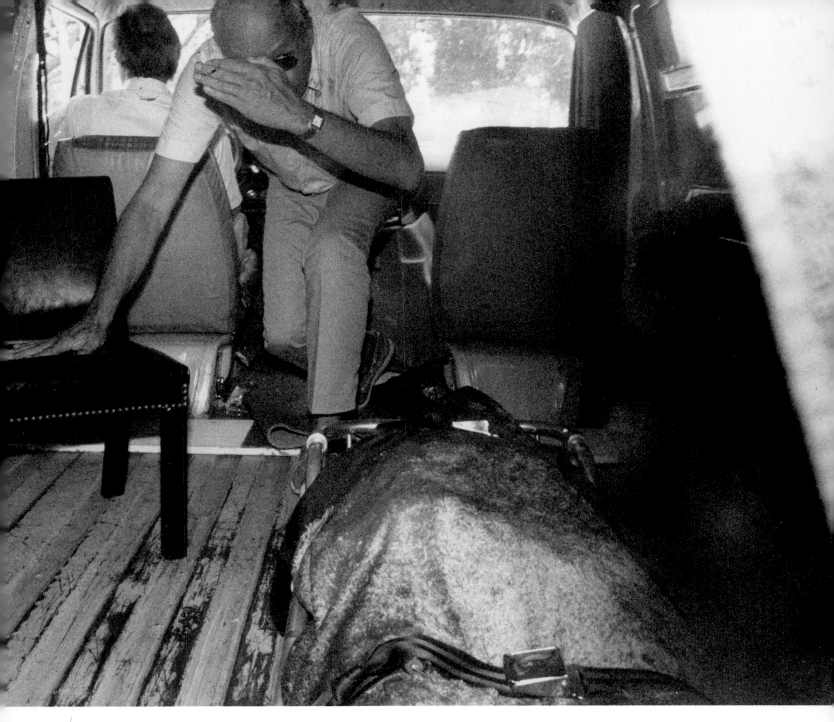

weren't using the regular gate at Forest Lawn and they weren't going to be able to just haul ass through. Of course, they would make sure there was someone to open it, but they were going to have to stop. I knew there'd be no time for me to stop my car and get out and catch the swing of the shades at that point. So as they slowed down and made the turn, I got out and chased behind the van as it was doing twenty miles an hour, until they stopped for the gate. As soon as they hit the brakes, the curtains parted; I put the camera right to the window and got two frames before they closed. Not only did they close, but the guys inside realized what I had done, and by the time I got to the third frame the only thing in the window was a hand. That's how I got the picture. What did Helmut Newton say about paparazzi? "The last great American art form." ✳ PHIL RAMEY

THE HAMBURGER AS WEAPON

THE STARS FIGHT BACK

It didn't take long for the early paparazzi of the Via Veneto to learn that confrontation sold. Picture editors were much more interested in photographs of an actor about to launch a punch than they were of him smiling as he got into his car, so photographers deliberately antagonized their targets until they reacted. Working in teams, one would go up to the subject and pop the flash right in his face. When the subject's response was to take a swing at the intruder, the photographer's partner was there to capture it. Another trick was falling in front of a celebrity so that the resulting picture had the appearance of confrontation. But even without deliberate provocation, the mere presence of the paparazzi often was, and still is, enough to incense celebrities to react violently.

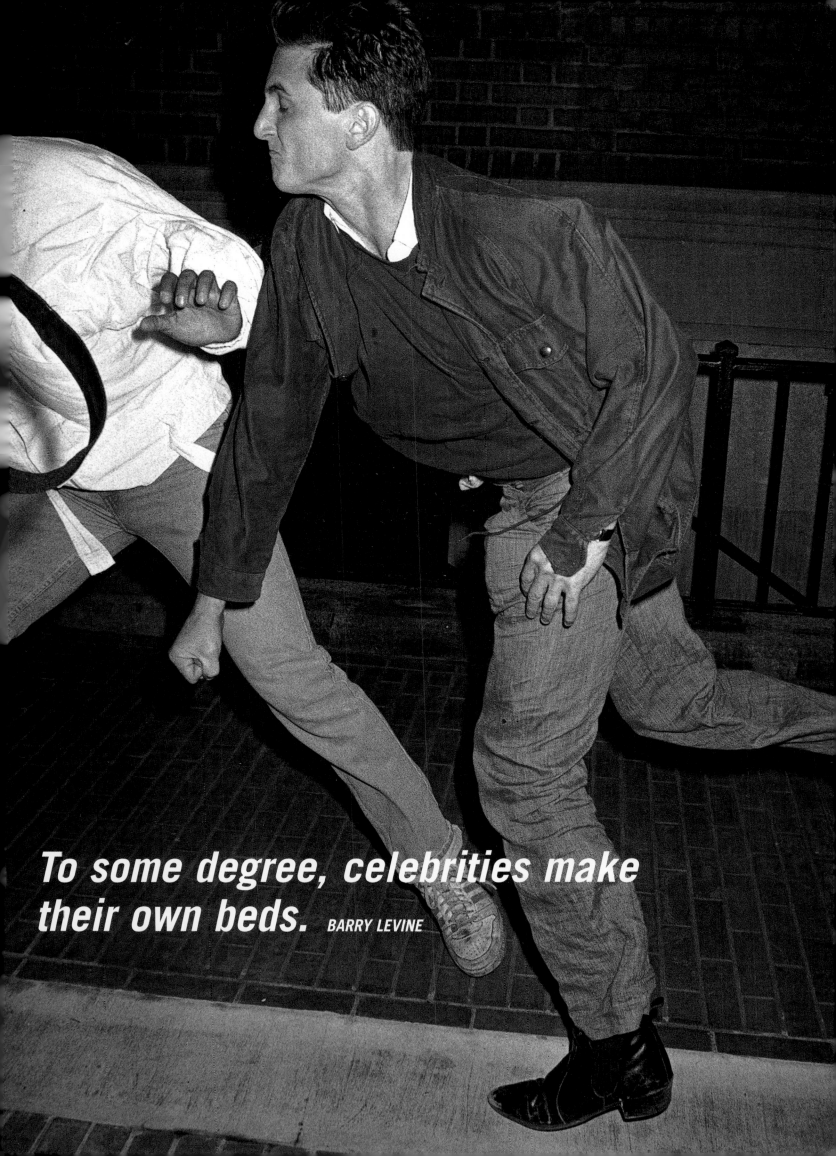

To some degree, celebrities make their own beds. *BARRY LEVINE*

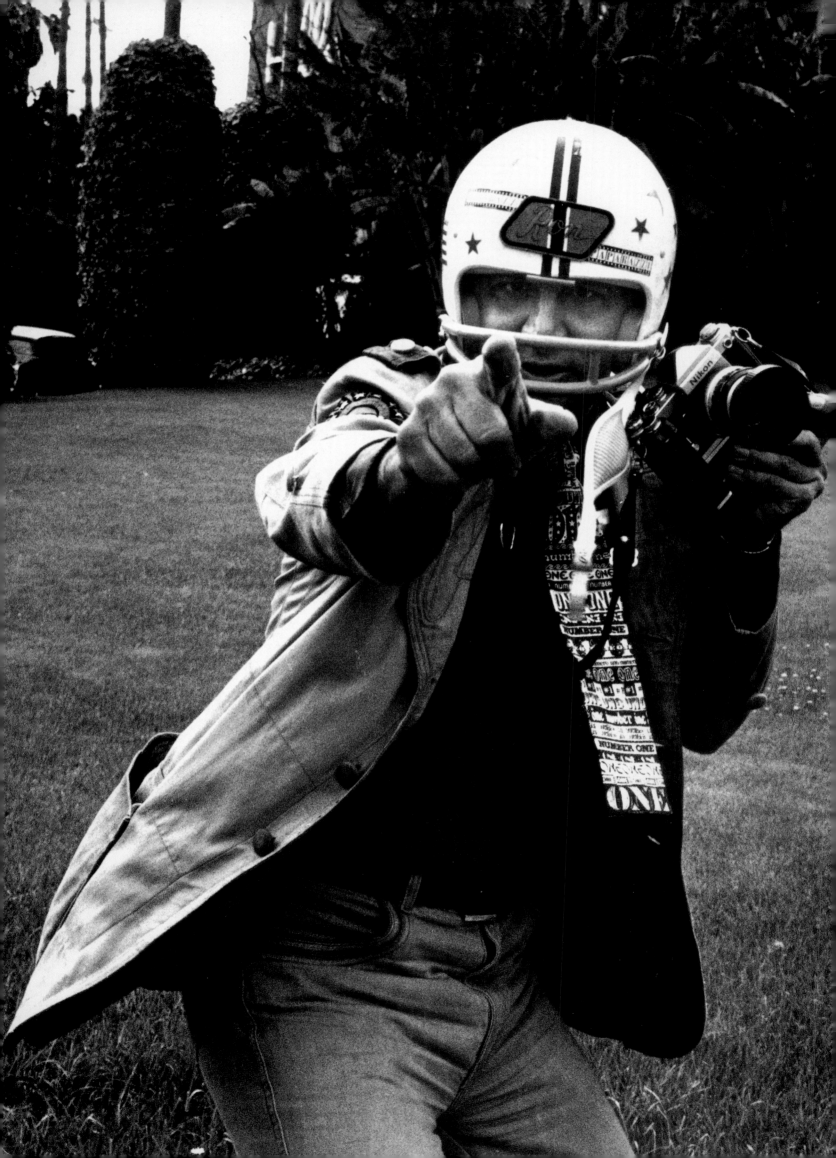

GET MAD

Ron Galella has received more than his share of celebrity hostility. As
well as having his life threatened by Richard Burton and subsequently
being beaten up on the set of one of Burton's films, he has been spat
at by Sean Penn, and in 1973 he had a run-in with Marlon Brando.
Brando was scheduled to appear on *The Dick Cavett Show*. Even
though Cavett's office wouldn't give Gallela any information about
the superstar's itinerary, he managed to track Brando down and
photograph his arrival at a New York heliport. He followed Brando
to the TV studio, but the hordes of fans and photographers made
it impossible for him to get any pictures. Galella, however, had an
exit strategy:

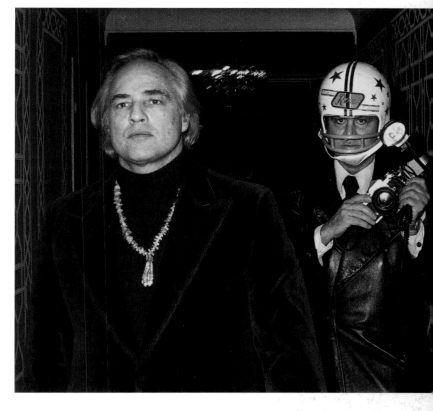

 "When the show was over, Brando came out with Cavett and
got in a limousine. Another photographer, Paul Schmulbach, and I
followed them to Chinatown; they got out of the car and started
walking, and we started shooting. After about a block they stopped,
and Brando called me over and said, 'What do you want that you
don't already have?' I answered that I'd like a picture of him without
sunglasses on, which both he and Cavett were wearing even though
it was nighttime. I was looking at Cavett because you always look at the person who's nicer in the hope
that he's going to do what you want. But Brando just flung at me—I didn't even see the punch. He hit me
with a right to the jaw. The blood was gushing; I put my handkerchief to my mouth. Paul was stunned—he
couldn't believe it. He didn't get the picture, of course. We got in the car and drove to Bellevue Hospital,
where they sewed me up. I also lost five teeth, four then and another one later."

 The next morning a fan photographed Brando leaving the Regency Hotel with his hand covered
in bandages: Galella's teeth had infected the actor's fist—nature's way of exacting a small measure of
revenge for the attack. Actually, the measure of revenge wasn't that small, because Brando had to stay
in New York City's Hospital for Special Surgery for three days and later pay Galella $40,000 in an out-of-
court settlement, and to the end of his life bore scars on his knuckles from the incident. Galella himself
has a dental bridge as a souvenir. He also has a theory of why he was slugged:

 "The interview Brando did with Cavett was about his sympathy for the American Indians, and he got
bad reviews. To this day I don't know exactly why he punched me, and Cavett won't tell me. But I think
that he was frustrated that the Indians didn't come across well, and he took his anger out on me. About a
year later, he had a press conference at the Waldorf-Astoria in New York, again with the Indians. This time
I decided to wear a football helmet that I had someone make for me. Again I brought Paul and told him he
had to get this picture of me with Brando. Naturally, we weren't invited into the press conference, but as
Brando was leaving, I pushed Paul to get the picture. Luckily, on the second exposure he got it. Great shot."

BRANDO-PROOFING: Ron
Galella dons protective clothing
(opposite) before heading out
to photograph Marlon Brando
at the Waldorf-Astoria in 1974
for the first time after being
punched in the mouth by the
actor. The helmet can be seen in
action in the photograph above.

Mustafa Khalili takes a philosophical view of the occasional physical abuse that seems to come with the job. On one occasion, Kid Rock had been performing live at a venue in Malibu, and Khalili and his partner were the only photographers present to shoot him and Pamela Anderson leaving the concert. When Rock realized he was being photographed, "he just flipped," says Khalili. "He attacked me, tried to push me into the middle of the highway, and broke three cameras. He went insane; he went mad, he lost it. He was very drunk."

Unlike Galella, Khalili didn't try to sue his attacker. He hadn't been hurt in the melee, and in fact, he's amazed that it doesn't happen more often. He accepts it as a part of the job, in the same way that combat photographers don't sue people who shoot at them: "That's being professional—do your picture and walk away."

Adriano Bartoloni was beaten for a different, and very Italian, reason. During the 1970s, he made the mistake of photographing Gigi Riva, a famous Italian soccer player, in the company of a woman. Riva was afraid of fan reaction to the photograph if his team lost—the inevitable accusations that he had wasted his energies on a woman instead of saving them for the game!

GET EVEN

Although on many occasions they are clearly tempted to just slug photographers, some celebrities come up with more original and inventive ways of expressing their anger. Brad Pitt in particular has developed several creative techniques. The cameras built into some traffic lights in Los Angeles are synchronized to photograph the license plate of any car that crosses the intersection on a red light. According to photographer Steven Ginsburg, Pitt has become expert at timing his driving so that anyone following will have to jump the red in order to keep up with him. At $350 a ticket for each infringement, the value of any pictures the photographer following him might get is reduced. Given the financial motivation of most paparazzi, as well as their dependence on having a valid a driver's license, this is a powerful deterrent.

Ginsburg tells of following Pitt all the way to the studio without a single photo possibility, then running across him by chance at a McDonald's a couple of hours later:

"He was waiting to make a left, and I came up in the right lane to try to shoot him. He saw me and started to duck while he was driving, so I let him go in front of me. He turned into Sunset Plaza Drive and pulled over. I pulled up behind him; he's just sitting there. I'm trying to see what he's doing through his window, but I can't make out anything. Ten minutes, nothing happens, so I decide to go around him. As soon as I draw level, he throws a cheeseburger all over me. Apparently he had been opening up ketchup packets and putting them on the cheeseburger. By the time he threw it, there must've been fifteen to twenty packets of ketchup on it. Naturally it was kind of a shock—I'm picking a pickle off of my face, and he's enjoying it. By the time I recovered enough to grab my camera, he'd driven off. So yeah, he's difficult, he's very difficult to get. He says it's a game, but it's not a game, at least not for me. I don't like him. He's not pleasant."

Ginsburg says his encounters with Pitt became more threatening "I shot him one day, and he saw me. 'Man, you don't want to start a war with me,' he said. 'You're right,' I said. 'I don't. I just need some pictures.' I took my pictures and he drove away. By complete chance I spotted him again the next day, and I shot him some more. He saw me, stopped, put his window down, and said, 'The war is on.'"

LET'S DO LUNCH: Brad Pitt and his wife, Jennifer Aniston, grab a bite to eat in West Hollywood, April 2001. The couple are regarded by fans as Hollywood's perfect couple, and images of them are in constant demand. For their marriage in July 2000, Pitt designed their wedding bands and entered into an agreement with the jewelry manufacturer that the rings would never be reproduced—which of course they were, selling for about $1,000 apiece.

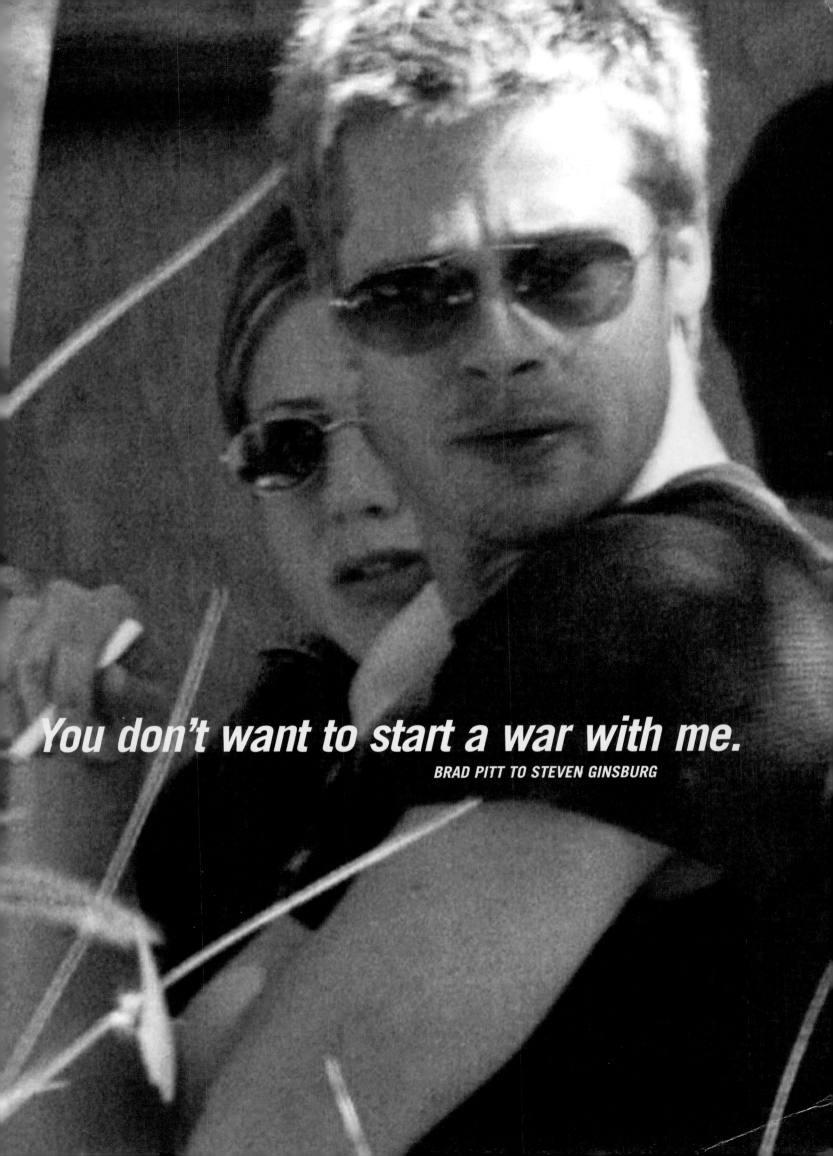

You don't want to start a war with me.
BRAD PITT TO STEVEN GINSBURG

The following day, Ginsburg was driving around as usual when he realized that he had been seeing the same set of yellow headlights in his rearview mirror for the last two hours. To test whether he was being followed, he pulled into the left lane and quickly back into the right; the car behind him did the same. He pulled into a 7-Eleven; so did the car:

"My heart's racing. I hadn't been doing the job all that long at the time, so I'm trying to call the guy I was working for, to tell him that I'm being followed. By this time there are people taking pictures of me, and a guy's videotaping me, so I drive over to my boss's house, freaking out. I call the police and tell them there are six people following me. I look outside the window and they're sitting outside."

The following day, every time Ginsburg pulled up at a red light, the same guys leaped out of the same car and photographed him. They camped outside his house for ten days. Though he can't prove it, he suspects they were private investigators paid by Pitt to give him a taste of his own medicine. It worked for a time—Ginsburg backed off for a couple of months, and the mysterious stalkers disappeared.

GET MAD AND GET EVEN

Another celebrity on Ginsburg's "least favorite" list is Cameron Diaz: "She's a nightmare for me, a nightmare." In one of the many run-ins he's had with her, she managed to get mad and even at the same time. He had received a tip that she and her boyfriend at the time, Jared Leto, were at a Los Angeles store called Guitar Center. As he drove up, he saw the two of them loading up their car with a considerable amount of equipment. He followed them home and shot some pictures of the actress in her yard pretending to play one of the guitars they had just purchased. The view of the yard from where he was parked, according to him, was clear and unimpeded, and so provided none of the expectations of privacy that the law demands that would prevent him from taking the photographs. But suddenly Leto saw him shooting from his Jeep Wrangler and came after him. The car had a stick shift; unfortunately Ginsburg hadn't depressed the clutch fully, and the wheels spun. Leto was able to get within accurate spitting range—and spat. Ginsburg took off, but the story didn't end there:

"Maybe two or three months later, I'm working on Diaz again, and she sees me. I'm thinking, Oh man, what am I going to do? I pull into a driveway, and she pulls in front of my car, blocking me in, rolls down her window, and says, 'If you're going to waste my time, I'm going to waste yours.' She rolls up the window, kicks back, and starts reading a book. For forty-five minutes I'm sitting there in somebody's driveway. I don't know what to do. You don't know what she's doing. Is she calling the police? I don't want it to go that far because it's not that big a deal for me. Was she having fun with it? I think so. Does she pretend to be angry? Yeah. And is she the person she is in the movies? No, not at all. She's horrible. Can't stand her."

GET CONTROL

In December 2003, Gwyneth Paltrow and her soon-to-be husband, Chris Martin, found out that she was pregnant with their first child. Photographs of the two of them leaving her doctor's office in Manhattan, him playfully rubbing her belly, appeared in magazines around the world. Another example of a ruthless paparazzo intruding upon a joyful, private moment in order to make a lot of money from an exclusive? No,

BIRD LAND: The middle finger of Cameron Diaz's right hand has been photographed more than almost any other part of her body. It is her default reaction to the presence of paparazzi, unless, of course, she's just drying her nail polish.

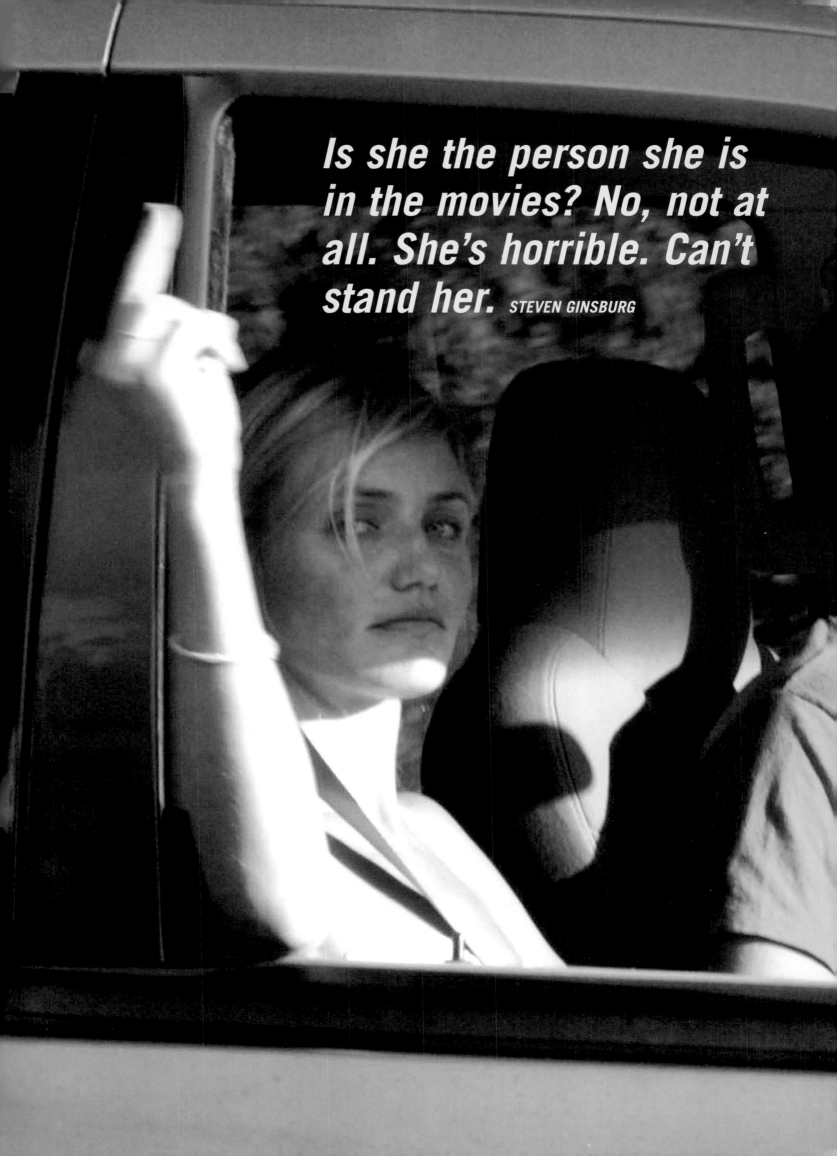

THE GOOD MOTHER:
Angelina Jolie allowed herself to be photographed in a Los Angeles park with her child, September 2002. By showing herself as an involved parent, she stood to gain the public's sympathy in her separation from her husband, actor Billy Bob Thornton. Celebrities frequently use the paparazzi when they have an agenda to pursue.

it probably wasn't. According to most people in the business, it was an example of a new trend whereby a publicist sets up and controls a set of pictures that are made to look like paparazzi shots. Publicists aren't in principle opposed to their clients being exposed to the kind of voyeurism the work of the paparazzi exploits. What disturbs them is having no control over which photographs go out into the market or where they are published. By setting up fake paparazzi situations, they are providing the public with what it wants while retaining a great degree of control.

"I think that ninety percent of the issues between the celebrities and the paparazzi are about control," says Phil Ramey. "These people become so fixated about their image—on the way up, anyway—and they have such an army of sycophants catering to their every whim that they believe they can control everything." He gives the example of the photographs of Tom Cruise and Penelope Cruz "caught" behind the Hollywood restaurant Spago. The publicist told the photographer where to be and when and then controlled where the pictures were published.

Publicists also try to use paparazzi to advance their agenda for honing their client's image in the public eye. Michael Jackson's publicist regularly alerted Ramey to situations in which the star could be seen going out with a woman, as happened one time in Malibu's Topanga Canyon when the King of Pop turned up at an out-of-the-way vegetarian restaurant with Brooke Shields.

Frank Griffin believes that in a way this strategy of the publicists validates what his photographers do: They and their clients are acknowledging that there is a need for this kind of work. But he also thinks that for the most part the celebrities would be much better off using real paparazzi: "We make things look much better because we do it as if it was a real event, and the celebrities don't even know that it's actually happening. It makes life a lot easier for both of us."

Making life easier is probably why celebrities have "official" paparazzi photographs in the first place. At the moments in their lives when they're most newsworthy, they hope that by releasing this kind of material, they'll reduce the number of photographers chasing them. It's a hope that Randy Bauer thinks is doomed from the outset: "When Reese Witherspoon did it, there were more photographers outside her house than ever before. It brings down the value of the pictures, but there are so many photographers in this town that the value can come down and they'll still work on it. Instead of making ten thousand, they'll make five thousand."

Whether it's an effective maneuver or not, it's one that more and more celebrities are doing in order to manage, and manipulate, the paparazzi. Brittain Stone recalls how Angelina Jolie allowed herself to be photographed with her son in a park when she broke up with Billy Bob Thornton, and that in doing so she gained some ground in the battle for public opinion. He thinks that it does go

If you actually have something that you do well, it can be hurt by too much of the paparazzi stuff. It's good to save a little bit of yourself. SUSAN SARANDON

some way to ease, at least temporarily, the pressure from the paparazzi, but that it probably buys only about a month or two, after which the latest available photos start to look old: "Adam Sandler made pictures of his wedding available to everyone, which was great. But there were still four or five helicopters hovering over it, including one of ours. It makes a little bit of difference, but it doesn't make a huge amount of difference."

If the publicists' biggest frustration with the paparazzi is that there's no way of controlling the distribution of the photographs, let alone their content, it's because control is, and always has been, important to Hollywood folk. Remember, the old studio system was all about keeping the actors in line and having complete power over what photographs were taken of them and where they appeared. The publicists whom dominate the scene today try to exert the same jurisdiction; but for all their machinations, the dominating influence behind the whole farrago is only partially under their control—the market. It's you and I who ultimately decide whom we want to see and where we want to see them. The Paltrow-Martin pregnancy pictures show the double standards that abound around the activities of the paparazzi, as Phil Ramey is quick to point out:

"Whether or not these situations devalue true paparazzi pictures depends upon what's available on the market that week and if I have something stronger that will compete with it. This is a wonderfully self-aggrandizing thing that celebrities do, and it reveals the essential duplicity of most of them and the people connected with them. I mean, Gwyneth Paltrow and her boyfriend scream the loudest about this kind of crap. He's sued various English newspapers; he evidently punched photographers who pursued him on their quickie wedding in Santa Barbara, and then they play a stunt like this where they feel they can control it and get the money. Well, you know, I guess they can have it both ways. But I don't want to listen to it, because I think it's all bullshit."

MY FAVORITE CELEBRITIES, OR SOMEBODY OUT THERE LIKES ME

AN ACCOMMODATING HILTON: In February 2003, at a car repair shop, Paris Hilton approached photographer Steven Ginsburg and asked if he wanted his photograph taken with her. You can see his reply.

STEVEN GINSBURG ON MATTHEW PERRY We're doing our job, we try to keep our distance, and a lot of the celebrities understand this. They say, "Do you have enough pictures? Do you want me to stand here for a minute and let you shoot?" Take Matthew Perry. He's an incredible guy—I've never ever seen him have a problem with anybody. He knows you're there, but he puts the top of his car down, he blares his music, and he cruises; he steams along and he doesn't care. Some of them see the camera and wave; others see the camera and just pretend they don't. I think they're saying, It's not going to go away, so why let it bother me, why spend every one of your days like Pierce Brosnan, coming up to these guys, telling them you're going to have them thrown out of this country. It's not going to happen; they're not doing anything illegal. I kind of respect Matthew Perry for that. I think he's just as big a star as Pierce Brosnan. At least to me he is.

PHIL RAMEY ON SEAN PENN Sean Penn approached me long after the Madonna years were over. They were very difficult times for him, for his mental stability—why wouldn't they be, considering that she's probably enough to make a sane person crazy. He approached me, and we had a little talk about a few things. He's a very intelligent guy, and I have a tremendous respect for his work. His movies unfortunately aren't the most wonderful things to watch; if you don't like angst, you don't go to see Sean Penn movies, but he does a wonderful job. I was around him from the beginning, and he's been consistent. He doesn't particularly care for the press or anything to do with the press, and never has. When I was still working premieres in the early eighties, hardly anybody knew who he was, other than his first movie, and he'd walk into premieres and never stop for the photographers; he had disdain for them then, when nobody knew or hardly cared who he was. That posture has remained consistent or has been exacerbated by him, sometimes to his own detriment; he did jail time, eventually, for slugging people.

MUSTAFA KHALILI ON BRITNEY, JOHNNY . . . I love doing Britney. She's always fun; she enjoys it. There's always a chase, always a follow, and she's always doing something interesting. She'll give you a picture whether she's smiling or crying. Johnny Depp, too. He's very discreet. I like that. He's a cool guy; he does his thing and gets on with it. I've only photographed Brad Pitt once; you've got to be as discreet as possible because he's very aware, very alert, always looking in his [rearview] mirror. He can be more hassle than it's worth, because he's going to send you on a wild-goose chase from time to time. You've got to respect that these people do what they do, that we do what we do, and that we have to give them their space or else they'll start hating us.

Certain people know my face, and they say hello. Geri Halliwell is more likely to give me a smile than a "screw" face because she knows me from London and from here. She knows that I keep my distance and that I'm not going to harass her and drive fast behind her if she's spotted me. If you respect them and give them their space, they'll respect you some of the time, which is better than none of the time. Cameron Diaz seems to love seeing pictures of herself with her finger up, because that's all she does. I like working on Cameron. I'm different to everyone on this, because it's a bit of a challenge. She's so alert, and she's so aware of everything. You've just got to be one step ahead of these people— know what they're like, know what they're going to do. I've got nothing against them.

STEVEN GINSBURG ON GWYNETH PALTROW You have to build relationships. We were in Kauai doing the Matt LeBlanc wedding, and through sheer luck we found Gwenyth Paltrow. Usually she'd be screaming, "You losers, I'll call the police," but just before she started yelling at me, I said, "Look, we have a problem with the wedding, they canceled helicopters, we've got nothing, we're wasting money, please help us out. We don't want to ruin your vacation, we don't want to follow you, we don't want to hide outside your house, we just need something to make this trip worthwhile." So she let us take "paparazzi" pictures: She posed, but she looked away from the camera. The next day we ran into Chris Martin, the lead singer of Coldplay, Gwenyth's boyfriend then, now husband, and he said, "Yeah, Gwyneth told me that you guys were all right," so he did the same thing. He walked along with us; actually bought us smoothies. Let us take some pictures of him as well. We put them all through England and made more than enough money for the trip; they saved our butts. "You guys, you're good people, and I appreciate that," Martin said. "When we see you again, we'll be happy to let you have some pictures." So now when there's a story breaking, that's when we can use that. I'm very happy that I'm young, because I have years to build these relationships.

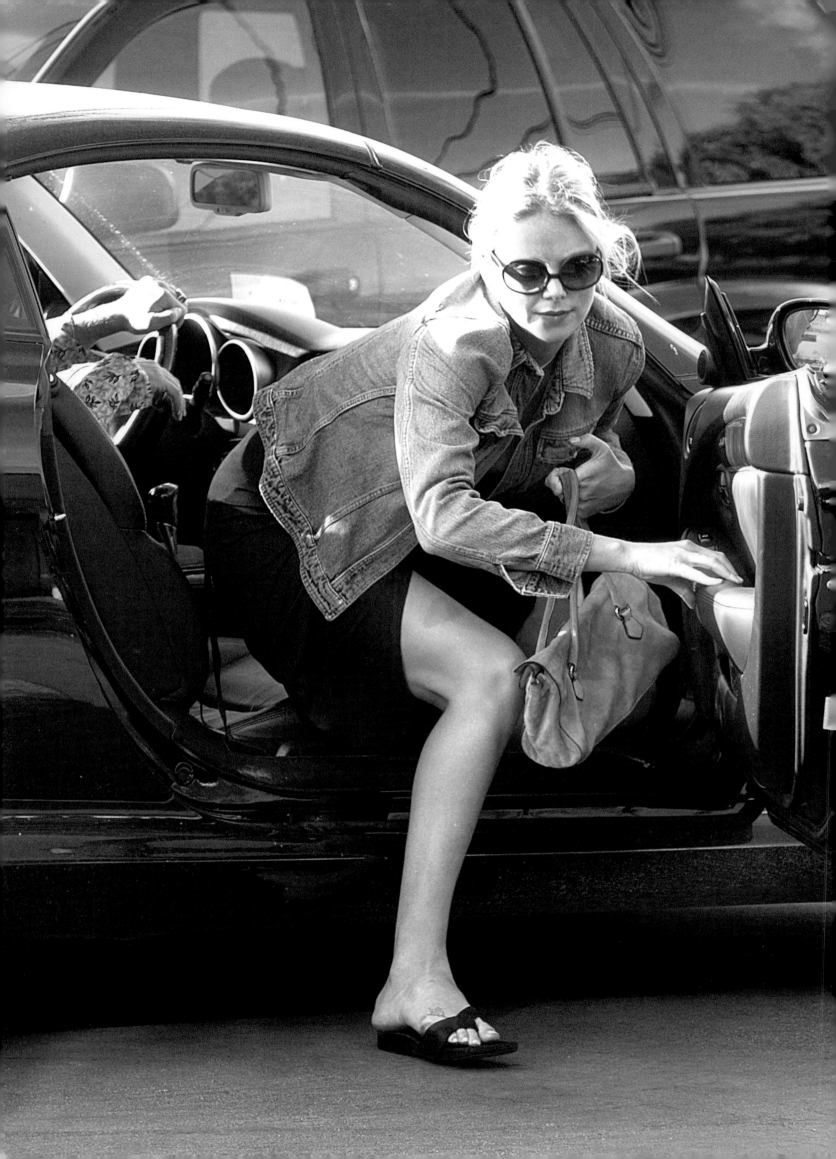

JUST ANOTHER DAY AT WORK

I was at a car wash getting my car done, and just as I was pulling out I saw Charlize Theron fly in. Usually she's thin, but she was overweight for a movie she was doing. She was with her boyfriend, who picked her up after she dropped off her car. I followed them to The Ivy; all these paparazzi were just hanging around outside as usual, waiting for something to happen.

After four hours, Charlize and her boyfriend leave. I start shooting; everybody starts shooting. They pull away fast, but I know where they're going, so I don't follow, I just go back to the car wash. When they arrive, I'm shooting, and the boyfriend comes up to me and says, "She's having a real rough day, can you back off?" I say, "Look, I just need a few pictures." He says okay, turns his back on me, and goes inside. Then they walk out together; she's holding a bottle of water, which she suddenly throws all over my head and camera. It was a brand-new camera, and I was worried it was broken. All the Mexican guys at the car wash are coming up to me, saying, "I'll testify, I'll testify," and giving me their names and numbers. She had recently done the same thing to another photographer. She's somebody I like to get all ways, because she's not the nicest person in the world. ✳ STEVEN GINSBURG

This is the frame before the water went all over my head and my camera. STEVEN GINSBURG

DON'T SHOOT THE BURN VICTIM

Around 1994, I was with my twelve-year-old adopted niece and her seventy-year-old grandfather at an antique dolls show at the Sheraton Universal in Los Angeles. There was a lot of great American folk art, too, which I'm interested in. As we were cruising the collections, one of the dealers spotted me and said, "Oh, you're the paparazzi." I said, "Yeah, but I'm not working," and he said, "Well, you should be. Why aren't you taking pictures of Michael Jackson? He's right over there." This was a big hall, but he was pointing to somebody only thirty feet away. I had noticed this person when I came into the hotel, because his whole face was wrapped up in bandages, with two little slits for the eyes; he had dark glasses on, and his arms and hands were wrapped in bandages and gloves. He was cripping along with the help of a cane and an assistant; I assumed he was a burn victim. "You've got to be kidding," I said to the dealer. "No," he said, "that's Michael Jackson. You should have been here at the last doll show, when he came dressed as a Hassidic Jew, right down to the black suit, the braids, everything."

I grabbed my niece and her grandfather, and we got up close to the guy; I was practically shoulder to shoulder with him, but he didn't notice me. He had red glasses on, not regular sunglasses—everything was red, the lenses, the frames, everything. I looked into the eyes, and right away I could tell that it was Michael Jackson. I got my niece and the grandfather to follow him while I went to the underground parking garage to grab a video camera because it was so dark in the ballroom. When I got back, the grandfather was waving to me in the corner, indicating that Michael was in the bathroom. I stood at the end of the hallway and rolled video; I got him hitching up his pants and then walking towards me before he spotted me. Then he went from burn victim to Wacko Jacko—he started swinging the cane around as if he was trying to bash me in the head. His wimp chauffeur slapped my leather jacket; on the videotape you can hear the slap of leather and me trying to be cool and saying to the guy, "That's not nice." I finally told Michael that if he'd really like to hit me with that cane, I was going to take it away from him and shove it up his ass. I said it in a very loud voice, which drew the attention of several people, including security. They separated us, dragged him to a corner, and thoroughly berated me for shooting video of this burn victim. As they escorted me from the hotel I told them, "That was no burn victim, that was Michael Jackson." ✳ PHIL RAMEY